DECOLONIZING THE ENGLISH LITERARY CURRICULUM

EDITED BY
ATO QUAYSON
ANKHI MUKHERJEE

EDITED BY
ATO QU...
ANKHI MUKHERJEE

DECOLONIZING THE ENGLISH LITERARY CURRICULUM

G000291637

Discover more about this title at
cup.org/DELC

CAMBRIDGE
UNIVERSITY PRESS

GRANTA

12 Addison Avenue, London WII 4QR | email: editorial@granta.com
To subscribe visit subscribe.granta.com, or call +44 (0)1371 851873

ISSUE 167: SPRING 2024

EDITOR	Thomas Meaney
MD & DEPUTY EDITOR	Luke Neima
ONLINE EDITOR	Josie Mitchell
MANAGING EDITOR	Tom Bolger
SENIOR DESIGNER	Daniela Silva
ASSISTANT EDITOR	Brodie Crellin
EDITORIAL ASSISTANT	Aea Varfis-van Warmelo
PHOTOGRAPHY EDITOR	Max Ferguson
COMMERCIAL DIRECTOR	Noel Murphy
OPERATIONS & SUBSCRIPTIONS	Sam Lachter
MARKETING	Simon Heafield
PUBLICITY	Pru Rowlandson, publicity@granta.com
CONTRACTS	Isabella Depiazzi
ADVERTISING	Renata Molina-Lopes, Renata.Molina-Lopes@granta.com
FINANCE	Suzanna Carr
SALES	Rosie Morgan
IT SUPPORT	Kieran Spiers, Mark Williams
PRODUCTION & DESIGN DIRECTOR	Sarah Wasley
PROOFS	Katherine Fry, Gesche Ipsen, Jessica Kelly, Jess Porter Will Rees, Francisco Vilhena
CONTRIBUTING EDITORS	Anne Carson, Rana Dasgupta, Michael Hofmann, A.M. Homes, Rahmane Idrissa, Anahid Nersessian, Leo Robson
PUBLISHER	Sigrid Rausing

p.185 'The True Depth of a Cave' by Rachel Kushner is an excerpt from *Creation Lake*, which will be published by Jonathan Cape and Scribner in September 2024; p.261 'On Boredom' by Nuar Alsadir uses an excerpt from *The Dream Songs* by John Berryman. Copyright © 1969 by John Berryman, renewed 1997 by Kate Donahue Berryman. Reprinted by permission of Farrar, Straus and Giroux and Faber and Faber Ltd. All rights reserved

MIX
Paper | Supporting
responsible forestry
FSC® C023419

WHERE YOUR ROLE MODELS BECOME YOUR MENTORS

WRITING MFA PROGRAM
FICTION, NONFICTION, POETRY, TRANSLATION

FULL-TIME FACULTY Paul Beatty, Susan Bernofsky, Anelise Chen, Nicholas Christopher, Jaquira Díaz, Timothy Donnelly, Rivka Galchen, Lis Harris, Leslie Jamison, Margo Jefferson, Heidi Julavits, Binnie Kirshenbaum, Dorothea Lasky, Victor LaValle, Sam Lipsyte, Ben Marcus, Shane McCrae, Deborah Paredez, Matthew Salesses, Gary Shteyngart, Wendy S. Walters, Lynn Xu, Alan Ziegler.

COLUMBIA UNIVERSITY SCHOOL OF THE ARTS

arts.columbia.edu/granta

CONTENTS

Surely there is a vein for the silver, and a place for gold where they fine it. Iron is taken out of the earth, and brass is molten out of the stone. He setteth an end to darkness, and searcheth out all perfection: the stones of darkness, and the shadow of death.

– Job 28: 1–3

Introduction

W e periodize most of human history according to the tools our ancestors mined from the earth: the Stone Age, the Iron Age, the Bronze Age. Culture has been bound up since the beginning with extraction. Among the first materials hominids mined for were red ochre and other concentrated pigments. They responded to the welter of godlike forces around them – floods, storms, shooting stars – by searching the depths below for colors with which they could mark their skin and animal hides, and bring a semblance of order to the world. There is a reason 'cosmetic' shares a root with 'cosmos'.

No one before modern times entered a mine except as a prisoner of war, a criminal or a slave, as Lewis Mumford once observed. Papyrus scraps from ancient Egypt detail the divisions of labor that mining demanded: those who prospected, those who tested rock, those who took charge of tools, those who supervised baskets, those who filled the baskets. Mining and quarrying shaped the governing forms of the ancient world, from empires to city-states. The democracy of fifth-century Athens, which allowed a sliver of its population to debate political questions, would not have been possible without the great Laurium silver mine outside the city, where prisoners and children worked to fill the coffers of the city's benefactors.

Mining in the age of European colonial expansion was both an engine of institutionalized slavery and modern liberation. The silver and gold mines of the Americas under the Spanish court's command became hubs of exploitation, fed with the labor of the indigenous empires they eradicated. The industrial revolution in Europe was, fundamentally, a turn from relying on the living environment (timber, draft horses) toward the dead (fossil fuels, iron ore), though two centuries later three billion people in the South still use biomass energy for their everyday cooking and heating. Extraction's cycle of boom and bust – discovery, exploitation, exhaustion, new discovery – became the cursus of capital itself. But counter-movements

flickered inside this development. The rise of modern democracy in England has been attributed, in part, to the rise of coal-mining, which allowed miners to organize and block production. Such opposition is harder to mount in the age of oil, when tankers glide through waters unobstructed by all but the most determined pirates.

It's little surprise that extraction – literal digging in the earth – has been a great subject of fiction, from the naturalism of Zola's *Germinal* – with its swinging Davy lamps and sweating girls at the coalface – to the most epic petro-novel of them all, Abdelrahman Munif's *Cities of Salt*. Joseph Conrad's *Nostromo* is in this sense mistitled: the protagonist of the novel is not an Italian strike-breaker, but the San Tomé silver mine. Modern American literature itself could be said to have been born underground and on the water. When Mark Twain went into the mining business with his brother Orion Clemens in Nevada in the 1860s, he didn't find much of value, but he picked up a different kind of argot: the vernacular of the miners, whose language, along with the steamboat-speech of the Mississippi, he wanted to preserve on the page. It's to Twain that we owe one of the most succinct definitions of a mine: a hole in the ground with a liar standing next to it. And what is *Moby-Dick* if not an ode to sperm-whale oil extraction?

In our own time, there is a vast appetite for the metals and materials required for the green transition: lithium and nickel for car batteries, cobalt and other metals for chips. Not since the 1970s have states on the global periphery been in a better position to extract concessions from the great powers, yet despite much talk almost nothing has come of it. The conditions on the ground – and mining corporations' lattice of legal protections for their technology and know-how – have made the emergence of an OPEC for minerals and metals unlikely.

On both old and new extraction sites, fresh confrontations continue to break out across the globe. In 2022, Serbian environmental groups blocked the lithium mining concession of Rio Tinto in the Jadar Valley, where a highly in-demand mineral, 'Jadarite', has been discovered. In

early 2023, a generation of German eco-activists were defeated in a bitter showdown with the company RWE, which has expanded an open-pit coal mine in the village of Lützerath in the Rhineland. Last October, a local political coalition in Panama stopped First Quantum Minerals from opening a copper mine just inland from the western coast, while António Costa, the prime minister of Portugal, resigned in the wake of allegations of corruption surrounding concessions for lithium mining in the country.

These emboldened protests against resource extraction arise in both the South and the North. As we enter a period of national onshoring, with the great powers all seeking to mine precious materials inside their own borders, under the banner of 'national security', the realities of extraction may once again become visible in the cores of the global economy. The chief paradox of the age is that even the movement to replace fossil fuels requires another round of mining. How to facilitate the extraction that is necessary without continuing on the path of endless accumulation? The current picture is not rosy. 'We're not really in an energy transition as it is popularly understood,' Thea Riofrancos told *Granta* for this issue. 'What we're in is a period of major energy *addition*, in which both fossil fuels and renewable sources are growing at a rapid clip.'

In this issue, James Pogue reports from the Central African Republic, where mining rights have long been in the crosshairs of global politics. In a historical meditation on the fate of Imperial Russia, Bathsheba Demuth moves among the ghosts of extraction along the Yukon River, pursuing different leads behind a mysterious massacre in the village of Nulato in 1851. Laleh Khalili uncoils the history of energy in Israel, where, as Golda Meir once mused, the early Zionists had chosen to colonize one of the few spots in the Middle East without oil. Anjan Sundaram reports from Mexico, where the country's cartels are in open conflict with local villages over the control of mining concessions. William Atkins writes from the Forest of Dean in Gloucestershire, where men (and one woman) dig for their own coal – and fuel their dignity – under a royal grant of

rights that dates back hundreds of years. The perversion of idealism in crypto-mining is the subject of Atossa Araxia Abrahamian's essay, which critically examines the greenification of Bitcoin mining, which globally uses roughly as much energy as Ireland. Inaugurating a new series of psychoanalytic essays for the magazine, Nuar Alsadir explores the trapped passion on the other side of boredom.

Summarizing the fiction in this issue, as in all issues of *Granta*, is a foolhardy exercise. Nevertheless: Benjamin Kunkel's 'Prairie Dogs' is a tale of a party gone wrong: a man coping with his environmental and social commitments momentarily succumbs to his own attraction to the apocalypse. Bruno Lacombe, the shadowy figure from Rachel Kushner's forthcoming novel, *Creation Lake*, has renounced modern life in favor of the historical continuum he finds in a cave. In 'Monkey Army', Eka Kurniawan's story of a degraded man guarding an extraction site in Java, the legend of the Ramayana gets reversed: the monkeys are not friends to humans, but wreak a reign of terror. Based on the life of the American ethnologist Richard Oglesby Marsh, Carlos Fonseca reflects in a multi-layered narrative on the arrival of scientific colonialism in Central America, and the abduction of a group of children, thought to belong to a lost tribe of Europeans. In Camilla Grudova's 'Nettle Tea', patients at an esoteric clinic submit to a rigorous process of extraction, as they learn to expel their unreturned desires. Unreturned desire is one of the undertones of Christian Lorentzen's story 'The Accursed Mountains', in which a literary journeyman in Albania deflects his feeling for a fellow traveler onto his dentist, who conducts a delicate extraction operation on his mouth.

G*ranta* will return to the theme of desire in a summer issue devoted to stories of deception and delusion. A close-up of the great extraction powerhouse of our time – China – will follow in the autumn. ∎

TM

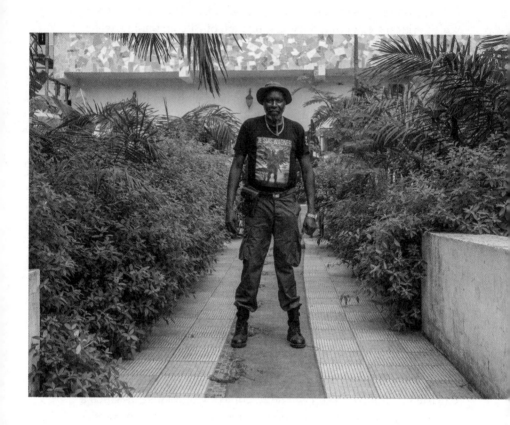

BARBARA DEBOUT
Fidèle Gouandjika, special counselor to Central African Republic President Faustin-Archange Touadéra, poses at home following the death of the former head of the Wagner Group, Yevgeny Prigozhin

WAGNER IN AFRICA

James Pogue

I was always confused about where people left their guns. Most of my days in the Central African Republic were spent on the riverside terrace of the Hôtel Oubangui, and although this was not by choice, it did turn out to be a convenient place to sense the atmosphere of intrigue that was settling over Bangui. It was the kind of mood that excites journalists. 'Rarely has such a fragrance of Cold War wafted over the banks of the Oubangui,' wrote the pan-African current affairs magazine *Jeune Afrique*. 'The truth is that a front in the war launched two years ago in Ukraine has opened in the heart of the Central African capital.' The hotel terrace was full of people who must have stowed weapons somewhere – weary peacekeepers in uniform, grim and silent local Wagner Group recruits, Rwandan soldiers, bodyguards for businessmen of all nationalities and descriptions. A combination of these came every afternoon to drink fruit juice or whiskey and look at the river, which was then miles wide, flooded and raging. Some of them may have had sidearms concealed on them, but as far as I could tell they all observed the no-guns policy marked at the hotel door, where a sticker showed a stencil of an M16, circled and crossed-out in the manner of the international 'no smoking' symbol. Even men in body armor with thirty-round magazines stuck into the front of their plate-carriers would walk unarmed through the lobby and loiter on the

terrace for hours. I wondered about this because I had very little else to do, and because in America we have a complex about leaving firearms in vehicles where they might be stolen. But I had been warned not to get caught reporting, so I never asked anyone where they left their guns.

I hadn't known about the rumors flying around before I got to CAR, as everyone calls it in English, pronouncing the acronym phonetically. 'ANNOUNCEMENT', Fidèle Gouandjika, the special counselor of CAR's president, and one of the most powerful people in the country, posted on Facebook on 10 November 2023. 'Heightened vigilance. The CIA is planning to visit CAR. I am always at the service of the sovereign people.'

On Russian Telegram channels they were more specific. They thought America was launching a shadow war: 'A CIA task force is due to arrive in Bangui in November,' one message read. 'The goal of this visit is to reinforce the American security sphere, and to collect information on the Wagner Group, because the United States is still unable to develop an efficient counter-strategy.'

The Americans were supposedly sending in a scouting party just as I arrived.

The Russians really were everywhere in Bangui. There was a Wagner base not far from my hotel, and convoys of men in Wagner uniforms passed at all hours, usually in groups of four or five Land Cruiser 79 pickups, the 4×4 of choice for rebel groups and mercenaries the world over. These usually carried five men wearing camo, face masks and short-brim caps, all sitting down with automatic rifles, while a gunner stood at a swivel-mounted DShK heavy machine gun. The first time I saw one of these convoys I locked eyes with a young guy in a skull mask. After a moment he raised his hand and gave me a slight wave.

The fixer I'd hired, a local TV correspondent named Leger-Serge Kokpakpa, laughed when I told him I'd ended up hiding the camo jacket I'd been wearing before he picked me up at M'Poko Airport. But a French journalist said I was giving off an *aspect militaire*, and I didn't want to draw attention. There were two Russian women on my

flight, and the man who came to pick them up reappeared half an hour later, standing listlessly in the dingy baggage claim area while I waited in line to apply for a visa. 'People watch white people here,' Leger-Serge said, when he noticed me glancing at the man. 'It's natural. Even white people watch white people.' But I was still edgy. Since at least the summer the airport had been 'entirely under the control of the Russians', according to sources within the 16,000-strong UN peacekeeping force in the country. It was the logistics hub for Wagner Group operations across Africa. 'The Russians know all the Americans who come into the country,' I was told. 'The customs people tell them. They just keep tabs.'

The customs agents took my passport and told me I would have to go to the national immigration office the next day to collect my visa. Leger-Serge pulled the ancient little Peugeot he'd borrowed away from the airport and into the mile-long row of tin shacks and cinderblock restaurants of Bangui's grand market. It seemed that every other car was a white pickup with the logo of an aid organization or 'UN' painted on its side. Then a new UAZ SUV with police lights flashing cut us off, forcing us to swerve to let them by. 'Those are the Russians, the Wagners,' Leger-Serge said. Central Africans use the terms interchangeably. 'They come and go, you never know when. They fly at all hours. They do what they want.'

Leger-Serge was a tall and somber 46-year-old who lived far out on the outskirts of Bangui. He was poor, and had little connection to the small and intimate networks of the elite. But in CAR, to be a journalist was still to be a part of a somewhat formalized professional caste. He called me his confrère, and told me about a colleague who'd had two of her sons murdered in front of her during the violence between Muslims and Christians in 2014. 'I get very discouraged all the time,' he said. 'My family is always worried about me.' He told me he'd left for Congo during the worst of the violence. 'But it's the job. I've fled before, I can always flee again.'

Leger-Serge showed me the colonial red-stone cathedral, and then took me to the monument commemorating the Russians killed while

fighting in the country: a squad of soldiers cast in bronze, pointing rifles or looking through binoculars into the distance. He was in love with Bangui – a city of about a million – known affectionately as 'Bangui La Coquette'.

'It's the only city in the country,' he said. 'Everyone knows everyone.'

The Hôtel Oubangui was a beige thirteen-story building from the seventies, aging into the kind of decrepit modernist aesthetic that people sometimes call African brutalism. The rooms were grim, but it was surrounded on one side by twisting banyan trees and towering silver-trunked kapoks. It stood on a rocky outcrop that jutted far into the Oubangui River, and there was a walkway you could follow to an abandoned restaurant where locals went to stare toward the Democratic Republic of Congo on the opposite bank. The river was so high that it had flooded the outcrop, sending cascades of water under the sagging plywood flooring of the walkway. Entire small islands of turf floated past, often with trees still standing in the middle of them. Delicate white ibises calmly rested on the branches as the water carried them along.

'It's the Bangui Riviera,' a Zambian army captain joked as I sat at the small hut that served as a bar. 'This is what they have.' He had been in CAR for six months with MINUSCA, as the UN force in CAR is known. Peacekeepers, he told me, were still being caught and killed in the bush. 'Right now in Bangui it is peaceful,' he said. 'But there are rebels even in the city, I know that for sure.' He was drinking Schweppes tonic. The Zambians loved tonic. 'The bush is harder,' he said. 'It's not like any other country, it's really jungle. The roads are bad. And they can attack you anywhere.'

In July of 2023, Vladimir Putin hosted the second annual Russia–Africa Summit in St Petersburg. The Russians wanted to 'pursue avenues that would liberate sovereign states from their colonial heritage', Dmitry Medvedev, Deputy Chairman of the Security

Council of Russia, said shortly before meeting with Faustin-Archange Touadéra, the math professor who'd been elected president of CAR in 2016.

At the summer summit, Putin announced a goodwill gesture: a delivery of grain to six African countries. CAR was to receive 50,000 tons of wheat. This turned out to be more complicated than anyone expected.

CAR, a country of five million people and the size of France, is landlocked. It has gold and diamonds, timber, some uranium, and even oil. But the country only has one industrial mine, and just 700 miles of paved roads. Its major logistical route is a heavily-guarded road running west from Bangui. The Russian wheat arrived at the port in Douala, Cameroon, ready to be transported to CAR, a country where more than two thirds of the population is dependent on aid, and where 5.6 percent of the population died in 2022 alone – meaning that a person in CAR is 741 percent more likely to die than in the rest of the world. But the grain sat at port. It had never occurred to the Russians that the country had no milling facilities to turn the wheat into flour.

The country was a French colony called *Oubangui-Chari* until 1960. It was nicknamed *la colonie poubelle* because it was where the French sent the officers and bureaucrats who scored lowest on exams. The French built very little infrastructure, relying on the *chicotte* – the hippo-hide whip that became emblematic of colonial labor in Equatorial Africa – and the practice of taking women and children hostage to force men to work as porters and in the cotton fields. After independence, CAR remained a cog in the geopolitical system known as the *Françafrique* – an unofficial but comprehensive network of French influence over its former colonies, built on intimate social ties with local elites, and a suite of military, financial, monetary and political agreements. French advisors had places in all of CAR's government ministries, and effectively ran most of them until the 1990s. All but two of CAR's presidents have been chosen with French involvement.

But France began to pull back in the 1990s, and the last troops left in 1998. Western leaders thought that a new international order of peace, democracy and globalization had opened, and that commerce would bring peace. After the end of the Cold War, they were no longer as interested in enforcing that peace themselves.

The experiment with multi-party democracy in CAR, like in many of France's former colonies, did not yield a strong state or stable governance. CAR instead became a multi-militia state, where rebel groups and enterprising mercenary types launched rebellions that were often little more than cover for banditry. One of these rebellions succeeded in 2013, when a loose grouping of mercenaries and largely Muslim rebels swept into power to overthrow then-president François Bozizé. This alliance, known as the Séléka, was in power for a year, during which they ruled with wanton and almost random cruelty, committing mass killings, seizing civilian houses, extorting and looting at will. A collection of self-defense groups known as the anti-Balaka fought back, triggering a cycle of brutal fratricidal killing that became known as *La Crise*. At its worst, in December 2013, 1,000 people were murdered in a single weekend in Bangui. Four hundred thousand people fled into the bush, or toward countries like Cameroon. I had a very difficult conversation with a man named Crepin Botto, the head of a victims' rights organization, who was working as a gas station attendant when he was kidnapped and tortured during the fighting. His life was only saved when a Muslim woman saw what was happening and decided to intervene. 'I was tortured for no reason, do you understand?' he told me. 'I can explain it to you, but when you write it down it means nothing. It's just another person who was tortured.'

French troops were redeployed to the country at the end of 2013 – and the UN sent in MINUSCA as a longer-term peacekeeping force. The Séléka-backed president was forced to resign. But neither the French nor MINUSCA were able to lead a war in the countryside, where the rebels regrouped. By this point, CAR was dependent on aid and security from the outside world. The country's elite

developed a foreign policy of 'cunning victimhood', playing foreign powers and aid groups for funds and backing, as the anthropologist Louisa Lombard describes it. 'Previously, concessions were primarily granted for resource extraction,' she wrote, 'but now, through foreign aid, all government prerogatives have been turned into concessions as well, amounting to the wholesale outsourcing of the country's sovereignty.'

La Crise was a defining trauma for Central Africans. Peace and security came to trump considerations about democracy or rule of law. Many people in CAR became cynical about the weak, if putatively democratic, states that the West has backed in the region. A wave of resentment swelled through Francophone Africa, and a new generation of leaders soon blamed France and the West for preaching liberal values while keeping their countries poor and dependent. 'These are the questions my generation is asking,' Burkina Faso's young president Ibrahim Traoré told an audience at the last Russia–Africa Summit. 'We ask how Africa, with so much wealth in our soil . . . how is Africa the poorest continent? Why is Africa a hungry continent? And why is it our leaders must go all over the world begging?'

Despite years of development aid, the countries in the orbit of the *Françafrique* system still mostly lack the infrastructure and access to capital that would allow them to exploit their own resources. China, which offers barter deals of infrastructure for resource concessions, and currently makes a foreign direct investment to African countries of $5.6 billion a year, has profited from this situation, pushing into stabler countries like Angola. But this model does not work everywhere. As the United States and France pulled back, a contiguous band of low-level war grew up across much of Africa north of the equator. Many of these conflicts have no prospect of ending any time soon. So mining the continent's resources has increasingly become an armed operation.

Nine Chinese miners were murdered in an attack in the bush a few months before I got to Bangui – the most violent single attack on Chinese nationals in Africa since the Cold War. Western security

analysts now predict that China will, like Russia before them, begin deploying private military companies to protect its resource interests on the continent. 'In the past, the United States and France took the lead in conducting anti-terrorism and anti-piracy operations in the region, which helped protect Chinese investments from direct threats,' one report from the Center for International and Strategic Studies put it. 'Gone are the days,' another report from the Center wrote, when mining companies doing business in Africa 'could rely on the Western security umbrella'.

Even Rwanda – Equatorial Africa's chief military superpower – has learned that states facing insurrections will gladly accept armed support to protect resource interests. The country has deployed troops to protect gas fields and ruby mines in Mozambique. It sent 2,000 or so troops to CAR under MINUSCA, alongside another 1,200 deployed as part of a bilateral military agreement – more, in total, than the Russians. Rwanda has very few resources of its own, but in CAR they have been given gold, diamond, and timber concessions. Rwandan state-linked companies have also acquired access to substantial tracts of agricultural land – a valuable resource for a small country where much of the arable land is already developed. 'Everything is a challenge here,' a Rwandan businessman told reporters, after he hired locals to cut a 40,000-acre cattle ranch out of the bush by machete. 'There's no housing, no water, no electricity. When I came it was forest.'

After two days I was still waiting for my visa. At a shop next door to the hotel I had a drink with a man named Eugène Simplice Touabona, a one-time Marxist and parliamentarian who now mostly lives in France. I took him to be in his sixties, but he admonished me when I asked. 'We have a saying here,' he said. '*Il faut pas demander l'âge des grand-frères*' – don't ask the age of your uncles. 'Have a whiskey,' he said, and poured out four fingers of scotch.

I wanted to talk to him about the anti-Western mood swirling around Francophone Africa. 'I'm a leftist,' he said. 'You know what

I mean by that as an African? I came out of the internationalist movement. I was trained in Moscow and Romania. I have had two Romanian wives. We had an international dream.'

He said that Westerners were foolish for thinking that the sudden burst of anti-imperialism was the result of Russian propaganda. 'It goes back further than the Russians probably even know,' he said. He talked about the Congolese pan-Africanist leader Patrice Lumumba, who was overthrown in a Belgian-orchestrated and CIA-backed plot in 1960, and Thomas Sankara, the anti-imperialist president of Burkina Faso, who was assassinated in 1987, after three years of revolutionary rule in which he refused to take money from the IMF, made the country agriculturally self-sufficient, and attempted to pull the country out of the French orbit. 'Do people in America know who Thomas Sankara is today? You will have to explain who he is to them. That legacy is more important than what Russia does now, because the West did this to themselves. You had people who wanted to develop Africa for us, in our own way, and then they were killed. We pay attention to this sort of thing. This is why there is Wagner.'

Central Africans never seemed to share the same difficulty that Western journalists have in describing the Wagner Group. They generally took for granted that it was acting in the interests of the Russian state. Until the death of its three most senior leaders in a plane crash last year, both Wagner and Russia worked to maintain the impression that the group operated independently. This was true, up to a point – Wagner had its own revenue streams and operated outside the formal structures of the Russian military and intelligence apparatus. In Africa, especially, the group seems to have been self-funding. But it was never a freelance geopolitical actor. The group received financial support from the state, and worked closely with Russia's foreign military intelligence service, the GRU. From its role in Eastern Ukraine, where it got its start in 2014, through Libya, Sudan, Syria and now Mali, the group offered Russia a way of conducting foreign operations while minimizing official military casualties and creating confusion among Western observers about

what Russia was really up to. But after Wagner's mutiny last spring, Moscow appears to have decided that the group was *too* independent. Putin publicly acknowledged that the group had received billions in state funding, and Russian intelligence began to take direct control of Wagner's revenue streams and political networks.

Wagner has been in CAR since 2018. Their support has allowed President Touadéra and his allies to rule in an increasingly draconian manner, but many people in the country seem happy to accept mercenaries in exchange for stability. I asked Touabona whether he thought that inviting Wagner in had been worthwhile.

He was done talking politics for the day. 'I don't think it does anything anymore,' he said. 'There are no ideologies now, only interests.'

A cloak-and-dagger story was emerging in real time. In September, a man named Michael Stock had flown to Bangui to meet with members of Touadéra's inner circle. Stock is the founder of an American security consultancy called Bancroft Global Development. According to his company bio, he 'is a cum laude graduate of Princeton University and a fifth-generation descendant of [. . .] investment bankers'. He came to negotiate a security cooperation accord, though all that the company spokesperson would call it was 'a framework to discuss possible future activities with the government of CAR'. Accompanying him, reportedly, was another Bancroft employee, Richard Rouget. Rouget is well known in French security circles: he once went by the name Colonel Sanders when he worked for the notorious French mercenary Bob Denard, who instigated four coups in the Comoro Islands. Denard was a living expression of the *Françafrique* system, organizing soldiers of fortune to fight in small wars across Africa from the early sixties to the late nineties, always with French political interests in mind. Rouget himself led a detachment of foreign fighters during the civil war in Côte d'Ivoire that began in 2002. He was the first person to be convicted under a South African law that barred the recruitment of mercenaries in

the country. He received a five-year suspended sentence. 'Tell the people there's no money in the mercenary business,' he said at his sentencing hearing.

But there is money in Bancroft's business. The company has been active for over a decade in Somalia, where it has constructed a base near the airport in Mogadishu. It is a major player in the country, responsible for forming anti-terror units in the long-running war against the Islamist insurgent group Al-Shabaab. The US State Department provided the funds for this work. For the last few years the company has declared revenues in the neighborhood of $20 million a year.

When news of Rouget and Stock's meeting in Bangui emerged, people concluded that the American government was using the company to make a push into the country. The meeting was first reported by *Africa Intelligence* – an outlet that charges nearly one thousand dollars a year for a subscription and was started under a different name by the French journalist and historian of *Françafrique* Antoine Glaser, the true archetype of a certain kind of throwback French journalist in Africa – the person who knows everyone, hears every rumor, has lived everywhere. It is a fount of deeply insider info, often sourced secondhand, and its reporting on Bancroft went largely unnoticed in the English-speaking world.

While I was in Bangui, the *New York Times* published another piece on the meeting, with the headline BATTLE FOR INFLUENCE RAGES IN HEART OF WAGNER'S OPERATIONS IN AFRICA. The *New York Times'* correspondent Elian Peltier confirmed the story about Bancroft meeting government officials, and cited unnamed sources that said the Biden Administration had offered a deal: 'security assistance in exchange for easing Wagner out'. Peltier reported, somewhat cryptically, that Touadéra's special counselor Fidèle Gouandjika had said there was a deadline for this deal – by December the CAR government had to decide whether to stick with Wagner or to 'partner' again with the West.

I didn't know how fraught the situation was before the *New York Times* article dropped. I took the short walk from the hotel to look

at the Maison Russe, the Russian cultural center that has become the symbol of the Wagner Group's presence in the country. In a conscious imitation of an *Alliance Française* outpost it offers language classes, film screenings and concerts. It features a carousel and playground. When I saw it, it was lit up with Christmas lights. The center is officially headed by a young and slightly effeminate man named Dmitry Syty, a former employee of the online troll farm used by Wagner in its overseas propaganda operations. Syty, whose wife is a French citizen and who himself has lived on and off in France, is the most visible Russian figure in the country, and a partner in Midas Resources, the company that has taken over much of the gold mining in the country. Midas Resources is one of a handful of Wagner-linked companies operating in CAR, which together generate as much as $1 billion a year from the country, according to a leaked American cable – an astonishing estimate given that the country's official GDP is only $2.3 billion a year. These companies rely on the logistical and financial network that Wagner has developed across Africa, from Madagascar to Cameroon to Sudan, evading US sanctions and moving goods in and out of the country. The money helps to fund both Wagner's operations around Africa and its outfit in Ukraine. Syty is also the owner of Africa Ti L'Or, the so-called *bière Russe* advertised on billboards all around Bangui. Rumors have it that he had something to do with two attempted fire bombings of the French-owned Castel brewery. His hand, in turn, was nearly blown off by a package bomb in December 2022, an attack he blamed on French intelligence. Young pro-Russia men responded by burning down the local DHL office and rioting outside the French embassy and the offices of the European Commission.

I was on the far side of the road as I passed the place, and I looked down for a moment to send a text. When I looked back up two young Black guards in camo were whistling and waving at me. They thought I'd been taking pictures. They told me to cross the street and come over to them, which I refused to do. They ran into the street, stopping traffic. One coolly raised his rifle, and the other walked up and

pushed his chest against my shoulder. They ordered me to unlock my phone and went through my photos. 'What were you doing? This is a military base,' they kept repeating. 'It's a *military* base.'

Russian involvement in CAR first began in 2017, when Russian Foreign Minister Sergey Lavrov helped the Touadéra government get a waiver for the UN arms embargo that was put in place during the civil war. It proposed a donation of small arms – sniper rifles, grenade launchers and AK-47s – for CAR's small and poorly trained military. France, in an effort to maintain its influence, responded by offering a shipment of assault rifles seized from armed groups in Somalia. CAR decided to accept the Russian arms. 'The West is not very much loved by many countries. And many see Russia as the country that will oppose the West,' Russian historian Dmitri Bondarenko gloated at the time.

It was early days in the populist turn in French-speaking Africa, which Russia tried to encourage. In 2018, the Kremlin invited Kémi Séba, a young, charismatic activist who had been involved in the radical Afrocentrist movement for many years, to visit Moscow. Séba is a major figure in the new pan-Africanist movement that was then gaining steam. Its watchwords were 'sovereignty', 'self-determination', and 'dignity', and it was an essentially revolutionary movement, calling for mass mobilization against a corrupt, French-aligned political class. Much of this anger was natural. But the anti-Western rhetoric fitted neatly with Russia's desire to preserve a semblance of autonomy in the global economy. Russia financed social media campaigns blaming France for poverty and insecurity in Africa, with varying degrees of success, from Madagascar to Mali. In CAR they backed a national radio station called Radio Lengo Songo, and organized anti-French and anti-UN demonstrations.

When Wagner mercenaries first appeared in the country they were officially known as 'civilian advisors'. But by 2020 their mission became clear, when former president Bozizé led a coalition of former Séléka fighters in an assault that made it all the way to the outskirts

of Bangui. An uneasy coalition of Wagner troops, UN soldiers, and Rwandan regulars drove the rebels back. The rebels, now known as the CPC, took to the bush and continued fighting.

Wagner waged a war of annihilation against them, following a sardonic directive to 'leave no trace'. It's hard to know how many Wagner fighters were actually in the country, but estimates suggest a peak of around 2,500, before they were drawn down to around 900 after the death of its founder Yevgeny Prigozhin. Wagner also recruited around 5,000 local fighters. 'We call them Black Russians,' an embassy employee in Bangui told me. 'They're honestly the scariest.'

Many of the rebel fighters are Muslim, and Wagner seems to have singled out the traditionally semi-nomadic Peul ethnic group, according to a recent report by the watchdog group The Sentry. They destroyed herding camps, razed villages, and looted gold and cattle to sell in Cameroon. They ordered the Central African Armed Forces soldiers fighting with them to gang-rape women and disobedient comrades-in-arms. 'They blame the Peul for everything,' I was told by Alain Nzilo, the founder of Corbeau News Centrafrique (CNC), a news site that has been banned in CAR since 2021. 'There's no journalists, no media out there,' he said. 'Just now at Bocaranga – they got there two weeks ago – they killed two people, raped a girl. In the bush, Wagner are kings.'

As they pacified the countryside, Wagner seized mines that were held by armed groups. Dormant mines began production again. Wagner took control of the country's only industrial gold mine at Ndassima. It was originally owned by the Canadian company AXMIN Inc., which shut down operations during the violence in 2013. In 2020, the government transferred Axmin's permit to Midas Resources. The Ndassima concession sits on a vast site – 138 square miles. To start industrial production Wagner had to take it over from a Christian militia of former anti-Balaka fighters. They hired 300 workers, gave them ID cards with personalized QR codes, and engaged in a 'cleansing' campaign, driving out local miners they

accused of digging illegally. 'They forbade anyone to go digging in Ndassima,' a witness from a village seventeen miles from the site said. 'They killed four collectors who had over 200 million CFA and 50 kilograms of gold. They stole everything. Then they put the fuel on the people who were tied up and they set fire.'

Ndassima is now estimated to be producing nearly $300 million worth of gold every year. Gold is easy to transport and offload into international markets, and the Russian state is likely to be profiting directly from the billions of dollars a year Wagner earns from gold sourced from countries like CAR and Sudan. Very little of this was disrupted after Wagner launched its mutiny in Russia. Fidèle Gouandjika appeared for TV cameras the day after Prigozhin's death, wearing a T-shirt reading JE SUIS WAGNER. A Russian intelligence operative named Denis Pavlov moved into the country, part of an effort to bring Wagner's networks under direct state control. But the Wagner name did not go away, and Russian forces in Africa continue to use the group's death's-head insignia

'The Russians did bring peace here,' a clothing-shop owner named Sonia Pona told me. She had to flee the country for Cameroon during the fighting in the 2010s. 'But now it's peaceful. I can have my business. We were a French colony and now we're a Russian colony. Maybe next we'll be an American colony. It's good to have options.' She was just one of the many people I spoke with who had mixed feelings about the presence of the Wagner Group in the country.

'We know about their practices, we know about the women and girls they take to their trucks,' the Cardinal of Bangui told the *New York Times*. 'They're no angels, and they behave savagely,' he said. 'They're still a lesser evil.'

Lewis Mudge, the Human Rights Watch Central Africa head, told me that Washington realized too late how desperate Central Africans were for the kind of security that Wagner brought. 'I've watched millions and millions of dollars being spent on peacekeeping groups,' he said. 'At least Wagner's having some success at pushing the armed groups to the periphery of the country.'

Soft power and development aid have proved less meaningful than the simple fact of providing security. 'The Americans are late to the game,' Mudge said when I brought up Bancroft. 'I know for a fact that they wanted the Rwandans to be a viable solution. They wanted the Rwandans to take the weight.' He said he didn't think an American private military company moving in would necessarily be all bad. 'If Bancroft can not abuse the local population and they can perform the security aspects that Wagner's performing, then that would objectively be a good thing.'

L eger-Serge and I were arrested when we went to pick up my visa. The US State Department later informed me that I was not technically arrested, and had only been 'detained'. But they hadn't been there when men with guns ordered us into the back of a Hilux and drove us to the headquarters of the Directorate de la Surveillance du Territoire. This was a repurposed shipping warehouse on the riverfront that everyone called 'the port'. It was on the same stretch of riverside road as my hotel.

A soldier took us up a flight of concrete stairs and sat us on a wooden bench in a narrow hallway to wait. We were questioned for a while by a Colonel named Yvon Mgara, who had a husky voice and an accent so thick that I kept having to ask him to repeat himself. He was very annoyed by the time he sent us in to General Dénis Mbaïgume, who was in charge of the country's internal security services. Mbaïgume was a tall man wearing a burgundy suit. He was sitting at a big wooden desk with almost nothing on it but his nameplate – his secretary outside had the only computer I saw in the whole building. He asked me what it was I did. Leger-Serge protested that I had my proper press accreditation, but the General didn't seem to care one way or the other.

Leger-Serge was very nervous, and kept saying that he did not want to have to flee or leave his children behind, like he had during the civil war.

'You know what problems we have had in this country,' Mbaïgume

said to him. He switched to Sango, the national language, and though I couldn't understand what they said, the phrase *La Crise* kept bobbing up. Mbaïgume switched back to French. 'I want to know what you were thinking,' he said, 'bringing such a person here? How could you be so stupid?'

He told us to wait outside, and Colonel Mgara took over again. He chatted a while with Leger-Serge in Sango.

'It's going to be fine,' Leger-Serge said to me when he turned away. 'We're speaking Sango. Here, that means there's no problem.'

It didn't work out that way. The Colonel took each of us separately for interrogation. He wrote out my answers with a ballpoint pen in tiny neat rows of cursive on sheets of printer paper. He kept me for two hours, and filled at least twenty pages. I could not believe his hand didn't cramp. He wanted details about my life. 'How is it that you don't have children?' he asked at one point. 'Why are you coming here to do this and you don't even have children? It's a strange decision.' I answered questions about where I went to elementary school and how much money I had in the bank.

'What is it you want to know about the country?' he asked me. 'If you just wanted to know things why can't you call? Do you not have WhatsApp?'

It was difficult to explain to him that I wanted to write a long and somewhat personal piece for a British literary magazine.

'Did they think you were a spy?' Lewis Mudge asked me later. I told him about trying to explain I was writing for *Granta*.

'Oh yeah,' he laughed. 'You were fucked.'

The General came in and spoke to the Colonel about another American who'd been detained at the airport, ostensibly for trying to enter without a visa – even though Americans have for years been able to apply for visas upon arrival. His name was Alex, and he'd come to CAR as part of an online community called Every Passport Stamp – a group 'for serious travelers', as their page puts it, 'chasing every country in the world'. He was a half-Asian tech worker from San Francisco, and he'd just married a woman he'd met in Colombia.

He was taken along with the head of a local tourist company, Honoré, the 34-year-old son of a well-connected Bangui family. Honoré had CAR, French and American citizenship, and left his wife and kids behind him in Dallas to return to the country, where he'd started a car-rental and tourist-guide business. He was big and had a slightly authoritative manner, and never seemed to go anywhere without an entourage of male henchmen and female secretaries, several of whom were waiting outside.

The two of them were making calls. Honoré contacted the Minister of Culture, who came in person to visit them. She couldn't do anything. The DST was under the control of the Minister of the Interior – an intimidating figure named Michel Nicaise Nassin, who was close with President Touadéra, and had previously been in charge of a secretive intelligence bureau that worked with high-placed Russians in Bangui and furnished intelligence directly to the president.

Alex called the US Embassy. A few hours later a team from the US State Department arrived. Two local employees – burly young guys from the Bureau of Diplomatic Security, the federal law enforcement arm of the State Department – arrived with a slim, silver-haired embassy attaché named Pedro Campo-Boué, who greeted us and went to talk to the General. One of the agents asked me for my sweatshirt, so he could hide his gun before accompanying Pedro in.

'This is not a violation,' Pedro told me later. 'You did nothing wrong. I cannot say exactly what I think is going on, but you're a journalist and I think you can surmise.' The Colonel ordered Leger-Serge, Honoré, Alex and me to the holding cell downstairs. There was wire over the windows, and an armed guard watched us. One of the Diplomatic Security agents, a muscular young white guy from Albuquerque named Jared, brought us water and protein bars. 'I just looked at the cell where they say you're going to sleep,' he said. 'To put it simply, you do not want to sleep there.'

A little while later we were called back up to see the General, who ordered us to hand over our phones and to tell him our passcodes, which he wrote down on a clean sheet of printer paper. I initially

refused and tried to hand mine off to Jared. 'I can't *tell* you to give up your phone here,' Jared said. 'But I will *advise* you very strongly to please do what he says.'

I wish I could say that all this was exciting, but it was just confusing and tiring and boring. Everyone knew that whatever was happening was not really about visas. No one even mentioned the visa issue until they brought Alex and Honoré from the airport. 'There are a lot of internal dynamics at play in the government right now,' Pedro whispered to me. He spoke formally, and took regular, surreptitious hits from an IQOS vape device. 'I can tell you that the interior minister is in charge of this, and that can make things complicated.'

Finally the General agreed to release us to the charge of the State Department, though without our passports or phones.

'Merci, mon général!' Pedro exclaimed when this was announced, in an exhalation of relief that made me think he had been worried. 'Merci, *merci*, mon général.'

I didn't hear anything from Leger-Serge the next morning. He left for home after the interrogation while Jared drove Alex and me back to the Hôtel Oubangui in an armored Land Cruiser. We went to see Honoré at the Hôtel Ledger, the grand, cream-colored colonial estate where ministers and businessmen and foreigners hang out by the pool or play tennis. We started drinking, and Honoré and I got to talking.

His father was a diplomat under a previous government. Honoré had gone to college in France, moved to Dallas and got American citizenship, and had been living in the US when he met president Touadéra at a gathering for CAR expats at a hotel in New York in 2017. He said that Touadéra told him the country needed young people like him. 'It's very powerful,' he told me later, 'when a president of your country looks you in the eyes and tells you, "We need you".'

He was unsure about coming back. His family home was taken over by the Séléka when they came to power, and his uncle was killed by a militiaman who wanted to steal his bicycle. But he decided to

return in 2019. 'I took a leap,' he said. 'I made this decision, I'm going to return and give back.'

Like many in the country, he appreciated what the Russians and the Rwandans accomplished. Honoré threw himself into building a large house and a business renting out trucks and private cars, along with a bit of guiding on the side. 'It was amazing, it was dynamic,' he said. 'You had this feeling that things were finally changing.'

'After 2013, the worst fighting in our history, with the dead bodies in the street and the horrible things that happened,' he said, 'people were fed up and said "never again". So when we saw the peacemaking force that came in?' I thought at first he was talking about the UN, but he meant the Russians. 'And after we saw France and the international force before that was just weakness? We said okay.'

'When they pushed the rebels away we were happy, we were clapping our hands,' he said. 'Because we knew the consequences. We are used to the casualties, we are *so* used in our history to running. And this time, we could say, "We're not going anywhere – the Russians have secured the capital".'

I asked him about the anti-Western feeling on the continent. 'It comes from this history of wondering why we're so left behind,' he said. 'We know that we are rich, that our ground is so rich. People have begun to ask the reason why progress hasn't happened. The answer to that in everyone's mouth becomes France.'

The Touadéra government developed this feeling, he thought. 'Our parents, the generation of people in government, were not pointing the finger at themselves. They were the generation that didn't stand up. They claimed that if they tried to do anything they'd be killed, or France would block us. There was always a reason not to stand up.'

But now he thought they'd let the Russian situation go too far.

'You know about the killings outside the capital,' he said. 'The rapes. They've become very violent over time. It's like they're fearless, and here it is this no man's land where they can do whatever they want.'

He seemed disquieted when I asked what he saw for the future. 'The game is really simple here,' he said. 'To any partner, we have the resources, they have the money. We need the money. But to find a fair strategy? We have a leadership that cannot do it. I don't know if we will ever do it.'

Wagner has taken over the country in many ways, and it is profiting greatly from the country's resources. But it has done so with the connivance and willing participation of many people in CAR, who think those resources wouldn't be exploited at all if they weren't there.

'A lot of Central Africans think about gold and diamonds differently from people in the West,' the journalist John Lechner, who is writing a book about Wagner, told me. He has lived in Bangui, speaks French, Sango and Russian, and has spent years interviewing Wagner fighters. 'In Central Africa that's how people make a living. They judge things on the basis of – is there security around the mines so we can go work in them?' They are less interested in where the minerals go than in stable employment. 'Wagner is getting the gold and diamonds, but they also provided men to end a civil war.'

The story common in the West, of an all-powerful Russian force come to sow chaos and strip the country of its resources, was much too simple. 'It's a story that fits everyone's priors. You see nefarious Russians and think *Heart of Darkness*, warlords in Africa. But there are 1,500–2,000 mercenaries in CAR,' Lechner told me. 'So obviously they don't control everything. It's a country at war – no one controls everything. Obviously they aren't in total control, because there are lots of people who attack and kill them.'

'Of course what Wagner does contributes to the conflict,' he said. 'But it's in a structural way. If you told American soldiers in Afghanistan in the 2000s they were creating more Taliban, they'd have been like, "What the fuck are you talking about?" – but, structurally, that's what happened.'

I hadn't heard from Leger-Serge because the DST arrested him the night he arrived home. They brought him back to the port for further questioning. He was shaken up when I finally got hold of him. He hadn't slept in the cell because he was too bothered by the mosquitoes. He had developed malaria, and looked awful. 'It's the job,' he said, and gave me a fist bump. Alex gave him some Malarone.

Honoré, Alex and I were still waiting on an update from the DST or the State Department. We spent a lot of time hanging out on the terrace of the Hôtel Bangui. The country's national holiday was coming up, and the hotel put out flags and bunting. The river was still miles wide, and moving so fast that it roared like a mountain rapid. Young men went out anyway to fish in long dugout pirogues, spinning the canoes through eddies and away from whirlpools. On some afternoons we were surveilled. A pair of men would calmly stand up and follow me whenever I left the terrace.

Honoré and Leger-Serge were very worried. They both seemed surprised that things still hadn't been resolved, and whispered to each other in Sango when we met for breakfast. Alex and I were drinking too much, for lack of anything better to do, which gave the uncertainty and frustration of being quasi-detained a physical manifestation of degradation and fatigue. I didn't notice at first when I began to show symptoms of malaria.

'I think I'm going to try to cross the river,' Alex kept saying. He was becoming more frantic by the day. 'I've been to Afghanistan. I've been to a lot of places. I've read what happens to people in places like this.' His wife had made him agree to give up adventure travel. My girlfriend, on the other hand, thought it was funny that I'd gone to write about extraction, and now might only get out of CAR if the American special forces sent an extraction team.

The first two nights we went out. We went to a series of bars where the young elite and international crowd hung out. It felt like Atlanta. We ended up drinking with a guy from Houston named Shaq, who knew about our situation. Everyone had heard about it, it seemed. He was in his thirties, and was in Bangui to start a construction business.

'It's been good, man, we're doing it. If you want to make money you have to go places people won't go. We deal with fucking everybody. I don't even speak French!'

I said I should come back sometime and start a business. 'Take my number bro,' he said. 'What people don't do is take fucking risks. Here it's a lot of risk. So it's money.'

We went to another bar called Sango, a place with a sort of Dubai-chic decor, which served shisha and Indian food. We couldn't find a cab when we left. Honoré's driver had gone home. We walked up to the main road to look for a taxi, and suddenly a truck full of police pulled up. A man with an AK-47 ordered us to get in the back. There were five or six police, all yelling. They took us to a police station, and the Commissaire began to shout at us. He told us it was illegal to go out in the country without a passport. But he hadn't asked us to show him our passports. So he knew about us too. He wanted money. I had spent almost all my cash at the bar, and only had 5,000 CFA on me – about eight dollars. Alex had $400 US and gave it up. They let us go.

We were confined to the hotel from then on. The pills for my malaria took a couple days to kick in. The disease weakens the muscles in the back of your neck, forcing you to go around with a hunched, hangdog aspect. The way I looked and felt seemed to match everyone's mood.

Occasionally Pedro came by the hotel to check on us, smoking his IQOS and speaking carefully about the situation. 'It's a very opaque structure of government that they have here, and it can be confusing, even for us. Especially for us.'

Jared, the Diplomatic Security officer, accompanied him, and forced MREs, water and more malaria pills on me. He seemed to take pride in making sure that I was going to be okay. 'Everyone hates the government until they get detained in a foreign country, right?'

At the end of the month we were finally told that we were being expelled. It was the day before the Fête Nationale, and the streets

were uncommonly clean. Flags hung everywhere. Jared picked us up in the armored Land Cruiser. Leger-Serge and Honoré came too, hoping to recover their phones and passports.

When we arrived at the airport, the police commissioner was there, looking solemn and wearing a blue-and-pink floral suit. He started yelling as soon as he saw us.

'Where are his pants?' he asked, pointing at Alex, who was wearing shorts. 'He needs to be wearing pants for this.' Jared apologized on Alex's behalf.

We stood around for hours, waiting for someone to bring our phones and passports. The Minister of Culture was apparently on her way to make sure everything went smoothly.

'There's a lot of stuff going on with America and Russia as you know,' Jared said. 'And so certain people who are close to Russia –'

'The Interior Minister,' Honoré cut in.

'Need to make it clear they're being hypervigilant. That they're going above and beyond. And so here we are,' he said. 'And the Minister of Interior is –'

'Everyone is scared of him,' Honoré cut in.

'He's unhinged, basically.'

We were finally taken to a small holding room, where our phones were taken out of a safe and given to another police officer, who also had in hand our *Ordre de Conduite à la Frontière*.

It was a strangely reflective moment. For Jared it was a job well done, seen through to the end. For Honoré it soured his hopes of coming back to his home country to help build its future. The next time we spoke he was back in Texas. For Alex it was the end of his 'Every Stamp' dream.

Back in Paris I was contacted by a reporter named François Mazet, the Central Africa correspondent for RFI. He'd heard about our detainment. We met for a coffee near Place de la République, and I told him I was embarrassed at how little I'd been able to report. He didn't think I'd have been able to travel outside of Bangui anyway.

'You wouldn't have got very far,' he said. 'The Black Russians would have stopped you at a checkpoint.'

He was about to publish a story about Washington's attempts to wedge Wagner out of the country. His sources told him that Bancroft was planning to create its own private military company in CAR, and was intending to move into protecting mines and other assets just like Wagner. He quoted an unnamed French military official who said that the Americans were coming to 'compete on Wagner's own ground, and bring an end to Russian hegemony over the country's institutions'.

'This deployment would explain the administrative difficulties that many Americans have seen in the past months in Bangui,' the piece said, when I read it two days later, 'including a journalist who was expelled despite having papers in order'.

It seemed the game was on. US TURNS TABLES ON PUTIN IN AFRICA PMC POWERPLAY, was the headline in *Newsweek*. But the State Department denied the story. 'The Department did not give a green light to Bancroft to begin operations, as some have falsely reported,' a spokesman told a press briefing. 'Fake News,' Pedro texted me.

Either the American government was hiding something, or Bancroft had decided to set up operations in CAR as a freelance actor. While I was in Paris, a representative of president Touadéra confirmed that Bancroft was establishing itself in the country. 'The Central African Republic is in the process of diversifying its relations. We are in the context of the reconstruction of the national army.' He listed off a host of countries that had offered trainers to the military. 'The President of the Republic always tells us: "I have my arms open to work with everyone".'

'It's not a secret anymore. The government itself announced it,' Alain Nzilo, the founder of CNC, told me. 'That shocked everyone. People were stunned to think that you could have Americans in the country with Wagner. They think basically that it's an American game to weaken Wagner's financial streams. Even the armed groups think that.'

'Touadéra is a very complicated man,' Nzilo told me. Touadéra was his math professor in college. 'He's a very dangerous man. He could be playing these kinds of games – he's very capable of saying, "Okay, you accuse me of being bought by the Russians? Look – I'll play with the Americans." It's a thing he would do. But among the population, on the streets, everyone thinks the American government is involved.'

In mid-January, *Jeune Afrique* published a long feature about the goings-on in Bangui. They reported that for all the talk, Bancroft only had two employees in the country. But they added new layers of intrigue – the Bancroft ex-mercenary Rouget apparently met with CAR officials in Paris, accompanied by a Franco-Moroccan named Alexandre Benalla – a man who was a close intimate and personal bodyguard to French President Emmanuel Macron, until Benalla was charged with assaulting protestors and received a three-year suspended prison sentence.

The Russians and their allies knew something was up. Hassan Bouba, CAR's minister of Herding and Animal Health – a wily and debonaire former Chadian spy, who is openly associated with Russia – launched a 'committee of control and investigation on the activities of Americans in CAR'. In early February, *Africa Intelligence* reported that a Bancroft employee had been arrested in Bangui. The government denied this.

I managed to get hold of Fidèle Gouandjika, who told me that Bancroft was indeed operating in the country. But he said that this didn't mean anything about a new partnership with America. 'We experimented for more than sixty years with the West,' he said. 'The West never did anything in CAR to bring peace, or to bring real democracy.'

'Of all ten heads of state here, we've had two presidents who were ever elected,' he said. 'Patassé, who was elected in 1993, who was a great friend of the Americans. And now President Touadéra, who is a great friend of the Russians.' He said what he wanted was

'real democracy', which in this case meant allowing Touadéra to serve indefinitely. A disputed referendum had just overturned the constitutional two-term limit for CAR presidents.

'The US hasn't brought democracy to Afghanistan,' he said, and went through a list of countries that had been failed by the US. It was the sort of thing you hear from anti-colonialists everywhere in Francophone Africa. I began to tune out, but then he started talking about the country's mineral wealth.

'Today, with Russia, we have projects,' he said. 'But –' he paused, and seemed to turn thoughtful: 'they say they're going to use our uranium to make nuclear power plants. They say they're going to develop our oil. They say they're going to make foundries and refineries for our gold. They say they're going to make a national diamond brokerage. They say they're going to make solar facilities, because we have sun here.' The connection was shaky, and I was having trouble making out his tone. At first I thought he believed that all of this was actually going to happen.

'They think we're still children,' he said. 'Like we were in the years when the French and Americans could fool us. We are a generation that all has degrees – we all have higher degrees. We're not like our parents' generation. Russia makes us these promises. But we're vigilant.'

I asked if he worried that the Russians were just new colonialists. 'Maybe the Russians want to colonize us,' he said. 'And we're going to accept that colonization, *if* this colonization can bring us development, *if* this colonization can allow us to process our minerals here in our own country. Then we're happy. But if it's a colonization like the French and the Americans,' he said, 'where at the slightest sound of gunfire they run? Then it's not worth it.'

This was a sentiment I heard over and over in CAR. People reproached the West less for being brutal than for being weak. It was impossible, as an American, not to experience the misadventure of deportation as an indicator of the decline of the power of what is still sometimes called the 'American Empire'. Russian-allied leaders in

CAR, Mali, and Burkina Faso regularly talk about the pullback of the West from the region as liberation. But the future in CAR was still going to be shaped by outside powers wielding armed force. Gouandjika did not criticize the West for sending troops to police the country or for exploiting its resources. He criticized it for being too pusillanimous to allow soldiers to die for the peace they professed to want, and for not trying hard enough to exploit the resources that the country offered. The West had, according to this view, kept the country colonized while trying to avoid the dirty work that came with being a colonizer. Wagner did not have the same reservations, and it had profited. Other powers, in other places, would learn the same lesson.

'We believed in the United States, you know?' Gouandjika said. 'We believed in the *power* of the Americans. But honestly now we've concluded that America's not . . . a strong state.'

'I'll give you an example,' he said. 'What did they do when they came here in 2003? They came to fight Joseph Kony in the northeast. They spent five, six years here, didn't get him, and then they left. Where is their power? Where are their satellites? Where are their all-seeing eyes?' He repeated, for emphasis, 'Where is their *power*?'

'The Americans only help us with their NGOs and their volunteers and humanitarian aid,' he said. 'But can you develop a country with humanitarian aid? We want them to create businesses in our country. We want them to develop our oil! We want them to come and pave roads to get to their sites. Okay, 80 percent of the benefit will go to them. But if the other 20 percent benefits us? That works.'

I thanked him for his time. He told me to call him any time. 'I am always here,' he said, 'to support the independent press.' ∎

This is the first of two articles of James Pogue's reporting for Granta. *This piece was supported by the Pulitzer Center on Crisis Reporting.*

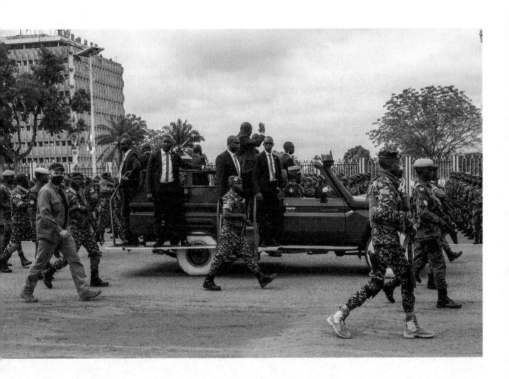

The president of the Central African Republic, Faustin-Archange Touadéra, stands on a truck in Bangui surrounded by security made up of CAR troops, Rwandan United Nations soldiers, and Russian paramilitaries, all heavily armed for the parade to celebrate the country's 64th anniversary of independence. 1 December 2022

MARKUS MATTHIAS KRÜGER
Winterdrama #8, 2009
Courtesy of Galerie Schwind

PRAIRIE DOGS

Benjamin Kunkel

The original idea, I admit, was mine, I take responsibility for that, and not only for that.

At a small dinner party my wife Helen and I hosted back in November, it seems like a long time ago now, several friends, new friends, not people we know very well, were complaining about how much time they spent on their phones, they were lamenting with early-middle-aged fatalism that their phones had long since been getting in the way of their reading real books, of their conversations with their children, of their exercise routines and their work, I remember that what struck me at the time was that anyone at all was still willing to complain out loud, even fatalistically, about a battle between us and our phones that everyone else already agreed had been so completely lost that the defeat was no longer even mentioned anymore, and it was then that I had and voiced my ill-considered and ultimately disastrous idea.

'We should have a phoneless party,' I said to the couple consisting of new friends as well as the couple – the Charlies we call them, a man named Charlie and a woman named Charlie – who counted as older friends, I looked at my wife (we are still married) and said: 'Why don't we have a phoneless party, a phone-free party? We could have it on New Year's Day? A day free of phones?'

BENJAMIN KUNKEL

I suggested that on January 1st people could come over in the morning, for brunch, and then stay all day, hanging out and listening to records in our living room, and/or hiking or (if there was snow) sledding in the park, before returning to the living room and the fire, and in deference to our new friends' enthusiasms – one of them, the woman, Sandra, was and I suppose still is a psychedelic entrepreneur specializing in little color-coded pills delivering different quantities of psilocybin powder representing everything from the most modest microdose up to a full-blown mind-rearranging trip – I also suggested that the guest room upstairs could function as a chill-out room, if that was still the term, for people who were tripping and didn't feel like engaging with the whole living-room social experience, and if there were MDMA-takers among our guests at the phoneless party these too could be accommodated, in their own room if they liked, for example in my and Helen's bedroom, and anyway the whole scene and event could function as a *be-in* (a term I knew hadn't been current for fifty years or more, and used facetiously) of undistracted company and recreation facilitated by, among other things, the absence of our phones that were otherwise (not that I said this part, that would have been unnecessary) all the time breaking up our attention into scattered meaningless fragments of amusement and dread.

'It's like they do this at plays and concerts these days, sometimes,' said Sandra – such a wholesomely pretty white woman, with broad, vaguely rural features, and immaculate peaches-and-cream skin, that she might have been the model for a fascist propaganda artist of some kind – who'd already warmed to the idea. 'They make you hand over your phone.'

'Exactly,' I said. 'We have this old wooden trunk in our bedroom. I could lock the phones in there.'

Helen too seemed to like the idea, possibly because of the prospect of our taking a bunch of drugs with friends as if we were still young, not so long ago I'd joked to her, when she'd been pressing me to take edibles before a movie, that youth was about telling yourself you really needed to stop doing so many drugs, while middle age, as it turned

out, was about telling yourself you really needed to start taking more drugs, I should mention that Helen and I don't have any children, only a cat named Harriet, so for us there really was no excuse not to spend more of our weekends becoming wiser, happier, more sexual beings by way of appropriate doses of mushrooms, MDMA, weed, et cetera, and in truth it was usually me who dragged his feet before this prospect, I suppose I was afraid that weed or mushrooms would only sharpen my attention to the horrors of the world, both the discreet grinding horror of collapse and the more spectacular horrors of state-led or freelance massacres, not to mention 'natural' disasters, and on account of these hovering intimations I feared I might not have such a good trip on mushrooms or edibles at all, meanwhile as for MDMA I knew that rolling (was this the term anymore?) on molly (was that the term either?) couldn't do much for me so long as I continued, like approximately half the people I knew, to take my daily SSRI.

'If we're going to do this,' Helen said brightly, 'we should send out an invitation soon. That way people can arrange babysitters.'

Helen I won't physically describe, she is a beautiful woman with little beside kindness in her eyes, but I find that once you are married (in my sole experience of the phenomenon so far, many of my friends, having been married at least twice by now, would be better qualified to say) you don't really see the person anymore after a while, instead you merely recognize them, they become so familiar in their features as almost to forfeit their features completely, a little bit as if they were your own feet or something, which you never pause to study or even to see before pulling on your wool socks.

'Oh yeah – great idea – we can hire a dog-sitter,' male Charlie was adding to the conversation, being, with female Charlie, the owner of a large, beautiful and needy Great Dane by the name of August, a name I'm sure I'll remember for the rest of my life.

The dinner party in question took place on Friday November 18th, I know this because I can still see in my Gmail that it was on Tuesday November 22nd that I sent out the invitation, to more than twenty friends, to a phone-free New Year's Day party that was to get

underway with brunch and last until people felt like going home, hopefully after dark, not that the arrival of dark (as the email didn't need to say) indicated such a long day when the days are so short not even two weeks past the solstice, and our house lies so close up against the foothills to the west of town, that the sun will have set, on early-winter days, before 3.30 in the afternoon.

The big-box liquor store out on Kiowa opens at 8 a.m. 365 days a year, so the sign posted on the sliding front door tells you, and already at 8.30 a.m. or so on New Year's Day, when I went out, on behalf of our guests, to buy some gin and mezcal, for brunch-time Bloody Marys and Bloody Marias respectively, it was apparent that this was an exceptionally windy day, in fact when I was driving back down Arapahoe with a passenger seat full of booze I discovered that the traffic lights had been knocked out by the wind, so that cautious drivers nosing out into the intersection had to take their turn, before accelerating, as if invisible stop signs stood at the corners of the streets rather than the dead sentries actually posted there.

Another way that I try to beat back any depression is with regular exercise, and so, after depositing the liquor back at home, I drove out to the open space south of town to get in a short run, was the idea, before our guests arrived, I was thinking that a jog through the fields near the creek, where trees were sparse, would be safer than running through the woods where a branch torn off a ponderosa by the crazy wind might well club me to the ground or worse.

Having earlier had to close my eyes against flying grit in the liquor store parking lot, when I got to the trailhead, before getting out of my car (an EV for what it's worth), I put on the wraparound sunglasses that ordinarily I only wear while biking, in order to shield my eyes, as I ran, from the scouring dust in the air, but even so, once I was 'running', or really stumbling, over the trail toward the mountains, shoved by the buffeting winds at my back, I didn't even make it a quarter of a mile before turning around and heading back to the car, out in the fields south of town there was no one else to see at

9.30 a.m. on a New Year's Day characterized so far by merciless winds of (as I later learned) 80–100 miles an hour, except for a young woman, no doubt a professional dog walker, walking four dogs on separate leashes through the pummeling air, and I was concerned enough for the young woman's unprotected eyes – she herself had no sunglasses on – that I offered her my wraparound sunglasses only to have her look at the author of this gesture as if he weren't at all the good man I was meaning to be but only a strange one, anyway not only did the dog walker refuse the gift of the wraparound shades but of course there was nothing I could do for the dogs and *their* eyes, and I've often wondered since that day, with a curious persistence, whether the eyes of any of the four dogs might have been injured by what I guess I've already called the scouring dust in the air, when I wonder this I always think also of the crazed ticking sound of the dry grasses rummaged or ransacked by the wind, these grasses making a sound, it seemed to me at the time, of so many wristwatches (not that wristwatches are worn anymore) having gone insane all at once.

Back at home I asked Helen whether I should maybe text our friends and advise them to venture out only with ski goggles or wraparound sunglasses, if they were still coming over for our phoneless party, that is, but sensibly she insisted: 'These are grown-ups, they can take care of themselves,' and indeed none of our guests arrived at our house complaining of any injured eyes, it was only a few days later that we learned that Sophie and Tim hadn't made the party because Sophie's right eye had been hit by a particle of glass flung through the air and she and Tim had therefore spent the day at one of the urgent-care outfits in the strip malls east of downtown.

For brunch we'd laid out in the kitchen an array of bagels and bagel trimmings as well as vegan and merely vegetarian spreads, we'd also set up a station for Bloody Marys and Marias, even though a number of people wouldn't be eating anything, or drinking beverages other than water, the better to absorb the psilocybin and/or MDMA they planned on taking.

'Are you going to take some molly?' Helen asked me hopefully before the first guests had arrived, and I reminded her that MDMA was unlikely to have any effect on me, given my course of antidepressants.

'Oh right,' she said. 'You could take mushrooms?'

Rather than reiterate my fear of having a bad trip if I were to take drugs at any time during the remainder of the twenty-first century, I just said that it seemed to me there ought to be at least one totally sober person at the party, in case of any eventualities.

'What eventualities?' Helen wanted to know.

'I mean,' I said, 'if we knew what they were . . .'

'We might as well have had kids,' she said, not unpleasantly, 'if you were going to be this square.'

'No one says square,' I said.

'I'm going to take some drugs,' she went on, adding that she might take both some psilocybin *and* some MDMA.

'I think the kids used to call that candyflipping.'

Sarcastically she said: 'Like at Burning Man in 2003?'

For the shortest segment of a moment I wondered why someone should speak of the futuristic year of 2003 as if it were decades ago.

'I think I'll also keep my phone on me,' I said. 'Just in case.'

'But it's a phoneless party,' Helen protested.

By noon or maybe 12.30 p.m. we'd welcomed into our house all thirteen of our guests through the back-patio door or else the front door, while I held whichever door it was against the wind, probably every one of the guests remarking as they took off their coats and boots about the absolutely crazy, totally insane wind, a few of them joking that the new year was off to an ominous start, before obediently handing over their phones which I then set down inside the mahogany trunk in our bedroom, more than a dozen years earlier I'd found the trunk in an antiques market in Buenos Aires and liked it so much that I'd had it shipped back to me in the States, the only real souvenir of a trip that otherwise I now hardly remembered, except to

know I'd taken it with my girlfriend at the time, she was someone I was these days hardly ever in touch with unless one of us had to let the other know that some person or animal we had in common had died, once upon a time we'd gone to Iguazú Falls in the north of Argentina and watched a river as broad as an interstate collapse below us into a cataract of steam, small swallows somehow darting in and out of their invisible nests behind the vertical sheets of deafening water.

It can't have been 2.30 p.m. yet before the party had sorted itself out into sober-enough people listening to LPs in the living room, and MDMA-takers in our bedroom, and elsewhere – outside in the yard, or upstairs in the guest room – people tripping hard enough on shrooms and/or molly as to want a little privacy, meanwhile I saw Helen go off, I didn't know where, with Rachel and Dan, admittedly a very attractive couple, looking a little wistful and even perhaps guilty as she went, not that we hadn't already discussed and both signed off on the possibility of (what to call it?) some extramarital activity one of these days if the spirit moved us, a possibility that didn't seem very probable to either of us but that we'd allowed for anyway, now that Helen was leaving my sight it seemed to me a more melancholy fact that nothing was likely to happen for her than it would have been had a threesome actually promised or threatened to take place.

In the living room, after making sure our guests all had the drinks and/or drugs they required, I put on a Sun Ra record which had seemed adequately psychedelic for the occasion but that, once it was spinning, sounded dirge-like to me with its disorderly trudging horns, so that before the first track had even concluded I turned the stereo over to my discreetly hulking friend Alex, a college friend who'd played tight end for two years, Alex had brought over a Boards of Canada vinyl reissue for the occasion, in fact it was a record that (in CD format) I'd listened to a lot back when the techno or IDM of the first George W. Bush administration had sounded to my ears like the front edge of now.

Against the seething aural wallpaper of the – to my ears – vaguely dysphoric and minatory clicks and bleeps and swells of what I

believed to be Boards of Canada's second album, male Charlie was soon telling a humorous story about a French friend of his and female Charlie's, a medical anthropologist, who'd recently visited them here in this college town at the edge of the Rockies and, in spite of his – the anthropologist's – travels throughout much of Europe, Asia and the Middle East (three regions of the globe I myself generally did my best not to think about, let alone visit), found himself freaked out by and almost frightened at the – to his French mind – very large and aggressive squirrels of central North America.

I was going to ask whether the French medical anthropologist hadn't even ever been to New York City or someplace like that, on some previous trip to North America, because didn't they have the same kind of squirrels there, of more or less the same very frightening dimensions? but, no need, this very same question was presently posed by a guy named Rob or Doug who'd accompanied Sandra and her husband to the party, I never heard from or about this generic male personage again, it was a bit like having a joke about some current event occur to you and placing it into the search bar of Twitter or X, or whatever the doomscrolling microblogging platform was called these days, only to confirm that dozens if not hundreds of other people had already hit on the very same joke as you and there was thus no need for you yourself to make it.

'Yeah, I know, he's definitely been to New York,' said male Charlie about the squirrel-menaced Frenchman. 'I guess the squirrels weren't the main thing he noticed there.'

Male Charlie, a tall and very handsome (I guess we have a lot of good-looking friends) half-Asian environmental consultant with a man bun, made this unobjectionably ordinary remark in the same tone of affable, accommodating decency that tends to characterize everything he says, and it occurred to me that I'd always had some difficulty talking to this Charlie for the simple reason that, not least because he was and no doubt still is in such good physical as well as mental shape, nothing at all seemed to be *wrong* with him, I'm not sure that I was even always very good at meeting his eyes.

Talk of the antic and threatening squirrels of North America, to which all of us were nevertheless totally accustomed, led in a moment to discussion of a more problematic local rodent, the prairie dog, whose colonies were often being flooded by county officials with poison gas so that the Hamas-like network of their tunnels beneath the fields couldn't be enlarged in such a way as to ruin the prospect of successful irrigation for local ranchers enjoying grazing rights on such publicly owned land.

'I guess they're doing what they have to do,' said Sandra's husband Christopher. 'But you can't help feeling bad for them.'

'Who, like, the prairie dogs? Or the poisoners?' Sandra asked.

'I mean I guess both,' Christopher said. 'Definitely both.'

Personally, I had attended a town-board meeting to speak up and object to the gassing of the prairie-dog colonies, suggesting that it was on the contrary ranchers and their cows who would do better to leave the land, after all the contribution of prairie dogs to climate change is surely negligible, something that can by no means be said of methane-emitting cattle, not to mention that death from poison gas must be unpleasant for mammals of all kinds, not just so-called human beings, but, on the occasion of the phone-free party, I kept this opinion to myself, not wanting to disrupt the conviviality of our friends, and instead simply ventured that capybaras, the large and tolerant buck-toothed creatures from South America, were a rodent that everyone liked and could get behind.

'I know,' Sandra said. 'Our daughter saw one – we try to keep her away from screens but someone showed her a picture of a capybara . . .'

'Search terms,' Doug/Rob – or maybe it was Tom? – weirdly muttered.

'. . . and from, like, that day,' Sandra went on, 'all she could think of was that she wants a stuffed capybara.'

'A plush toy,' Christopher clarified. 'No taxidermy.'

'And it turns out,' Sandra said, 'they just don't make them! No capybara plush toys! You can't even order one from Ecuador or wherever. Not even Peru!'

Things seemed to be going pretty well, I thought, here you had a cheerful, facetious, and occasionally informative discussion of a variety of rodents that would no doubt soon turn into a similarly cheerful, facetious, and occasionally informative discussion of some unrelated topic or other, and then another topic, until the sun started going down, and beyond, with everyone having a pretty good time at our New Year's Day party, when it occurred to me that I genuinely – and without even having had a drink, let alone taken any drugs – didn't know what year it was, neither what year had just ended last night nor what year it had already started being today, I mean I knew of course that it had to be two thousand and twenty-something, with the last two digits in the lower or middle twenties, but I didn't know what the precise number was, or if we were in the midst of the first or second term of President Biden or Trump, and therefore I thought: Something is happening to me, something not good, to my brain, and at the same time had the chance to wonder, with a neutrality barely even laced with melancholy, whether my wife Helen might be right now enjoying herself in a sexual or at least physical, perhaps cuddle-puddle (to use the archaic term) sort of way, as obviously she had every right to do, especially when her husband was mildly afflicted from day to day with an increasingly immedicable depression.

Something I try to do on the last weekend of each month is to sweep the pine needles off the flat roof over our living room, otherwise the gutters and drains get clogged, and so on New Year's Day my green fiberglass ladder was still leaning up against the house and visible outside the living-room window, and, without knowing exactly why I needed to get away from the eight or nine chattering friends hanging out in our living room and listening to Boards of Canada, now the B-side of the record, I excused myself to go outside and climb up the ladder to the flat roof above the living room, and, once I was up there, sober as a church mouse while everyone else was either tripping or rolling or buzzed on a Bloody Mary or Maria, I grabbed the nylon rope attached with a carabiner to the chimney over

the living room and heaved myself up onto the smaller roof over the older portion of the house, with its steep eaves and tar shingles, and it was then that I saw the enormous and gathering cloud of smoke pouring toward us from the east, over the suburban tracts of ranch houses and bungalows and other low-slung dwellings, despite the speed of the wind the huge cloud was unfurling toward us with an almost stately motion, the sound of sirens in the air seemed meanwhile to confirm the reality of this terrible sight, although upon hearing the sirens I felt sure that I'd already been hearing their distributed wailing sounds for some time.

Instinctively I took out my phone and, after magnifying the picture to three times its ordinary size, started filming the advancing cloud of smoke until it occurred to me, as I looked through my phone at this oncoming spectacle, that I'd signed up for Cheyenne County's free disaster notification service and, in fact, once I'd momentarily lowered the phone and taken it off airplane mode, there it was, a text message from the county government ordering my and Helen's neighborhood to be evacuated due to a rapidly growing wildfire, of course upon seeing the message I googled the word *wildfire* and the name of our city, and saw that the local paper, recently purchased by a private equity firm, still employed at least enough journalists as to be reporting on the large blaze, driven by the exceedingly high and unseasonable winds of the day, that had begun in the plains to the east and already consumed an unknown number of structures on the edge of town.

Nothing could have been clearer at the moment than that it was my immediate responsibility, as a sober person with a phone, to clamber back down the ladder and let everyone know, in the living room or anywhere else they might be, that an evacuation order had been issued for our neighborhood and perhaps also for theirs, unfortunately we all had to clear out of the house and people should return right away to their own homes if need be to fetch their animals and/or children and/or elderly parents, I, being sober, could drive anyone who wasn't able to drive him- or herself, things were going to

be okay but we had to leave *now*, the trouble, however, up there on the roof, with the sun already going down at three in the afternoon, was that some strange mood of calmness, accompanied by what was almost a feeling of satisfaction, almost some species of fulfillment, came over me as I stood there, and for more than two and a half long minutes (I still have the video on my phone) I simply stood still and recorded the boiling wall of advancing smoke inside of which, before too long, flames were visible as well, I seem while I stood there to have experienced the sensation that my small life was no longer a sidelined phenomenon while some planetary juggernaut rolled on, some part of me, that is, seems to have been glad and even gratified to be directly in the line of approaching danger, and anyway I couldn't just yet rappel down the roof holding the nylon rope, I couldn't yet go and climb down the ladder, instead I just stayed on the roof and filmed the approaching smoke and flames with my phone until I heard a voice from our yard (it was Charlie's, male Charlie's) calling my name and demanding to know dude where are you?

Once I was back in the living room everyone was naturally demanding to know what was up with all the sirens and wanting me urgently to give them back their phones, everyone soon seemed to be gathered around me in the bedroom, waiting for me to unlock the trunk, as I explained to them that I'd received an evacuation order for the neighborhood.

'Wait what caused the fire man?' male Charlie wanted to know.

Someone said: 'Fucking powerlines . . .' and plausibly enough cursed the local utility.

'I don't know,' I said. 'Maybe dry grass. It's been very dry,' as a regular visitor to the US Drought Monitor website, I knew that our region had been deeply in drought for months.

The nightmare of any cautious man must be to have been somehow totally reckless behind his own back, and it emerged, as everyone hovered around me and my locked wooden trunk, demanding their phones back so they could reach their children or elderly parents or neighbors, or simply so they could access the

breaking news, that I couldn't find the little brass key to the lock on the trunk, I truly couldn't seem to find the key to the thing at all.

'I can't find the key,' I said, I was glad that Helen wasn't present to witness this incomprehensible failure.

'What the fuck dude?' tall looming Charlie the man was asking me.

I felt that I knew I'd put the key in the breast pocket of my stupid puffer jacket, it seemed to me that I could see in my memory the gesture of my having done so, but there was no key to be found either in that pocket or in any other pocket I had on my person, nor when I rushed to the kitchen could I find the vanished key on the corner of the counter where I also had a – contradictory – picture of my having left it, very strangely in the months since the fire I've also been haunted by a confabulated image of the fugitive brass key falling off of me, out of a breast pocket on some shirt I don't own, as I climb head first down the ladder from the roof, something I know I never did or even, physically, could possibly do.

'I have an axe,' I said to the group and ran off to the carport, the truth was I'd bought an axe some time ago to split firewood before realizing that this task was more difficult and dangerous than I'd anticipated and then learning I could instead buy firewood already split into the correct size for our efficient little wood-burning stove, anyway upon my return to the bedroom I started hacking away at the trunk.

'Let me take that,' large well-built Alex said, he grabbed the scarcely used axe from my hands, and with three or four slow, practiced blows he split open the dark wood of the trunk, everyone was soon grabbing their phone from the ruined thing like so many starving people straining after thrown rations in a video clip.

In the upstairs bedroom I found Helen alone and weeping with all her clothes on, she seemed strangely unsurprised to see me arrive with Harriet the cat in her carrier and one go-bag on my back, the other, Helen's, in my hands.

'The roads are jammed,' I said. 'The streets . . .' I was referring to the frozen traffic. 'We have to go on foot.'

She nodded as if to confirm this was only something she already knew, and in a minute she had on her ski jacket and warmest wool hat as we walked very quickly, with some of our friends and many of our neighbors, some of whom we'd never seen before, or maybe these were only visitors, down the sidewalks sloping toward the creek, past countless stalled honking cars as we went.

'I'm on drugs,' Helen said, it sounded pitifully factual.

'I know,' I said.

'I don't have my gloves,' she said.

'Here take mine.'

'But then you don't have yours.'

Harriet the cat was meanwhile crying continuously inside her carrier.

'She's so afraid,' Helen said, like a child.

M y culpability in the disaster was established by the recording I'd made on the roof.

Downstairs in the bedroom, before the other phones were recovered from the trunk, I'd handed over my phone to female Charlie, telling her the passcode, and I guess the camera app was still open and so she saw the video I'd taken up there and sent it to herself (of course I had her as a contact in my phone – and still do), by the next day if not before she had already forwarded the telltale video to most of her fellow partygoers, not to mention other concerned and outraged people.

Nobody we or our friends knew were among the three people who died in the fire, but the Charlies' house was one of the hundred and then some that were destroyed by what's since been called the second most destructive wildfire in state history, and another thing I have to admit, there is no way around it, is that the Charlies' dog, the Great Dane, was inside their house when it burned, one can only hope that August died of smoke inhalation before the flames could reach him.

The question of course is whether the three minutes I spent on the roof, plus the maybe four it took to break apart the trunk with an

axe and recover everyone's phone, would have been enough to allow the Charlies to make it home before all the streets were choked and save their dog, or whether they could at least have called a neighbor in time to ask him or her to rescue August, whether that would have made a decisive difference, and in this context naturally it would have been gauche and insensitive of me to insist to the Charlies: But didn't you tell us you'd hire a dog-sitter? and when I reminded Helen of this overlooked piece of our late-November dinner-party conversation, saying 'But didn't they tell us they'd hire a dog-sitter?' she simply looked at me and blinked.

About two weeks after the fire, female Charlie emailed me and said she doubted the extra minutes would have really mattered in the end and that I shouldn't feel bad, in fact she was the person who ought to feel bad, she went on, for sending around my video from the roof to so many of our friends and blaming me for the wasted interval, in reply I wrote back saying of course I understood her passing around the video, everyone is curious about a disaster, I added that Helen and I hoped to see her and the other Charlie soon and I told her that in spite of her graciousness I would always regret the moments I'd squandered during which she and her husband might have called a neighbor, I said too that I couldn't imagine what it was like to have lost a home as well as a beloved animal and that both Charlies should come stay in our guest bedroom for as long as they liked if this might be convenient for them, of course it doesn't surprise or affront me that I never heard back from either Charlie or from most of the friends who attended our New Year's Day party, it doesn't surprise me either that Helen has hardly touched me since we returned to our intact house late at night on the day of the fire, nothing can justify my extra minutes on the roof, nor do I know what happened to the key, instead I feel myself to have descended head first down the ladder and watched in slow motion as the brass key to the wooden trunk containing all the phones tumbled out of my pocket, even though I know as certainly as any scientist believes in his findings that this can't have been the case.

'You don't have any idea what happened to the key?' I asked Helen the other day.

'How dare you,' she said.

I also have another image, of my responding for some reason to the initial sight of an advancing war zone-sized cloud of smoke by throwing the key off the roof into our back garden, with its wintry deadheaded flowers and accidental mulch of pine needles and ragged patches of stale snow, but this too I know to be false, even though I've spent hours by now looking in just the spot where, according to this image, the key must have fallen. ■

WORKING THE SOIL
AND THE CLOUD

Danny Franzreb

Introduction by Atossa Araxia Abrahamian

M y first in-person encounter with the cryptocurrency world
was at Progressbar, a hackerspace in Bratislava, on a freezing
winter weekend in early 2014. I'd traveled from New York to write
a profile of Mike Gogulski, an ex-Floridian ex-raver who'd become
stateless by choice and started a life on the margins of Slovak
society with his then wife, a cat, and dozens of personal computers.
Progressbar was where Mike hung out with other hacker types. They
spent a lot of time thinking and talking about cryptocurrencies; there
was even a local Bitcoin ATM – at the time a real novelty.

Mike was the only one to have changed his life so radically.
Nobody I met there seemed to think it was a wise move on Mike's
part to renounce his US citizenship. Still, they respected the ideas
behind his decision. Those ideas, Mike explained over whiskey and
bong hits, were political: as an anarchist, he wanted no part in the
business of citizenship, or states, or nations. 'Citizenship is a tool of
class division, a tool of hierarchy, an instrument of social control,' he
said. 'There is no equality between citizens and non-citizens.'

A stateless currency represented an extension of that ideal. Mike
supported himself by operating a Bitcoin 'mixing' service – essentially,
a way to add a layer of anonymity to cryptocurrency – while working
as a translator on the side. He wrote a blog, nostate.org, and dabbled
in commerce on the dark web.

My trip only lasted a few days, but it was enough to get a feel for the (admittedly modest) Bratislava crypto scene. It was also, in retrospect, a critical moment for digital currency – not just its market value, which began fluctuating wildly, but for what it represented beyond the screens.

Because if Bitcoin and its sister cryptocurrencies once attracted the likes of Mike Gogulski, who saw in it the contours of life outside the mainstream, it has since transformed its public face. Critics contend that cryptocurrencies neither produce nor represent anything of value, and that any value ascribed to them is nothing more than a speculative bubble. But the currency has also been absorbed into the architecture of the global economy – roughly 30 percent of traditional hedge funds now invest in crypto assets. It has gone from obscure to overexposed. Progressbar is still around. It has pivoted to coworking.

Bitcoin was invented in 2008 by the pseudonymous Satoshi Nakamoto as a model for a more transparent monetary environment.

Bitcoin mining was originally intended to be carried out by a network of individuals on personal computers equipped with special hardware – though 'mining' is a bit of a misnomer. What really happens is that the computers compete to validate each other's transactions on a ledger called the blockchain by solving encrypted hexadecimal numbers. This is a complex and energy-intensive computational process, but the miner that manages to solve the encryption first is rewarded for their efforts with new Bitcoin. What sustains and validates the decentralised ledger that is Bitcoin, then, are the very computers mining for it.

At first, the coins were plentiful and easy enough to mine in a personal capacity: the Bitcoin blockchain adds a lucrative 'block' roughly every ten minutes. But the more machines vie to validate the blocks, the more energy is needed to compete. As more 'coins' have been doled out to miners, they have grown scarcer and more onerous to obtain.

By design, the rewards for mining also halve around every four years, with the objective of keeping inflation in check. This means

fewer coins for more effort: the machines demand ever more cheap (read: dirty) energy to run and require cold climates to stop them from overheating. Today, Bitcoins are 'mined' by a galaxy of computers around the world, in industrial settings far from city centers, and mostly in the US, Kazakhstan, and Russia.

If Bitcoin started off as a utopian thought experiment, its shortcomings wound up feeding off of the existing system's flaws and making our whole world more toxic (in that sense, it does resemble real-world mining). Estimates vary, but in the aggregate, mining operations release the equivalent amount of CO_2 as a small European country. About half of it, according to Bloomberg, comes from non-renewable sources.

Much of the trouble stems again from the fact that Bitcoins are finite in number: of the 21 million, around 19 have been dispensed. This means they pass muster with inflation hawks, monetarists, and critics of fractional reserve banking. Their creation of 'value' on the blockchain also pleases people who desire decentralization (even though the algorithm tends to favor large-scale verification operations, which ends up concentrating power among a small number of highly productive miners). Even so, the idea is that the network obviates the need for a higher authority: on the blockchain, anyone can keep track of anything, from shipments of physical goods to the transfer of digital ones, and easily produce receipts. It's possible to trace a Bitcoin's every move, all the way back to when and where it was mined, without relying on a bank to hold on to the data.

Like all money, Bitcoin is valuable only to the degree that people believe in its value. Unlike most money, there is no state authority to support or ratify these beliefs. This is the point; it is also the problem. It's either a house of cards or one of the most brilliant money-making schemes in modern history – possibly both.

The cost of one coin has risen and fallen drastically since Bitcoins began trading in online exchanges in 2010 (this was also the year that Bitcoins were first used to purchase physical goods: two pizzas in Florida for 10,000 BTC). Bitcoin has naturally attracted money launderers and other criminals because it is so unregulated. The coins have also spawned hundreds, if not thousands, of other

kinds of digital cash, not to mention other digital 'commodities' like NFTs – the internet's answer to baseball cards or Pogs.

Shortly after I landed back in New York from my long weekend in Slovakia, one Bitcoin was worth barely over $100, down from ten times that sum the month prior. It hit a high of $67,789 in late 2021, making a handful of early adopters extremely wealthy, and a larger group of speculators very rich. I myself am a minor beneficiary of this boom: having bought a few dollars' worth in 2017 on a lark, I checked back in 2020 to find my investment had ballooned to more than $1,400. I sold it immediately. (I was also given $20 worth in early 2015 by a source trying to explain Bitcoin to me, but I lost the code, and forfeited a small fortune. It is estimated that one-fifth of all Bitcoins have met the same fate.)

In the process of this transformation, crypto in general and Bitcoin in particular have become synonymous with a cabal of tacky, greedy, small-minded 'bros' who proselytize with the fervor of a pyramid-scheme hype-man. They include financiers, lawyers, consultants, and heads of state clamoring to attract these entrepreneurs and take a cut of the profit. Central bankers and regulators pursue 'legal frameworks' (deciding what agency will regulate them, and how) to sanitize and co-opt the crypto economy. El Salvador has adopted Bitcoin as legal tender, though it is unclear if all that many Salvadorians use it to buy things. In Switzerland, the city of Lugano and the canton of Zug allow taxpayers to settle fines and bills with crypto. The Bitcoin's initial stateless utopianism, if you can even call it that, is a distant memory.

In *Number Go Up*, the journalist Zeke Faux showed in detail how much of the crypto world is propped up by false claims, aggressive public relations campaigns, and willful ignorance. The pursuit of a fortune in crypto has led to many ordinary people losing their savings in pursuit of promised returns that could never be delivered.

In 2014, though, crypto – and in particular, Mike Gogulski's small scene – still reminded me of the punk squats I used to frequent as a teenager in Geneva: basically respectable, a little misguided, and trying hard despite this to live differently. The cypherpunks of

Bratislava, a town full of futuristic Soviet architecture, seemed to come by their paranoia honestly. It was dark all the time. The Old Town's windows seemed to all be shuttered, tinted, or drawn, even during the day. I had the distinct sense that someone was watching.

The 1990s are usually credited (or blamed) for the rise of cyber-utopian thinking – the belief that the 'net' would end social hierarchies and make work easier, fairer, more lucrative, even fun. Of course, that didn't happen. But the events that took place between Occupy Wall Street and the election of Donald Trump brought a renewed interest in anarchist and libertarian thought, and the media's ongoing preoccupation with crypto suggests that those old ideas – and I'm thinking in particular of John Perry Barlow's declaration of independence for cyberspace – did not disappear so much as go dormant, to reappear in reaction to a spate of interlinked geopolitical shocks.

The global economy was still in tatters after the 2008 crash. Privacy in the digital realm felt impossible in the aftermath of revelations about mass US-government-sponsored surveillance leaked by Chelsea Manning and Edward Snowden. In this cultural context, the prospect of a freewheeling unregulated system of digital exchange upending the nation state's monopoly on currency was at least intellectually exciting. In September 2014, the now Republican donor Peter Thiel and the late radical anthropologist David Graeber debated each other in New York City. I remember them agreeing good-naturedly on pretty much everything.

In *Proof of Work*, Ulm-based photographer Danny Franzreb travels the world to track down the heirs to this idealism: people who, in spite of the reams of bad press and the spectacular failures of large-scale crypto operations like the meltdown of the Mt. Gox exchange and Sam Bankman-Fried's FTX, still believe they can change the world. Franzreb's focus is largely environmental. The emissions produced by Bitcoin mining have prompted activists and the media to condemn the practice. The outrage seems to have stuck. Even if you do not understand how Bitcoin works or why it matters, you can easily grasp that an armory full of humming machines needs energy to function.

Franzreb's subjects pursue their Bitcoins by different means. They're home-grown, organic, and sustainably powered by solar, water and nuclear energy: the slow food of extractivism. The ambitions of his subjects are, on the one hand, vastly diminished from the grandiose fantasy of bank-free, state-free money, but their goals are also more achievable. The question is, to what end?

Franzreb began his project by casting around for willing participants in Facebook groups whose members thought he was a taxman or a cop. Gradually, he won over an unusually sympathetic group who invited him to take photographs of them and their work. They are heirs to the crypto movement's early idealism, and it's a testament to the industry's bad reputation that their focus seems to be on cleaning up its image instead of dreaming up systemic change. To meaningfully reduce Bitcoin's energy footprint would require rethinking its reliance on cryptographic puzzle-solving, not to mention its insistence on artificial scarcity. In other words, it would mean revising the concept entirely.

Franzreb met them in fields and factories and office parks, in Irkutsk and Karelia, in Vienna and Munich. He photographed them in Hönigsberg, Austria, and Tongeren, a Belgian town near the Dutch border. Franzreb made several stops in his native Germany: Simbach am Inn, Bad Kreuznach, and Schweinfurt.

His photographs at once reinforce common stereotypes – there's the requisite fat guy in a crewneck sitting with his computing gear in harsh lighting – while reverse-engineering these tropes into something more surprising. In Sweden, he shoots a willowy young woman – a rarity in this milieu – tending to a vertical garden of vibrant green shoots. Outside temperatures can sink below twenty degrees Celsius, but thanks to the computers' excess heat warming the greenhouse, the plants thrive.

In the media, Bitcoins tend to be associated with strings of ones and zeros, a gold 'coin' seared with a garish B, steely hallways in the style of *The Matrix*, and Bored Apes (NFTs that, not long ago, were valued at hundreds of thousands of dollars). These aesthetic limitations aren't Bitcoin's alone: computers, and what's inside them, aren't much to look at. But the Bitcoin set seem to have gone out of

their way to make their world as off-putting as possible. Franzreb nods at their choice of imagery – the coin, the hallway, the memory cards and machines – while pushing us to consider what, and who, brings it to life.

He travels through rusting factories and rainy landscapes, documenting the bleak topography of post-industrial Europe. Franzreb visits a Bitcoin mine in Segezha, Russia, that has taken up in a former aluminum factory not far from a decommissioned mine. On the walls, he finds photographs of miners operating machinery underground. One generation works the soil, while the other works the cloud.

Elsewhere, Franzreb contemplates a Belgian mine powered by biogas from surplus McDonald's and discarded apples. One striking image shows a cascade of decaying fruit tumbling down a hill into some mud. It looks otherworldly – Cézanne by way of AI by way of the apocalypse. There's also a shot of pennies embedded in dirt, and one of an imposing mound of soil.

The soil both matters and doesn't: since crypto-mining companies chase permissive regulations and low energy prices, they could be here today and gone tomorrow. When China, once the second-biggest producer of the currency, banned Bitcoin mining on account of its energy consumption in 2021, Kazakhstan stepped in to welcome them instead.

Franzreb's work takes after the artist Trevor Paglen's spectral photographs of the real-world internet – undersea cables, most famously, but also data centers and satellites. Paglen set out to actually witness the sites of digital exchange himself, and with that knowledge, visualize infrastructure we rely on constantly but that is deliberately hidden from view. Both artists pinpoint portals between the physical and the metaphysical, collapsing the dualism that sustains these technological systems.

Unlike Paglen's impressionistic underwater compositions, Franzreb's images are visceral, even disgusting. His work reminds us that a stableful of servers crammed into a warehouse in Siberia has a sound, a taste, a smell – and that they still have people tending

to them. His scenes from inside the computer compounds feel particularly biotic. Intestinal cables spill out of computer towers like disemboweled carrion. They almost look like they are writhing.

The relationship between machines and nature preoccupies Franzreb. Sometimes, the two feed off of each other, producing unexpected byproducts. This is not so much innovation as it is recycling; a thought experiment, not a revolution (apples are, after all, for eating). It seems doubtful that green energy sources can be enough to redeem crypto, which also causes substantial air, water and noise pollution, making it harder for countries to lower their emissions to meet climate goals. But there is a grasping sincerity in the way that Franzreb portrays his subjects, be they humans or machines. It reminds me of the Swiss punk rockers of my adolescence, and the young programmers in tinted glasses I met in Bratislava years ago. ■

Photography by Danny Franzreb / Anzenberger Agency

```
*** 28:07 *** 6/4 15:29 *************************************
Eth: Mining ETH on eu1.ethermine.org:14444 for 12:23
Eth: Accepted shares 551 (1 stales), rejected shares 0 (0 stales)
Eth: Incorrect shares 0 (0.00%), est. stales percentage 0.18%
Eth: Maximum difficulty of found share: 290.0 TH (!!!)
Eth: Average speed (5 min): 22.593 MH/s
Eth: Effective speed: 23.37 MH/s; at pool: 23.37 MH/s

Eth: New job #347cb459 from eu1.ethermine.org:14444; diff: 4295MH
GPU0: 59C 55% 92W
GPUs power: 92.0 W; 246 kH/J
Eth: New job #ff70961c from eu1.ethermine.org:14444; diff: 4295MH
Eth speed: 22.600 MH/s, shares: 551/0/0, time: 28:07
Eth: New job #dde715ba from eu1.ethermine.org:14444; diff: 4295MH
Eth: New job #499dab95 from eu1.ethermine.org:14444; diff: 4295MH
Eth: New job #56a6eac4 from eu1.ethermine.org:14444; diff: 4295MH
Eth speed: 22.581 MH/s, shares: 551/0/0, time: 28:07
Eth: New job #ba263e92 from eu1.ethermine.org:14444; diff: 4295MH
Eth: New job #c2404bed from eu1.ethermine.org:14444; diff: 4295MH
Eth: New job #030e2e15 from eu1.ethermine.org:14444; diff: 4295MH
Eth speed: 22.601 MH/s, shares: 551/0/0, time: 28:07
Eth speed: 22.602 MH/s, shares: 551/0/0, time: 28:07
Eth: New job #8fc470f1 from eu1.ethermine.org:14444; diff: 4295MH
Eth: New job #e0f64b25 from eu1.ethermine.org:14444; diff: 4295MH
Eth speed: 22.595 MH/s, shares: 551/0/0, time: 28:07
Eth speed: 22.610 MH/s, shares: 551/0/0, time: 28:07
GPU0: 59C 55% 91W
GPUs power: 91.5 W; 247 kH/J
Eth speed: 22.610 MH/s, shares: 551/0/0, time: 28:08
Eth: New job #c629094a from eu1.ethermine.org:14444; diff: 4295MH
Eth speed: 22.600 MH/s, shares: 551/0/0, time: 28:08
Eth speed: 22.606 MH/s, shares: 551/0/0, time: 28:08

*** 28:08 *** 6/4 15:29 *************************************
Eth: Mining ETH on eu1.ethermine.org:14444 for 12:24
Eth: Accepted shares 551 (1 stales), rejected shares 0 (0 stales)
Eth: Incorrect shares 0 (0.00%), est. stales percentage 0.18%
Eth: Maximum difficulty of found share: 290.0 TH (!!!)
Eth: Average speed (5 min): 22.593 MH/s
Eth: Effective speed: 23.36 MH/s; at pool: 23.36 MH/s

Eth speed: 22.607 MH/s, shares: 551/0/0, time: 28:08
Eth: New job #82a3722f from eu1.ethermine.org:14444; diff: 4295MH
Eth speed: 22.617 MH/s, shares: 551/0/0, time: 28:08
Eth speed: 22.620 MH/s, shares: 551/0/0, time: 28:08
GPU0: 59C 55% 92W
GPUs power: 92.2 W; 245 kH/J
Eth: New job #6000f712 from eu1.ethermine.org:14444; diff: 4295MH
Eth speed: 22.620 MH/s, shares: 551/0/0, time: 28:08
Eth speed: 22.625 MH/s, shares: 551/0/0, time: 28:08
Eth: New job #78818fae from eu1.ethermine.org:14444; diff: 4295MH
Eth: New job #7ab31907 from eu1.ethermine.org:14444; diff: 4295MH
Eth: New job #a426e5ba from eu1.ethermine.org:14444; diff: 4295MH
Eth speed: 22.618 MH/s, shares: 551/0/0, time: 28:08
Eth: New job #4f79c22a from eu1.ethermine.org:14444; diff: 4295MH
```

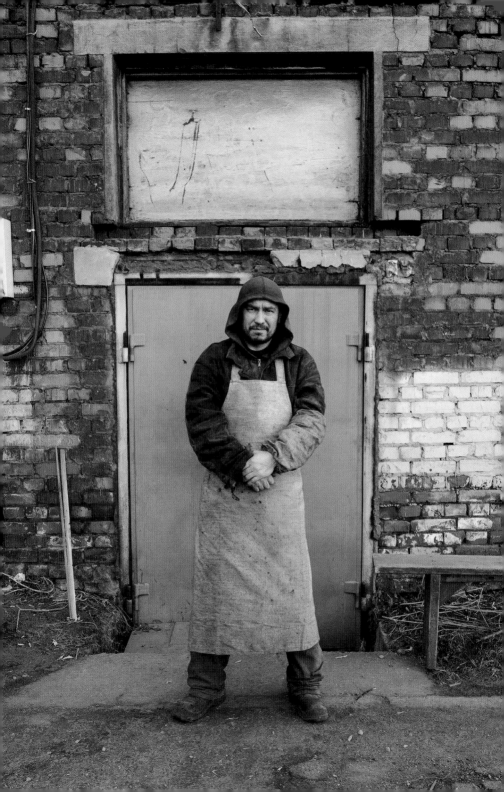

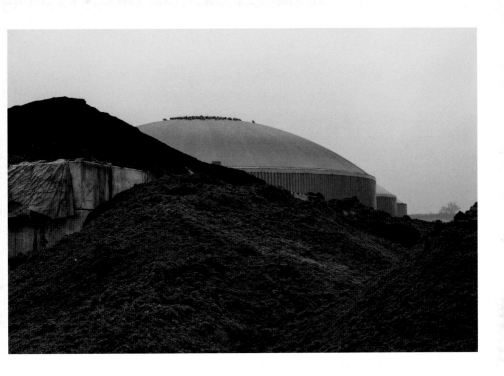

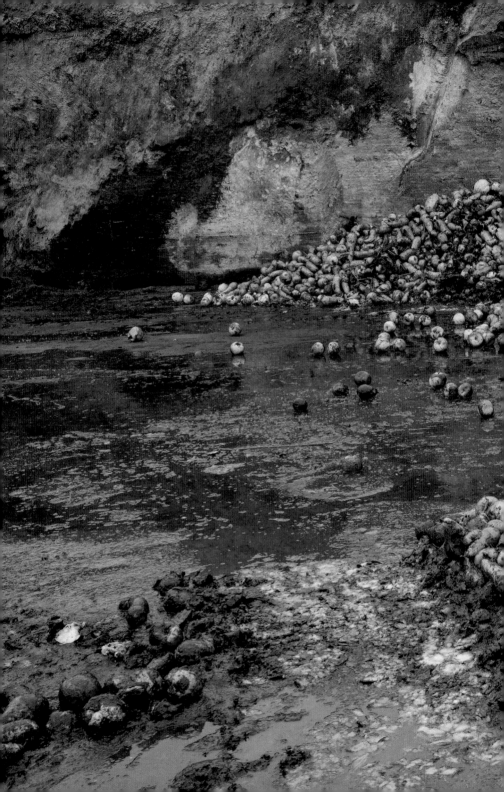

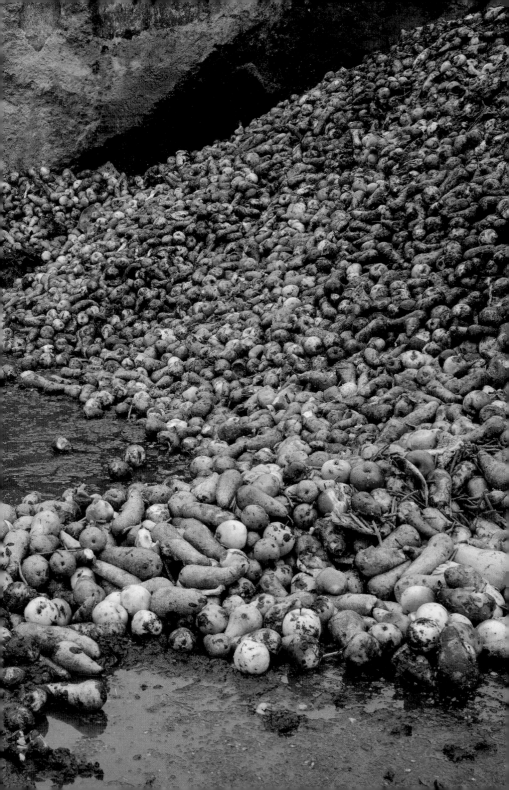

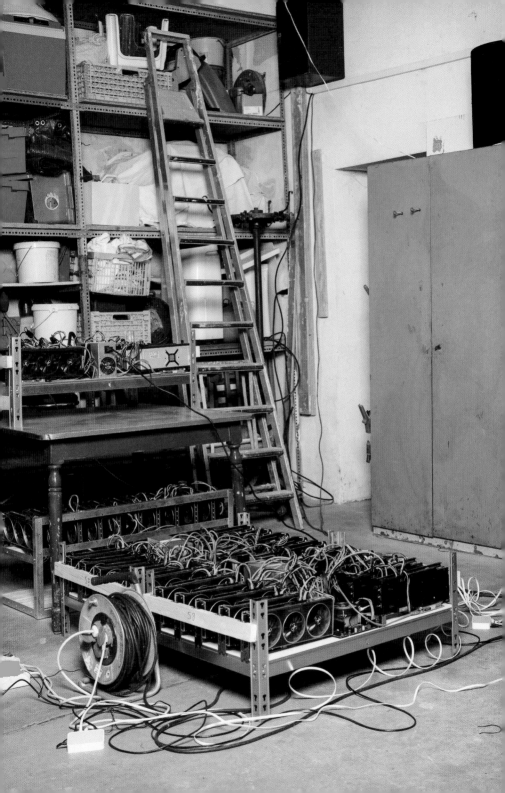

CBC
CURTIS BROWN CREATIVE

THE WRITING SCHOOL FROM THE
MAJOR LITERARY & TALENT AGENCY

SAVE 30%
MIX & MATCH 3 OR MORE COURSES

Unleash your imagination & raise your writing game

WRITING LITERARY FICTION
with Tessa Hadley

WRITING SHORT STORIES
with Cynan Jones

WRITING POETRY
with Anthony Anaxagorou

Join an online course and hone your storytelling skills with advice from award-winning authors

Watch inspiring teaching videos.
Further your learning with practical writing tasks.
Find your writing community in our online student forum.
Study at times to suit you, wherever you are in the world.

Enrol today & take the next step on your writing journey

www.curtisbrowncreative.co.uk

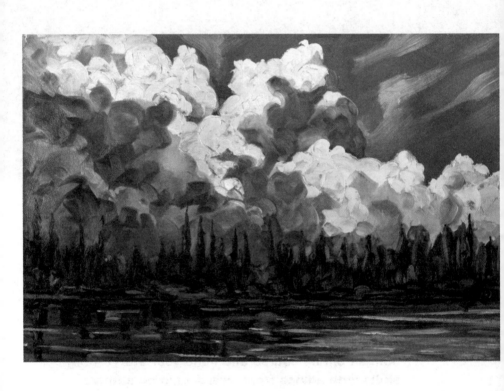

HALIN DE REPENTIGNY
Thunder on the Yukon River, 2022

WHERE THE
LANGUAGE CHANGES

Bathsheba Demuth

T he trees that form the boreal forest along the Yukon River mark
the time elapsed since the last cataclysm. In the wake of fire or
flood or axe, willows and alders are the first to root. Balsam poplar
grow into the majority after two decades; white spruce after two
centuries; black spruce emerge as sentinels of land that has gone the
better part of a millennium without great disturbance. Seen from our
boat on the river, the passing trees offer a history in the vertical, the
measure of years visible in greens from silver-pale to inky dark.

We are on the Porcupine River, half a day's travel still from its
confluence with the Yukon River. Gwich'in land. Stanley Njootli and
I have known each other since I moved to his village on the Porcupine
as his dog-sledding apprentice more than twenty years ago. Now in
his seventies, he's become like a second father, and he remains spry
and keen to spend weeks with our lives tethered to his flat-bottomed
aluminum boat as we travel towards the Yukon's Delta, where in the
long meeting of the river with the Bering Sea the channel grows to
half a mile wide. Stanley has friends in every village, and family in
many of them. I know no one who can better read the tempers of
water, or of people.

It is June, when the Arctic sun's only concession to darkness is
a brief 2 a.m. twilight. The solar glut makes the willow and poplar

so dense with new leaf they can conceal a thousand-pound young bull moose and his shadow. Amid this vegetation, it's several days before I discern the signs of people. A triangle where a cabin roof meets walls. The right angles of tent poles lashed to hold canvas. The stakes of a fish rack, ready to hold the split bodies of salmon over smoke. Tree growth carries a touch of the circular. Human geometry snags the eye. The exception is where beavers are at work. From mid-river, their felled poplars look like the beams of a cabin in early construction. It's only when we pull near to the bank that we can tell who cut the line in the trees.

Between here and the sea, more than a thousand miles, no village on the Porcupine or Yukon can be reached by road. Or rather, the river is the road and has been as far back as there are stories. It is fitting, then, that we are heading downriver following a particular story, that of a place called Nulato.

'There is only one way to settle ourselves in this country,' wrote Ferdinand Petrovich Wrangel' in 1832. 'Namely, to settle on the Kvikpak River itself.' Wrangel', who managed the empire's colonial venture in Alaska, the Russian-American Company, did not know that Kuigpak meant *big river* in Yup'ik, the language of the people of the Yukon Delta. Nor did he know how far inland the river ran, how many people lived along it, or what they called themselves in what languages. Yet, 'No matter the difficulty of this undertaking, I will stop at nothing,' Wrangel' wrote of moving onto the river now known as the Yukon. He knew the upriver country was rich in beavers, and he was on the hunt for pelts.

I am on the hunt for the Russian Empire, or what traces might still exist of its colonial enterprise, which ended a mere thirty-five years after Wrangel' wrote his letter. In the stories that define Alaska's history, the Russian presence here is usually passed over for the gold rushes and oil wells, for earth-searing damage. What Russia took – the lives of animals – can regenerate. But the act of taking has a legacy even if the most visible scars have faded. No theft is free.

On the river, time is marked in other ways, and by other cataclysms. I first heard of the tensions between the Russian traders and Native peoples on the Yukon when I came north to work with Stanley's dog team. By day, depending on the season, I trained huskies or fished or cut wood. By night, I listened to stories. This was long before I became a historian by trade – at eighteen I barely knew Russia had once been an empire – but I kept a sporadic journal. One entry, near-illegible from water stains, reads: 'C.A. says the Gwich'in once went downriver to repel the Russians.' My notes are not generous, but the line was an aside, told midstream in a story about conflicts in Gwich'in history that I was too shy to interrupt. But I remember the emotional peal, the sensation of dread and curiosity, because of the next word in my journal, now smudged: *massacre.*

And so, even before I even knew its name, I have wanted to see Nulato. I have gone looking for it in archives – in the records of the Russian-American Company, where Nulato is listed as a trading post with tallies of beaver furs, or in a file of old photographs at the University of Alaska Fairbanks. One photograph in that collection shows a wooden cross, inscribed: DERIABIN: KILLED BY KOYUKOK INDIANS IN THE NULATO MASSACRE, FEB 16 1851. But much of the history of the Yukon River lives with the river. We are traveling downstream looking for the signs of the past that are inseparable from place.

I hear the beaver first, a percussive sound breaking over the grumbling hum of our Honda outboard. Beavers, when aggrieved, slap the water broadside with their tails, a crack and splash before they dive. I signal to Stanley and he throttles back the engine. We wait to see where the whiskered head will rise.

The beaver surfaces fifty feet downstream, just the break of water over the muzzle showing, and the glint of the black eyes. Vigilant, but not warning us of trespass. Water is a beaver's element: their paws webbed, their tail a paddle, their body kept dry by a dense, almost downy coat under sleek guard hairs. Few furs are warmer, or more resistant to damp. The beaver dives again. Stanley turns the boat

back into the main channel. A bright afternoon, tender and warm. A few clouds pass delicate shadows over the far hills, black spruce and blueberry brambles.

We come to the first village, Fort Yukon, in the evening. Gravel roads, dusty with summer heat. Children shrieking with glee from bicycles. White spruce thick behind town. A history of past floods, some houses sitting empty and shifted askew by the power of high Yukon water, others bright with new paint. We have a lot of visiting to do – I have friends here, and Stanley says, not really joking, that half the town are his relatives.

My first stop is to see Richard Carroll. Brisk and with the build of a man who chops his own firewood, we met last time I was in Fort Yukon and have corresponded ever since. He is a historian of this part of Gwich'in country, and texts me periodically – always in all caps, often at 1 a.m. – to see if I might have a document he needs. I come bearing copies of census records: a trade, of a kind, as I have questions about the Russian Empire.

I find Richard pottering in part of an old cabin that is now his office, surrounded by sloping piles of church registers and books about the fur trade. While he heats water for tea, the conversation loops through the past distant and proximate – the forest fire twenty years ago that changed caribou migration, the height of the river (too high), the temperature this summer (too warm). With steam rising from mugs of Lipton, Richard turns to the serious history, a story about Shahnuuti', the nineteenth-century Gwich'in leader from Fort Yukon so formidable he survived being bitten by a grizzly. I ask if Richard has ever heard about a Gwich'in altercation with the Russians. Richard considers. 'Well, no,' he says, speaking of the past in the present tense. 'Not fighting, not us going down that way to fight, I don't think.' He pauses. 'But we do hear things, even that far away. How many people downriver died of smallpox, I think it was. Some epidemic. We hear stories up this way of their men bothering women.' He gives me a sharp look. 'And I tell you, what I know about Nulato is, you kill two white people, that's a massacre.'

In 1835, three years after Wrangel' had promised to build settlements on the Yukon River, a Russian-American Company agent named Vasilii Donskoi opened an odinochka – a small trading post, no more than a log cabin – in the village of Iqugmiut, two hundred miles inland on the Yukon. In his first season, Donskoi sent 850 beaver skins back to Russia.

The pelts were bound for places that had slaughtered their local beavers. The Eurasian species, *Castor fiber*, had been extinct in Britain and was rare across much of Europe since the 1500s. In western Russia, hunters trapped fur species to scarcity and exported their pelts. By the middle of the sixteenth century, the Russian Empire answered this lack by sending trappers and Cossacks east into the Siberian taiga. Musket-armed soldiers coerced the Ket, Even, Selkup, Koryak, and Siberia's other indigenous peoples to pay tribute in pelts; animal death became the price of stopping violence or restoring hostages. The land claimed by the tsars doubled by 1620, with fur revenues filling state coffers. French furriers began calling beaver *Castor de Mosckvie* for its association with Russia. Puritans wore felted beaver – produced using a Russian technique – across the Atlantic. Rembrandt drew himself in a beaver hat. Vermeer painted the lush sheen of light on beaver fur. Napoleon Bonaparte wore a beaver bicorn at Waterloo. Even the dried-stiff bundles of North American beaver, *Castor canadensis*, arriving from the British, Dutch and French colonies could not sate the demand.

A beaver gives birth only once a year, and four kits is a large litter. Already by 1683, Siberia's military governors had reported that the 'forest-dwelling natives have trapped all the available animals'. One response, in the face of such visible extermination, would be to restrain the pace of killing. Russia's imperial leaders kept driving eastward. Wrangel' knew the pattern: eradicate and move on. Even with good returns from the outpost in Iqugmiut, he ordered traders to continue up the Yukon. The river's beavers were, by then, among the last in the world unharrowed by imperial commerce.

In Fort Yukon, we check the propeller for dents, repack tools, tents and coffee – 'a disaster to run out', Stanley says, more than once, so we have five pounds – along with blue plastic bins of pancake mix, Toll House cookies, and pilot bread, an indestructible round cracker best eaten with bone marrow or seal fat. The wind is calm, the sun is at its perennial summer slant, never far above the horizon. Ahead, the river eases into the slow, braided channels of the Yukon Flats, unrestrained by hills for nearly two hundred miles. It is a country with fewer people than moose.

As we travel, I look into sloughs for chewed branches, a paw-mark in mud – signs of beaver life, and also the life that their work shelters. The habit of selecting alder and birch for building dams and lodges shapes the forest, as does their method of coppicing willows. The ponds, which beavers form into moats against lynxes and wolves, are home to insects that feed bivalves, bivalves that feed fish, fish that feed eagles and bears. In ecological terms, their presence makes the land home to more life, in both kind and quantity. A beaver lodge marks a diffuse, vital abundance.

When we reach the next village, a day later, Stanley and I visit with Paul Williams Senior and his son, Paul Williams Junior. We spend a languid day cooking caribou meat in the yard and telling stories, or listening, in my case. The men are all fluent in Gwich'in and in speaking it their faces carry the joy of a thirst sated. I grow drowsy from food and the hot sun – 'Too hot,' Paul Junior says. 'The sun is too strong these days.' Stanley leans over. 'He says it was Shahnuuti',' Stanley nods to Paul Senior, 'who went downriver by canoe. With many men, cooperating with the Koyukon, because of how the Russians were acting.' Stanley pauses. 'There is a story that the first white man's boats we saw were around that time, near here.'

There are many stories about Shahnuuti' in Gwich'in country – Richard Carroll's was one of them. Stanley has many. In the middle of the nineteenth century, he was the most formidable man in this part of the world, brilliant and terrible by turns. His grave is perhaps a hundred and fifty miles upriver from us, a known place – and a

reminder that not so long ago, no tsar or foreign market set the terms of life here.

That evening, in my orange tent on the riverbank, I dig through my Helly Hansen rain gear and mosquito repellant for the waterproof bag that holds my computer and its scans of the Russian-American Company records, the correspondence of Wrangel'. I do not expect to find Shahnuuti's name; the letters are sparse in such detail. But there is always a hope that the past will slot itself into a clear joint, this fact meeting another fact, the right angle of interpretation obvious. I fall asleep in a thicket of nineteenth-century Cyrillic handwriting, one word arcing into the next, a directive from long ago: 'You are advised to go until you reach the place where the language changes and the forests begin.'

Petr Malakhov – his father a Russian-American Company employee, his mother Unangax̂ from the Aleutian Islands – journeyed far enough up the river in 1838 that he reached a point where the language changed: from Yup'ik land, where the river was known as Kuigpak, into Koyukon country, where the river's name was Yookkene. Among domed hills and black spruce swamps over four hundred river miles from the Bering Sea, Malakhov found a community of thirty or so people led by a man named Unillu. Fed and sheltered by Unillu's family, Malakhov learned the name of the place – Noolaaghado – and that in spring, Koyukon people gathered there to celebrate and to trade and dry fish. Malakhov carried a report back to the Russian-American Company that Nulato, in his transcription, was well situated for an odinochka.

The place was right, but the time was not. Russian power in Alaska was slight, particularly away from the coasts, where too few people were scattered across too much land for them to attempt the brutal policies used in Siberia. But the arrival of traders still brought violence. As Malakhov prepared a dog team to haul supplies to Nulato, intending to open a trading post, smallpox loosed from Russian ships cut up the Yukon. In March 1839, Malakhov found

Unillu mourning the deaths of most of his people, including several of his children; grief-mad, he burned himself in his home. For the next two years, the Koyukon came to Nulato only when Russian traders were absent, and only to burn the cabins and storehouse. Downriver, Yup'ik attacked the Iqugmiut odinochka for bringing so much suffering. Malakhov accidentally killed a fellow trader that spring, and although acquitted of any wrongdoing, never returned to the Yukon.

Yet there was still the lure of beavers. In the 1840s, the empire returned to Nulato, opening a post that, under the direction of another trader, Vasilii Deriabin, grew to a barracks and large cabin, a banya and several storehouses. Born a peasant in Archangelsk, on the northern coast of Russia, Deriabin made a home of Nulato – taking in Unillu's surviving children, marrying a Koyukon woman from upriver, and having children of his own. How did he make sense of his presence in the hollowness that smallpox left along the river? Did he hear, from the community around him, from his own family, of the spiritual disputes growing between the Koyukon, or the conflicts brewing upriver to restore balance to the world? Deriabin was warned, like all men working for the Company, that his trade was an invasion, that the odinochka might challenge powerful people. But despite orders from the Company to fortify the post, Deriabin never built a stockade at Nulato.

Perhaps Deriabin's worries were dulled by his remit: to separate beavers from their lives. At this, he was exceptional. Nulato could send up to three thousand beaver pelts westward a year. The Russian Empire's act – the fundamental act of all colonial extraction – was to maraud through the intricate and knotted bonds that hold people and place together, the bonds of an ecosystem and of a society, and render them down to a single element: gold, zinc, beaver.

Empire advances on acts of subtraction – skins from beavers and beavers from the land they help make. We cannot know what small havocs came to the pools near all those untended dams; whether

the bears or the eagles noticed, if the bivalves and fish diminished – but when empire moved on, the beavers returned. The lodges that Stanley and I see along the river are living places, built with pale new branches worked in with age-darkened wood. Inside, this season's kits will swim within days of birth.

Fifty miles upriver from Nulato, in the town of Galena, we rest for several days. This is Koyukon country, past where Stanley has relatives, but he has traveled here before. In the midnight light we gather by the bank. People meander in and out with news. Not many moose this summer, so many died in floods in the spring. The Yukon is so warm this year that kids are swimming in it, something they never could have done twenty years ago. Sheefish guts and moose meat fry over a driftwood fire. Gulls swoop over the bright, slivering river.

We borrow a truck to fill our 20-gallon fuel drums. Mosquitos drift and bother. There is one petrol pump open, a few miles from the Yukon: a metered hose attached directly to a 5,000-gallon tank. Waiting customers – someone from the Alaska Department of Fish and Game, two young men in orange coveralls with all-terrain vehicles, red jerrycans tied over the back fenders – talk over the rippling gasoline fumes. The salmon are not running this summer: too much commercial fishing the past few years. The water is awfully, unusually high. Ravens croak from the white spruce. As I pay, the man at the pump nods toward the radio where a report about the Manh Choh mine comes in with the static. 'A new damn gold rush,' he says. 'Same thing different day.'

In town, we find Gilbert Huntington, a slight man probably in his late sixties, with a reputation as a fisher and musher. He speaks with a charismatic reserve that makes us lean in closer to hear, his stories handed down from his Koyukon grandmother Anna and her husband Sidney, a New Yorker who came north for gold in 1897 and never left. I ask about Nulato. Deriabin's wife, Gilbert says, the one he married in Nulato, was the daughter of Larion, a Koyukon leader from upriver of the odinochka. Larion could tolerate the marriage, at first, up until a second daughter moved to the post.

'There was a British man there,' Gilbert says. 'Barnard. Those Russians, they were polite. They knew who was powerful here. But Barnard wanted to talk to Larion, and just commanded him, told him to come.' Lieutenant Barnard had been dispatched by one of the vessels searching for Sir John Franklin's lost expedition, to follow a rumor of white men in the interior, and wanted information from Larion. There was also rumor of a relationship, or worse, with Larion's second daughter.

Larion sent a messenger some five hundred miles upriver to Shahnuuti' at Fort Yukon, Gilbert thinks, asking for a military alliance. Gwich'in men came down by canoe in the autumn to join the Koyukon. The rudeness, the family-stealing, the waves of illness, perhaps Shahnuuti''s wariness that Russian traders were moving further upriver: any welcome the foreigners at Nulato had was long overstayed.

By the time we leave Galena, the dimensions of a narrative have formed. Shahnuuti' and Larion, the Gwich'in and Koyukon leaders, were part of an alliance against transgressions on their land, a push to make the Russians recognize indigenous sovereignty. On the cusp of unfathomable change – gold rushes and colonial rule – they knew to act. It is a seductive story. In the nearly two centuries since the Russian-American Company came here to strip value from the land, the acquisitive impulse of governments and companies has only expanded: not enough fish in the Yukon and too much heat everywhere. Looking forward is vertiginous. I want the past to have precise contours, to contain some lesson for how to weather the cataclysms to come.

On a midwinter night in 1851, Deriabin left his cabin, perhaps for firewood or the outhouse or perhaps he could already hear screams from the Koyukon houses down the bank. The yard, bright from a waxing gibbous moon, was full of armed men. Shock turned to action – Deriabin seized, Deriabin stabbed, Deriabin stumbled back inside, where his wife barred the door. Deriabin dead. Terrible

flames from the village, shouts, wailing, the panic of dogs. Barnard awoke in time to fire his rifle. He wrote to Edward Adams, a doctor from the same British rescue mission, the next morning: 'I [am] dreadfully wounded in the abdomen – my entrails are hanging out. I don't suppose I shall live long enough to see you. Nearly all the natives of the village are murdered – let out for this with all haste.'

Adams was wintering at a Russian-American Company outpost on the Bering Sea when the letter found him. It would take him a month to reach Nulato. The village was in ruins: over fifty Koyukon dead; homes burned; the survivors fearful. One man had his nose, eyes and ears sliced away, his temples gored by spears. Barnard had succumbed to his wounds. Adams learned that the attackers were upriver Koyukon, but, out of his linguistic and political depth, he could only guess the motive. An insult from a trader, perhaps. Punishment for collaboration with the Russians. As the living scattered to their relatives, Adams carried the only written account of February 1851 back to Britain.

Two white men make a massacre. Adams's diary has yielded interpretations by outsiders and passers-through. The first histories were embellished to support that old colonial idol, the civilizing mission. Epidemics recede; Koyukon dead fade against Barnard's loss to irrational savagery on the frontier. A century later, the 'Nulato massacre' became an economic tale: the upriver Koyukon attacked Nulato out of revenge, angered that downstream Koyukon had trade advantage at the Russian post. In either version, the people at Nulato are familiar victims, collateral damage to advancing empire. A logic in which extraction, once it begins, contaminates all, every choice reduced to progress, profit, or death. But this is not such a singular story. The river is home to other kinds of cataclysm.

We reach Nulato on a morning with the kind of dense calm and low haze that comes to the river as weather brews. We have traveled more than eight hundred miles to a town where, now, people speak English in everyday conversation, a legacy of the colonial

order that succeeded the Russian Empire. The church is Catholic. The priest, Father Tsing, was born in Vietnam, and is as beloved for his mechanical expertise – 'I can go to the dump, get parts, there's enough to remake everyone's engines' – as for his spiritual guidance. When we meet him at the church, he agrees to drive us through hills now full of homes. Most of the village has retreated from the riverbank, abandoning houses too close to spring floods, only for the buildings to nearly burn down in a wildfire eight years ago. Charred black spruce remain, spire gray and stripped of branches. A forest of lines.

We visit the village council building, compact and well lived-in, its narrow halls covered floor to ceiling with newspaper clippings featuring local people – the high school basketball team going to Fairbanks; the election of a new tribal government, who together manage social services, environmental projects, and employment. The main room is busy with a safety training session for construction crews – a prerequisite for oil or gold work. I overhear someone say there are too many beavers now. 'Too much to eat these days, too much willow can grow in these hot winters.' I ask Martha Turner, who works for the tribal government, if it is possible to visit the Nulato odinochka ruins. She pauses. 'That is a bad place.' Another pause. 'It is not a good place to bother.'

We hear versions of this all afternoon – *this is a place we do not go.* I ask after Miranda Wright, a Koyukon anthropologist rumored to be in town. I have been reading her writing in the evenings, a history of the world Adams could not see. From a collection of oral histories and discussions with Elders along the river, Wright pieced together how a deyenenh – a Koyukon person of great spiritual power, able to shape or trouble the cosmic order – killed many upriver people in the late 1840s. The deaths were terrible, not only for the immediate loss, but also because they signaled a tilt in the balance of the universe. Repair required the deyenenh's death, and that his eyes and ears be cut away to dull his power, like the man with the mutilated face that Adams described in his account. In February 1851, the deyenenh –

Wright learned his name, but will not write it – was in Nulato for a winter celebration. Wright is in Fairbanks, so I cannot ask her if a pact between Larion and Shahnuuti' makes any sense, in Nulato, or if theirs are stories that belong to upriver country. I cannot ask if Deriabin and Barnard were the targets that night or not. I cannot yet even articulate the real question: did I also come to the river assuming all conflict is over commerce? The pall that empire and its descendants cast over the world makes it easy to see it as the cause of any event, eliding other truths.

Father Tsing offers to drive us out toward what remains of the odinochka. The village is no longer close to the old Russian buildings, and the spruce growth means nothing can be seen from a distance. The gravel road toward the post is flooded. Quiet pools of coffee-colored water. Alder thicket above our heads. It would be possible to walk into the ruins, but we do not. The air is dense with something more than rain. Stanley and I exchange a look. Unsaid between us is the sense that to go farther is wrong. *That is a place we do not go.*

We take to the river as a storm gathers. The light breaks from under the horizon-line of a thundercloud, turning the silt-thick Yukon purplish. The village recedes as the boat moves into the current, away from the bank. Somewhere, behind the curtain of trees, are the foundations of buildings I will never see.

I came to the Yukon to settle something in my mind – I came to solve and to find. But to find is also, often, to take – a pelt, a gold nugget, a lesson, a single history. A history of empire and its resisters. Yet the past is not simply a resource, a place to find answers for the present. It is a place to humble ourselves in the knowledge that we were not inevitable. Nothing as big and old as the Yukon will be home to one story, or even one story about what happened on a moonlit February night. Not everything can be reduced to certainty. Miranda Wright writes of how her father advised her, when she was training in

archeology, to leave graves alone. 'The work of the spiritual realm,' he said, 'and the cause of the death must remain a mystery.'

The anti-imperial, the move against the drive to rip value out of the land, is in florescence. The beavers, returning, and all that their dams bring with them. The trees rising. And stories that make room for one another. Shahnuuti' keeping the Russians at a distance. Barnard running afoul of local practice. The death of a deyenenh, full of meaning beyond trade.

We are a few hours downriver from Nulato when the rain comes. As I look out at the banks, dribbling mud as we pass, I remember with a jolt another photograph in the Fairbanks archive. It is from Nulato, probably the 1920s. The shifting course of the Yukon River has cut into a burial ground. Naked skeletons – once the Koyukon women, children, men, old, young who died in 1851 – are stark white against dark soil. A group of visitors, tourists from their casual dress, poses with the bones, holding them as if they are sports kit for a game of their own making. ■

Creative Writing and Literature

Study part-time with Oxford

UNIVERSITY OF OXFORD

Develop your own creativity or examine that of others with a short course or part-time qualification from one of the world's oldest and largest communities of part-time adult learners.

Short courses in Oxford and online
- Workshops and day schools
- Weekend events
- Weekly learning courses
- Summer schools in Oxford

Part-time qualifications
- Certificate in English Literature
- Diploma in Creative Writing
- MSt in Creative Writing
- MSt in Literature and Arts

SCAN TO LEARN MORE

X 🅞 **@OxfordConted**
www.conted.ox.ac.uk/granta2024

JULIAN CHARRIÈRE
Controlled Burn / Open-Pit Mine G.4, 2023. VG Bild-Kunst / DACS

THE EXTRACTED EARTH

Interview with Thea Riofrancos

What has been hailed as the 'green transition' – the global project to end large-scale extraction of fossil fuels – requires a shift to a new set of extractive projects. Green technologies depend on minerals and metals locked in the earth: lithium, cobalt, nickel, copper, and, above all, iron for steel. The exploitation, corruption and environmental destruction involved in the mining of these materials are not on the wane. But what can be done to counter the interests behind them? What possibilities are there for a less ecologically compromised and economically stratified future?

Thea Riofrancos is a political scientist whose research focuses on the politics and economics of extraction. In 2019, she co-authored *A Planet to Win*, proposing a political strategy and material blueprint for a just, green future that tackled the dilemma of extraction for the energy transition. Her scholarly book, *Resource Radicals: From Petro-Nationalism to Post-Extractivism in Ecuador* (2020), examines Ecuador in the 2000s, and the conflict between new political groups demanding environmental restoration and a traditional Left government that aimed to use mining revenues to pay for social services and infrastructure. In her most recent work, the forthcoming book *Extraction*, Riofrancos focuses on the global lithium industry in light of the green transition.

The editor of *Granta* spoke with Riofrancos in February.

EDITOR: How should we think of extraction as an activity across the millennia?

THEA RIOFRANCOS: Extraction is a very old practice. We can say that it is as old as human history. For example, the indigenous peoples that first settled in the Atacama Desert of northern Chile around 12,000 BP mined for silica, iron and copper. Archeological evidence suggests rudimentary quarries, as well as surface deposits of the siliceous rocks used to make knives and scrapers and other tools. Today when we think about extraction, we tend to think about a set of economic sectors, like the so-called extractive sectors of oil, gas and mining. Extraction in these sectors means that you're removing something from nature that nature cannot replenish on human timescales. That's why we call them non-renewable.

EDITOR: When does extraction in the more modern, large-scale industrial sense begin?

RIOFRANCOS: The main changes began in the late fifteenth century, when Europeans started to look to the outer world for resources – especially to the Americas. What started as a project to add to the Crown's wealth of silver and gold became a search for the raw materials that could feed the nascent industrial processes then developing in Europe. A cycle of growth and expansion followed, and extraction on a planetary scale began. Europeans secured capital and resources across the globe, violently incorporating local populations into the extractive circuit. This basic model – large-scale, export-oriented, environmentally reckless mining in the Global South to serve production and consumption elsewhere – continues today. But there have been major changes. Three key shifts are the rise of state-owned mining and fossil-fuel firms in the Global South, the growth of mining powerhouses like Canada and Australia in the Global North, and the entrance of China as a major importer.

EDITOR: The conquistadors in the Americas were after precious metals: gold and silver. On the one hand, these were convenient: they didn't require a great deal of technology to mine and they could be shipped back in galleons to Europe. On the other hand, extraction as it was conducted by the Europeans involves a great deal of forced labor, since you want as many hands as possible sifting through the surface. When does the shift happen to more common metals that require more intense, technology-dependent mining and are less easy to carry off the continent? When does the qualitative shift to modern extraction – which of course hardly precludes slavery, and may even intensify it – begin?

RIOFRANCOS: If we take the example of Latin America, extraction intensified in the decades after independence from Spain – this was one of the outcomes of the Creole revolutions of the early nineteenth century. The now politically independent states were still dependent on the processes of resource extraction, which became the basis of their economies. Leasing and taxing the state's resource wealth, whether tin or guano, became essential to public budgets. The independence of these countries coincided with the expansion of industrialization across Europe and North America. If gold and silver previously served to fill the monarchs' coffers and acted primarily as a unit of exchange, now a whole new bevy of minerals were needed as industrial inputs. This phase of extraction is linked to the production of commodities on a global scale; it's the start of a new era.

EDITOR: Extractivism, as an -ism, seems like a concept fraught with imprecision. What does 'extractivism' denote that 'extraction' does not cover? How do you make use of a term that seems almost indistinguishable from human activity itself?

RIOFRANCOS: Extractivism is almost extractive as a concept, isn't it? We often hear the term in relation to Big Tech, cryptocurrency and knowledge sectors. Extraction is the act itself, extractivism is the larger

system by which natural resources are taken from one place and moved to another with minimal processing. That lack of processing is the key component, as it preserves an economic imbalance – the raw materials and the finished goods are separated. One way to think about it more precisely is that extractivism is the modality through which capitalism is lived in the periphery. I'm riffing on Stuart Hall's analysis of class and race. It is through mines that the places peripheral to the centers of finance and industry became incorporated into capitalism. Entire societies are shaped by the fact that the extraction of materials is the fundamental economic basis of their economies, and therefore shapes everything from ideology to civil society, from labor relations to subjectivity. And the implications are not just domestic; extractivism reinforces these countries' position in the world system. Indeed, one of the factors that defines being part of the Global South is being a net provider of raw materials to the global economy.

EDITOR: Can we really say that this is a phenomenon confined to the periphery? Extractivism was – and is – an inescapable part of the imperial cores. The Normandy of Émile Zola figures as a kind of mine-pocked wasteland. The last two hard coal mines only closed in the Rhineland a few years ago, and a new one is set to open in Cumbria.

RIOFRANCOS: Think of it in terms of the percentage extractive industries take up of the country's GDP or annual budget. How much state revenue comes from extraction and other 'nature-facing' sectors? The US is currently the world's number one oil and gas producer. But oil and gas are not central to the government because there are so many other streams of revenue, including income taxes. Proper petrostates tend to have very low income or wealth taxes – most of their revenue comes from royalties and taxation on oil. So in the case of an extraction-based economy, we're talking about the fiscal model of the state. If you have an oil-price crash in the US, it's considered good news, despite the fact that the US is a major oil

exporter. The majority of working people benefit from cheaper gas at the pump. Most oil-exporting countries, by contrast, don't like oil-price crashes because government income, and by extension the rest of society, suffers.

EDITOR: A lot of your research now focuses on lithium. Why zoom in on that mineral? What does it tell us about resource extraction writ large?

RIOFRANCOS: Lithium is a crucial input for the batteries that power electric vehicles. EVs are in turn the dominant approach to taking emissions out of transportation – and transportation is central to dealing with the climate crisis (in the US, it's the number one source of our emissions). You can look at the sudden spike in demand for this mineral as a microcosm for the green transition as a whole.

No part of the process is simple. The auto industry is a multi-trillion-dollar global economic sector with close ties to the political system and historically quite powerful labor unions. So the attempt to change how cars are produced has quickly become an arena populated by fiercely competing interests.

Conflicts have also erupted upstream. At the beginning of the supply chain, protests over the mining of lithium, from Argentina to the southwestern US to Portugal, have thrown into relief the contradictions of the energy transition. Despite the end goal of moving away from fossil fuels, on a local level the transition can mean more extraction, not less. And – corporate green rhetoric aside – mining for minerals like lithium is no different from any other mining: it's largely organized by multinational companies with little public accountability, is rarely properly regulated, and mostly conducted in marginalized communities and upon vulnerable ecosystems. Reckoning with all of these tensions reveals the contradictions inherent in the new 'green' sectors of the economy.

EDITOR: How does the recent bout of onshoring figure in this? The US and several European governments have declared that they now

need to bring back certain types of mining that they were content, as you say, to push out to the periphery for decades.

RIOFRANCOS: There's a shift, and it's worth attending to, but we shouldn't get too carried away with the idea. It still remains a fact that the bulk of raw materials for global production come from the Global South, as well as from a couple of large mining producers in the Global North. The overall trend, historically, has been towards offshoring: there are environmental, economic and finally political reasons to import minerals from elsewhere rather than mine domestically (among many reasons why, miners have been inconveniently militant and well organized since the advent of industrialization). But recently we do seem to be in a new era of onshoring. The US, UK and EU are now prioritizing mining within their borders, especially for so-called 'critical minerals', like lithium, needed for the energy transition.

In the peak period of neoliberal globalization in the 1990s and early 2000s, if you asked any economist or policymaker how we should think about sourcing raw materials for finished goods, they would say comparative advantage is most efficient. Wherever the minerals can be gotten cheapest and fastest – from the most pliable states with the fewest regulations – that's where they should come from. There were rumblings to the contrary that started in the wake of the financial crisis, just because of how serious a blow that crash was to many preconceived notions about neoliberal globalization, but there wasn't really a political opening for change.

The rare-earths crisis in 2010, when China supposedly made it impossible for anyone to get rare earths, was an important milestone. Well before Western media and politicians took notice, China had been quietly limiting the extraction and export of rare-earth elements. China's goals were twofold: limiting an industry infamous for the contamination of water, soil and workers and, perhaps more importantly, leapfrogging up the value chain by using the minerals for domestic industry rather than shipping them off in raw form to global markets. In other words, the Chinese Communist Party

(CCP) identified a fundamental tension between export-oriented extraction and economic development, and prioritized the latter. Indonesia's 2020 ban on the export of unprocessed nickel, and the subsequent development of a battery supply chain there, can be seen in a similar light. In late 2010, the Chinese military impeded a rare-earth shipment to Japan following a dispute in the contested waters between Taiwan and Okinawa. Although minor and unrelated to industrial policy, the international press called it an 'embargo', setting off a market panic and bellicose speeches from US lawmakers – and sparking calls to reshore rare-earth mining. (The US had been a major global producer of these minerals until the Mountain Pass mine in California was closed in 2002, on environmental grounds.) Misinterpretations can have quite real consequences.

Following the onset of the Covid pandemic, as well as the recent spate of geopolitical conflagrations, new fears about vulnerable supply chains have emerged. EU and US policymakers decided we should no longer just rely on imports from unpredictable places, or places that are not firm political allies. We should, to the degree possible, onshore, or onshore with our allies, gaining direct territorial access or control over these inputs. So yes, there's been a significant shift. New mining projects are certainly being developed from the western US to the Iberian peninsula to the Upper Rhine Valley. But mining in Global South extractive zones, from Chile to the Democratic Republic of Congo, continues apace.

EDITOR: In the Global South, there has been a variety of political responses to extractive projects. One is resource nationalism: states aim to take direct control and expel or at least better govern foreign capital. Another is anti-extractivism: mining and oil projects are outright opposed with a goal of transitioning to a 'post-extractive' economy. You write as someone sympathetic to the claims of both resource nationalists and anti-extractivists. In fact, you have argued that they need to combine their strategies.

RIOFRANCOS: I do think it's possible to have it both ways. There's nothing necessarily contradictory about wanting more public involvement – I'll use that word rather than state involvement, because I think we can think more broadly than the state itself – wanting whatever extraction takes place to maximize public benefit (especially in the zones of extraction), and wanting to environmentally control or limit extraction to what is socially necessary, rather than what is most profitable.

On the one hand, there's the resource nationalist idea that the people should own their country's resources – that everything should be extracted to benefit the *demos*. The resource nationalist view is very clear on who should lose power: transnational capital and multinational corporations. But that view is – or can be – consistent with the idea that we should limit how much overall extraction takes place. More extraction doesn't necessarily equal more well-being. Much of it is not sustainable in any sense of the term. But if the goal is to phase out extractive sectors then you need public involvement in that process. This might seem like an outlandish idea; it's perhaps hard to imagine a country with abundant mineral or oil reserves simply leaving that wealth underground. But there are precedents here, historical and contemporary. During the early years of OPEC's formation, ministers of these petrostates openly discussed the benefits of a more conservative approach to extraction so as not to exhaust a fundamentally nonrenewable resource. More recently, in Panama, El Salvador, Costa Rica, Ecuador and elsewhere in Latin America, broad popular movements have achieved bans on new extraction, whether in specific ecosystems or the country as a whole.

EDITOR: Why can't the end of mass-scale fossil fuels be instead a technocratic, elite-driven project?

RIOFRANCOS: It's abundantly clear that the phaseout of oil, gas and coal isn't happening anywhere near as fast as the climate crisis requires. As long as fossil fuels are a profitable investment, and so

long as there is growing energy demand, the buildout will continue. Some combination of social pressure and government intervention will be required to neutralize and eventually eliminate the behemoth that this sector has become. The problem is that the world's two most powerful countries, for quite different reasons, have no immediate interest in abandoning fossil fuels. China, while expanding renewables at an astonishing annual rate, still relies on coal for more than half of its energy consumption. And the US is an oil and gas juggernaut in its own right. The situation is further complicated by the reality that lower-income petrostates – from Ecuador to Nigeria – would cease to have state budgets if oil was phased out overnight; there needs to be a multilateral plan for redistributive finance to address what happens in the latter stages of the process.

Just letting capitalism do its thing isn't working. Some have faith that 'green capital' – i.e. firms and investors in renewable energy or climate technology sectors – will peel off from its fossil counterpart, allying with progressive policymakers and social movements to push a fast transition. The reality is more grim. Green capital is not nearly as economically or politically powerful as fossil capital, and not as neatly distinguished from the latter as we might like. Lithium batteries were partly developed in Exxon's labs amid their sprawling petrochemical facilities. That was in the 1970s, the era of the 'oil shock' that sent Western governments and oil companies looking for alternatives to crude (when markets re-stabilized, Exxon suddenly lost interest in a post-oil world). Today, we see much of Big Oil diversifying into renewable energy projects – although the investments are often paltry enough to make one wonder if the goal is PR rather than really moving 'Beyond Petroleum' – as BP tried, and ultimately failed, to rebrand itself. Commodity giants like Glencore retain hold of major coal assets while diversifying into lithium-battery recycling plants. In a throwback to its early involvement in batteries, Exxon is now planning to mine lithium in Arkansas.

EDITOR: Lula's Brazil may have been the most successful case of resource nationalism in our lifetimes. Programs such as the Bolsa Família – Brazil's nationwide social-assistance initiative for low-income families – were built on the back of intensified extraction and the export of iron ore and oil. But now some anti-extractivist groups can boast of considerable, if temporary, successes from a more localized perspective. How are these taking shape?

RIOFRANCOS: There were massive protests in Panama last year against the Canadian company First Quantum Minerals, which owns the concession at the Cobre mine. It had been operating for around twenty years, which is notable, since typically we find militancy centers around new sites of extraction. The protest wasn't restricted to the enclave: it wasn't just blockading machinery. It made the mine an issue for the elected government. Panamanian civil society was able to convince political and party leaders of their cause.

A similar thing happened in Serbia in 2022, when a popular movement managed to cancel Rio Tinto's contract for lithium at Jadar. Both of these movements – in Panama and Serbia – turned a local issue into a national grievance, centered around government dealings with the firms, and environmental harm. These victories may only be temporary, or limited to certain parts of the country. But they point to new ways to manoeuvre, opportunities to implement new and better regulation, to scrap and renegotiate contracts, and to rethink the economic development model.

EDITOR: How do anti-extractivist strategies differ in the Global North and the Global South?

RIOFRANCOS: There's a lot of overlap. You get people in parts of Nevada (where a lithium rush is underway) and Chile (the world's second largest producer of the mineral) who say: we have more in common with each other than we do with the elites in our respective capitals. There are networks of anti-oil activists now that stretch from

the Sarayaku territories in Ecuador's Amazon to Standing Rock in North Dakota. If there's a major difference in approach, it has to do with the violence that activists in the Global South can expect. The protesters at Standing Rock were treated brutally – I don't want to downplay that – but in places like Mexico, Central America and Colombia, environmental activists are regularly assaulted or even killed. Latin America is the most dangerous region in the world to be a land or water defender.

'Community opposition' is a broader category in the Global North, and can even be a misnomer. It might just refer to Koch money funneled into a front group that's opposing a wind farm. This is why I reject the term 'Nimbyism', not because some people don't want things in their backyard, but because that characterization doesn't speak adequately to the array of forms of localized opposition at play. I don't like conflating anti-mining and anti-solar activism. I haven't yet seen any evidence of nefarious oil money funding anti-mining protests. But we have seen that happen with some – though absolutely not all – of the opposition to wind and solar.

EDITOR: How does the mining industry perceive the green transition?

RIOFRANCOS: My experience of going to mining industry conventions is that corporations are very anxious right now. Which is not to say they aren't still powerful. But the mining industry sounds different when the public isn't present. They have major problems, a chief one being financing. After the big commodity bust in the mid-2010s, there's been a reluctance on the part of Wall Street to finance the sort of long-term, risky, deferred-profit extractive projects that have high upfront capital costs and very lengthy routes to profitability. The 2014 bust saw a consolidation of the 'capital discipline' that forces firms to increase dividends and conduct share buy-backs instead of investing in more productive operations. So one anxiety of the mining sector is just attracting their friends in the finance sector. A related concern has to do with supply. There are concerns about bringing

enough supply – cobalt, copper, lithium – online fast enough to meet rising demand.

EDITOR: But if supply is tight, don't prices go up?

RIOFRANCOS: Of course, but an industry that's a supplier to major companies – battery producers, car companies, etc. – wants to have a reputation for reliability. Reliability is often better than scarcity for the ongoing profitability of major mining firms. But the thing that most worries the mining industry – more than finance, more than the reliability of supply – is the so-called social license to operate. Over the past couple of decades there has been a rise in community-level militancy. I've mentioned the protests in Panama and Serbia, but there are many, many more. Some mining projects have been stalled for years or a decade with no clarity over when or even whether they will resume. Mining companies no longer feel confident that local populations will accept their operations, which has resulted in a whole cottage industry of consultants on corporate social responsibility, green credentials and ethical certification schemes. The classical form of contention in the mining industry for the past century was labor. And strikes still happen. But given how much automation has changed the sector and reduced its labor intensity, community and frontline conflict have become the primary concerns.

EDITOR: If the green transition requires getting vast amounts of new metals and minerals out of the ground in a short period of time, doesn't one still have to reckon with the mining companies? Their combination of technology and know-how seems hard to replicate quickly.

RIOFRANCOS: It may be hard to replicate quickly. But it is not impossible. We know from past examples, whether copper or oil, that governments in the Global South can successfully establish state-owned companies that either replace or, more commonly, operate

jointly with multinational firms. Before Allende nationalized Chile's copper sector, the mines were the property of US companies; before Saudi Aramco, Saudi Arabia's oil was in the hands of a consortium of American firms. The question is not whether there are alternatives to shareholder-owned multinationals. The question is, under what conditions can Latin American or African governments gain the know-how, technology and, crucially, the capital to shift the balance of power from the private to the public sector? How can they move from eking out a sliver of royalties to actually being involved in mining operations? What leverage do governments have over multinational capital? The answer, first and foremost, is that they control the resource deposits that investors want. Once permits are acquired and initial investments in physical plants are made, the reality of the huge sunk costs can erode the bargaining position of foreign firms. This is what's called the 'obsolescing bargain' of extractive-sector negotiations. It's not shocking that we see higher levels of state involvement in oil and mining than in other sectors. There's precedent for this to happen with other energy transition minerals as well. We have seen lithium nationalizations in Mexico and Bolivia, with Chile potentially on the horizon; following in Indonesia's footsteps, Zimbabwe banned raw lithium exports. In all these cases, it seems unlikely that these governments can go at it entirely alone, which brings us back to questions of access to capital, leverage, and technology transfer.

EDITOR: What are the limitations for states that want to pursue resource nationalism, whether by expropriating foreign firms or by other means?

RIOFRANCOS: Resource nationalism and the creation of state-owned firms only confront part of the conundrum of extractivism. What these address are the ownership issue, and the question of the distribution of the economic benefits. What they don't deal with are two other looming problems: the underdevelopment trap of specializing in

primary materials, and the problem of socio-environmental harm. This is not to say nationalization isn't a crucial tool. It is. But on its own it isn't enough.

EDITOR: What makes the governance of states undergoing an extraction boom so challenging?

RIOFRANCOS: The sheer power of multinational companies means there's an asymmetric relation between them and their host states. The more important question becomes: why are we experiencing such a boom and such a rush around the inputs for the green transition? Evidently the main driver of demand for, say, lithium, is electric vehicles. But that raises the further question: is there a way to organize the decarbonization of transport without reproducing auto dependency? The real challenge we face is to avoid reproducing our current, entrenched habits via green technology.

EDITOR: The Russian invasion of Ukraine in 2022 galvanized Europeans to think about moving away from Russian fossil fuel, while at the same time making them more dependent on US supplies of liquid natural gas (LNG). How are geopolitical threats jumpstarting the way we think about resources?

RIOFRANCOS: Competition between the so-called Great Powers has transformed supply chains into terrains of competition. This is especially the case with China and the US, two states with large fiscal capacities. They are the ones that see themselves in the most dramatic tension with one another, despite periodic denials. It's hard to imagine a scenario in which the Inflation Reduction Act could have passed in the US Congress without that underlying sense of competition.

These geopolitical changes have given some political impetus in Europe to the renewable energy transition. In the US, however, they have also created a big opening for the domestic oil and gas industry. As soon as Europe makes progress in its own energy transition, and

no longer needs to import as much US LNG, that LNG is going to broadly shift to markets in Asia. So while geopolitical tension is a motivating force for policy-led shifts in energy usage, which could lead to benefits from a climate perspective, those same factors also motivate increases in oil and gas extraction. We're not really in an energy transition as it is popularly understood. What we're in is a period of major energy *addition*, in which both fossil fuels and renewable sources are growing at a rapid clip.

EDITOR: How does the Chinese state feature in this future?

RIOFRANCOS: Through intelligent planning China got a head start on many green technology sectors while the West was still in climate denial mode. The CCP didn't do this to benefit the climate per se, though there were important incentives around the local politics of pollution. It was a very carefully thought out industrial strategy. They recognized where there were openings and niches in the global production network. Understandably convinced that Western and Japanese firms dominated traditional auto, China has made itself into an EV juggernaut. Local governments and provinces were roped into the scheme and even competed with one another – the challenge was who could get the most EVs on the road.

Chinese firms are asset-seeking, because they are not able to satisfy all their need for the raw materials for batteries, EVs and other green tech products within China's jurisdiction. They have gone to Africa, Latin America and Australia. When they embark on mining projects, they're open to joint ventures, and they're much less picky than Western goverments about working with state-owned companies. They have been innovative in their deal-making, offering things like advance royalties on mines to ensure host governments are flush with cash from the start. They prioritize access to resources over the strict profitability of the project. They don't have to please Wall Street. That is a fundamental difference in parameters compared to Western multinationals.

What makes me uneasy is the way that European and especially American policymakers explain China's success as a conspiracy. How it actually happened is textbook planning, in an industrial policy sense. China's industrial policy has become a model, whether acknowledged or not, that a lot of other countries will now want to copy. Whether they have the capacity to do so is a different story. China's development strategy, especially in renewables, has raised the question of whether the standard of neoliberal globalization is competitive in the long-term.

EDITOR: Would you say there is planning envy of China on the part of some Western policymakers?

RIOFRANCOS: Adjacent to the word 'planning' is the word 'coordination'. It's helpful to have a state with a bird's eye view, and to have interfaces between the public and private sector. It may even be advantageous, in some sense we might not like to admit, to have an authoritarian regime that can enforce and obligate its population to behave and consume in certain ways. There is still no national or consistent charging network for EVs across the US, the UK or Europe. When you think about what the blockages and obstacles to this are, they often have to do with the coordination between different firms across the supply chain, between the financial and the industrial sectors, and between government and society. A more robust public sector with real enforcement capacity could help alleviate some of those coordination dilemmas.

EDITOR: What is to be done?

RIOFRANCOS: We should ask: who are the people most intimately involved in the energy transition? The US recently experienced one of its largest strikes in the past decade, led by a very militant United Auto Workers. Their argument was not to stop electrification, or to cling to the traditional gasoline-powered automobile industry – they

wanted to embrace electrification, but wanted to ensure workers benefited from dignified jobs, ones that revitalized communities left behind by deindustrialization. They had a powerful message, and their tactics worked well. They reversed decisions the auto companies had made to reduce union presence at battery plants.

On the other end of the supply chain, we've seen frontline resistance to mining projects that, in many cases, shouldn't be allowed to go forward as designed, whether that's because they would be environmentally destructive or because they would disturb long-standing cultural connections to the land. We need to look, too, to other centers that are not traditionally included in the discussion of the green transition. What's happening with transit systems and urban planning? Where are the communities pushing for alternatives, organizing fare-free electric buses, bike lanes and safer streetscapes? We see such initiatives, with varying levels of success, popping up across Europe, the UK and the US, from efforts to dramatically reduce car use in cities like Paris or Barcelona, to the huge popularity of flat-rate monthly rail passes in Germany, to people organizing against the 'death spiral' affecting transit systems across US metro regions.

Essentially, we have to imagine what a coalition of organized constituencies of workers and communities looks like. This means looking at the concrete contexts of supply chains from end to end, from mines to factories, recycling plants to transit hubs. For me, this is what being a materialist means. Staying close to the ground, detecting emergent phenomena before their full efflorescence, imagining political possibilities that fulfill social needs while harmonizing nature and economy. ■

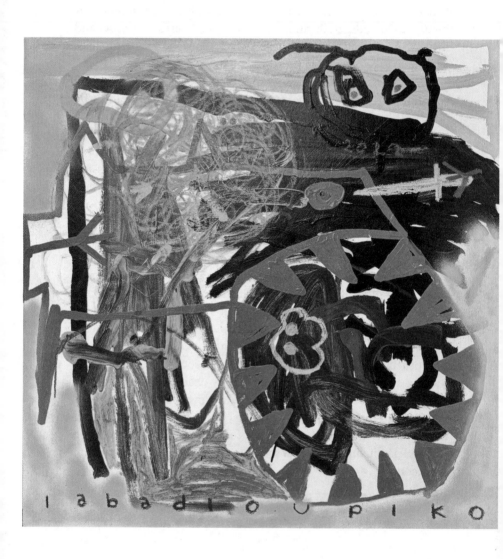

IABADIOU PIKO
Blue Predator, 2022
Courtesy of D Gallerie

MONKEY ARMY

Eka Kurniawan

TRANSLATED FROM THE INDONESIAN BY ANNIE TUCKER

He'd called the office and asked how he was supposed to rid the excavation site of monkeys. 'For good,' they'd said. The instruction was curt and final: 'You know how to do it.'

Darmin opened the supply closet, took out an air rifle, pumped it, loaded the bullets, tiptoed to the window, cracked it open, and peered out from behind the curtain. There were a few monkeys in the yard. Macaques. Two of them were fighting over a plastic bag, the others just milled around. He looked for the biggest and found it sitting near the bushes, watching over his troop. Darmin got in position. He could hear himself breathing. He aimed at the monkey's chest, but at the last moment raised the rifle just a hair or two above the monkey's head.

The shot rang out. He saw the big monkey startle and run, heard hoots and screams as the troop fled into the thicket, reaching for twigs and clambering up branches.

He went out of the house, still carrying the rifle. The monkeys were gone from the yard now. They'd been a problem for weeks. A rifle shot could scare them away, but they always came back. It was annoying, but it was his job.

He stood watch in the yard in case the creatures returned. He could still occasionally hear their shrieks, but there was no other sign of them.

The residential units for the workers consisted of a few bunkhouses each. They stood in a row looking out on a small yard, which also functioned as a dirt road, and a ridge beyond that. Three bachelors lived in the house on the right, but they'd all gone out that morning to inspect a line-up of excavators. The house on the left had been for the company doctor, a middle-aged man who'd arrived with his wife and small daughter. But the child couldn't bear the monkeys and so they'd moved back to the city. Now the doctor came and went every day, about an hour's drive. Darmin lived alone. A kid fresh out of college had been rooming with him, but when the monkeys arrived, he'd gone back home without a word.

The monkeys here were mercilessly stupid. Their brains had been braised by the sun. They had watched the huts being built along the slope of the hill, hundreds of workers arriving with their trucks and heavy machinery. When the trucks roared and whined, they should have known to withdraw further into the jungle. Instead, they came in gangs, baring their teeth in wide grins. They thought the humans would be threatened. Darmin lifted his rifle and shot into the air, and they scattered.

But the animals were too stupid to stay away. They came back again. People had started digging up the earth and, slowly but surely, the hills had been flattened and new valleys had been created. For months now the revving of engines had replaced the rushing of wind and the splashing of water, and bright work lights glared all night long.

The monkeys were disturbed, and it seemed as though they had to disturb the humans in return. It had reached new heights a few weeks ago: a child in the Unit XII settlement had fought with a monkey over a bag of peanuts until another monkey came and the pair attacked him. The child suffered bites on his cheek and arm. The company sent the kid to the hospital. There were no signs of rabies, but the incident had aggravated the workers who lived in the bunkhouses. As time passed, the monkeys kept growing bolder. Then a foreman was riding his motorcycle when a monkey suddenly attacked from

above, leaping down onto him from a branch. The bite wasn't bad, but the man lost control of the bike, was thrown into a ditch, and broke his arm. A truck driver sleeping in his cabin was attacked too. Deep scratches across his face left him scarred, and partially blind from a ruptured eyeball.

That was when they called the forest police and filed a report with the local military headquarters. Neither the police nor the military took them seriously. Instead they said, 'You guys can take care of this monkey business yourselves.'

More than twenty years ago, Darmin had lived in a settlement on the edge of a teak forest that belonged to the government. He didn't do much back then. He would cut down teak in secret and sell the poached timber to a middleman. If the forest police caught him, he would have to split the profits – later he also shared them with a soldier from the military office. He lived alone. Five years earlier, his wife had died giving birth to their child, who didn't survive either.

One day there was a commotion. People were angry with the old witch doctor. He knew the guy lived in the neighboring forest. Villagers with strange ailments would go visit him, as would folks wanting other kinds of things – to have a child, to make someone suffer. Darmin had never really thought about him one way or another until that day, when the extent of his crimes was revealed.

The witch doctor didn't just heal all kinds of illness. He also used magic, and many had died at his hand – at least, that's what people believed. He was long rumored to be lecherous, but when word got out that he'd robbed a local girl of her virtue, the people's anger erupted. A throng had gathered outside his house, armed with machetes and spears, but no one dared actually go inside and grab him.

Darmin heard all this. He knew the girl they were talking about. He would often pass her in the mornings, when she was on her way to school, and she would always greet him, 'Good morning, Uncle.' He was in fact no relation to her, but her warmth always made him

imagine what his child might have been like if she'd lived. The thought of the witch doctor taking her honor made his chest feel hot. Without saying much, he charged toward the man's house.

There he saw faces full of rage, which he recognized, and fear, which disgusted him. Were they afraid of the man's power? That's bullshit, he thought. He didn't believe in magic or witchcraft. He grabbed a machete out of someone's hand, kicked down the door and strode into the house.

Once inside he saw the man right there, peering out through a crack in the window. His wife was huddled over, crying into her hands. The witch doctor turned in surprise. When he met Darmin's gaze, his eyes were pleading.

Darmin walked toward him, the machete raised high in his clenched fist. The witch doctor cupped his hands together at his chest, begging for mercy, but Darmin didn't feel compelled to show any. His fist flew down. A powerful swing from a hand accustomed to wielding an axe that chopped down teak trees. The blade struck the witch doctor's neck. Blood gushed. His head sagged. When she realized what was happening, the wife let out a piercing scream. With one more slash the witch doctor's head was severed from its body. Darmin carried the head out into the yard by its hair, then threw it to the ground.

The police arrested Darmin. For weeks, in jail, he kept asking himself: What have I done? Why did I kill him? Where did I get the nerve? He shuddered to remember it. Someone from the local military office came to visit him, to comfort him. The soldier said the villagers had finally mustered up some courage. They had slit the throats of a dozen other witch doctors. He didn't know exactly how many, but people were talking about it. He was surprised there were that many in the village.

'The newspapers will all write about it for a few months, but those guys will still be dead,' the soldier said. 'And they deserve to be dead.' The judge sentenced him to seven years, but he was only in jail for three months and a few days. One day the warden brought him to the

exit door and whispered, 'You can go.' Darmin returned to his house and the villagers treated him with great respect. He didn't need to steal teak anymore, the villagers did it for him. Logs piled up behind his house. A middleman came with a guarded truck and hauled the timber away. For years, until the villagers' respect wore thin, he didn't need to do a thing.

The next day a monkey came to the mining site and bit an excavator operator, leaving a gaping wound in his neck. The doctor had to transport him to the hospital, praying he didn't die on the way.

'What a bother,' Darmin thought. He'd started to miss those boring days when he hadn't had to do anything.

Now he was responsible for worksite safety. The company did get some help from the army and the local youth organizations, but he was the one who had to travel from the bunkhouses into the teak forests every day, ensuring everything was all right. Sometimes an environmental group came on behalf of the river, which was badly polluted, or the hill that had been blasted away and collapsed, or most often on behalf of the people, who were poor. There might be some commotion then, but – though it wasn't easy – you could still talk it out, you could still reason with them. And if words didn't work, money usually did.

Unfortunately, you can't reason with a monkey.

'You have to kill at least one of them,' said Agus Maulana, a fellow worker who was always neatly dressed. 'And that'll be a sign to the others.'

'No,' said Darmin. 'We just need to keep chasing them all away.'

It still bothered him, the thought of how he'd killed that witch doctor. He didn't understand how he could have done it. When he was in prison he'd vowed he would never hurt anyone again, and not just another human being. He'd told the people in the office too – he was willing to stand guard, but he wasn't going to kill the monkeys.

He'd handed out some air rifles, just in case, but warned the

workers not to shoot at the animals. They should only shoot into the sky. That way the monkeys would be scared away, and no one would get shot accidentally. But the incident with the excavator operator had proved that at least one of the monkeys was no longer afraid of the sound.

Darmin finally went into the forest. Agus Maulana went with him.

'I still say it would be good to kill just one, before they kill one of us.'

'There's no way a monkey could kill a human,' Darmin said. 'Anyway, we'll wind up on the news if we start killing monkeys.'

'No we won't,' laughed Agus Maulana. 'No one would know.'

'Aren't the monkeys protected? I've never seen monkeys like this in my village.'

'What the hell does it matter, brother!' said Agus Maulana. 'In this country, people are so easily killed – hundreds of thousands of people have been shot to death, maybe more. What's so bad about killing a few monkeys?'

Darmin still didn't believe the problem could be solved that way. Humans had choices. They could choose to dig up the land, raze the forest, send their filth into the rivers and the oceans. It didn't matter why. For progress. For the millions of stomachs that had to be filled up with food. They could also choose to leave nature as it was. Monkeys didn't have a choice. They lived where they lived.

Darmin had always been able to scatter the monkeys. They would hear his warning shot, get scared, scream, and run away. But they wouldn't disappear forever. They would change their routine temporarily, be gone for a day or two, then suddenly reappear to attack another worker.

There was one hillside still filled with towering trees. Over its peak was another bare expanse, primed for excavation. So it was likely the monkeys were there, on that hillside.

Behind his glasses, Agus Maulana's eyes scanned the foliage. He turned to one side and then another. Darmin thought the youth wasn't really suited for life in the jungle, nor a bunkhouse, nor an

excavation site. His slight build was made for walking down a city sidewalk, carrying a briefcase. Even so, Agus Maulana seemed to enjoy the opportunity for adventure.

'There's a group of them, brother,' Agus Maulana called out.

Darmin had seen them too. They were clustered in a tree, filling its branches, staring back at them. Sensing a threat, they were starting to shriek and grin, displaying sharp canines. Darmin lifted his rifle and shot up into the air. The monkeys were startled, and as they started to move, the tree began swaying violently. They jumped to the branches of another tree, which started to rustle and shake as they landed, then settled in a third.

Darmin chased after the monkeys, again aiming his rifle up at the empty air. He pulled the trigger, a shot rang out. The monkeys again went swinging and leaping farther away. Their chaotic screams were answered with more, from somewhere in the distance.

Darmin chased the monkeys as far away as he could. In between the excavation sites, there was a kind of corridor of trees that stretched out far as the eye could see. Darmin wondered if they could lead the monkeys all the way down that corridor, chase them back to a part of the jungle that remained untouched.

There was another thing Darmin regretted: punching an old man in the face – a really old guy, in his eighties. He did what people told him to do. He was a machine.

The old man had been the last holdout. He'd refused to sell his fields, which were right in the middle of where the reservoir was supposed to be. They were building a dam. They'd tried all the different ways to convince him to go, including offering him twice as much money than the other landowners had gotten. He didn't care about the money.

Someone high up in the company had thrown up his hands and suggested the man should simply be killed. Darmin wasn't sure why they thought he should be the one to do it. When they asked him about it, Darmin cursed them. No, he would never kill anyone ever

again. They didn't try to force him, especially not after the man was interviewed on television. They just ordered Darmin to find some other way to take care of it. Frustrated, and out of ideas, Darmin had finally walked up to the old guy and punched him in the face.

Word was his jaw was fractured. Darmin was embarrassed – not of what he'd done, but that it didn't even solve the problem. For a few days they'd been targeted by the media. Twice Darmin had to go to the police station.

Agus Maulana came to help. He tracked the old man down after he was discharged from the hospital, and he brought a kyai with him. The kyai spoke to the old man.

'What did he say?' Darmin asked, weeks after the fields had been surrendered and submerged.

Agus Maulana chuckled. 'The kyai said this life is nothing but a game. A diversion. Eternal life comes in the hereafter, so why get so caught up in the concerns of this mortal world?'

After that they had often worked together, at different places. A few years ago, the man who got him out of prison had connected them with the company. They dug coal mines in two districts, and nickel at the last place. Moving from project to project he had seen men paving wide roads, building long bridges that connected two islands, constructing underground trains, ports, airfields. He might never have seen any of it if he'd kept leading his old life at the edge of the teak forest.

'Fuck!' It was the first time Darmin had ever heard Agus Maulana swear.

'Fucking dog! Devil! Bastard!'

Wati, a young woman from the office in the city, had come to the mine for the monthly audit. She'd spent the night in a bunkhouse with two coworkers and that was her last night on this earth. The monkeys had attacked as they slept. The three women were set upon by dozens of them. Two suffered scratches and bites, but Wati ran out of the house screaming. The monkeys chased her. They caught her,

scratched and bit. They clung to her arms and her clothes. As the girl was running, staggering and swaying, one monkey clambered up onto her face and grabbed a fistful of her hair. She slipped and went sliding down a steep slope. She fell forward and her stomach was impaled on a sharp rock.

Agus Maulana had been fond of her. Apparently the feeling was mutual. Darmin had seen them eating in the work canteen together, gazing into each other's eyes. Secretly he'd hoped that the two would be happy together. He understood why the young man was swearing. He understood when Agus Maulana snatched up a rifle and rushed toward the forest. Darmin took his own rifle, and his bullets, and hurried after.

Darmin heard Agus Maulana's shots. When he approached, the youth was shooting blindly into the trees. There was a troop of monkeys in the branches and they scattered in a cacophony of shouts. Darmin realized the young man was a terrible shot. Not even one bullet had landed.

'I'll kill you all! You dogs, you pigs, you fucks!'

The young man didn't look at Darmin, just kept pacing. Every time he saw the foliage move, he would lift his rifle and shoot. Sometimes it was just a squirrel, or a bird. He didn't care. If he saw a monkey, his eyes would flash and he'd start shooting wildly again. Again and again. But not even one bullet met its mark. The young man threw himself down into the grass and sobbed.

'You're useless, brother,' he murmured through his sobs. 'You hold a rifle, and you can shoot, but you don't even have the guts to kill a monkey.'

The next morning, as Wati's corpse was being loaded into the car that would take it back to the city, Darmin went out on his motorcycle, a rifle at his back. He rode slowly, away from the main road, following a small footpath into the forest.

'You're useless, brother.'

The words seemed to echo through the forest, bouncing off the

cliff walls and reflecting off the surface of every leaf. He stopped riding only when the path came to a sudden end. He dismounted and left the motorbike lying there in the grass. He continued on foot, pushing through the brush. He could faintly hear monkeys yelling and chattering. He walked toward the sounds.

Soon he saw them. Did it really have to be this way? Did they really have to die for some lumpy mounds of dirt that had been dredged up from the bowels of the earth?

'You're useless.' Again the words echoed. 'You don't even have the guts to kill a monkey, brother.'

He watched the monkey troop closely. He took note of the biggest, who was also the slowest. The animals seemed to become aware of his presence. They started yelling louder, screaming, baring their teeth. Darmin raised his rifle. He pointed it at the big monkey, which he took for the alpha, their chief. He aimed for the head.

'Shoot, brother!'

He heard himself exhale, then retrained his eyes on the biggest monkey and realized: the monkey was pregnant. They looked at each other. The monkey scratched its stomach, as if to make sure the little monkey inside its body was all right. Darmin's finger began to tremble.

His vision blurred. The monkey let out a strangled cry and went flying. Darmin could hear its body crashing down through the thicket, landing on the dirt with a thump. Seeing the dead body, its head exploded, the other monkeys took flight in earnest. Their screams were no longer threats, but were filled now with powerlessness and fear.

Darmin turned, his rifle still raised, and followed them, shivering. The whole time he saw nothing. His entire body had gone cold except his head, which was smoldering.

That day Darmin killed nineteen monkeys and strung them all up from the branches.

But that didn't keep the monkeys away. At night, they came to the

bunkhouses, and kept everyone awake with their screams. A few of them pissed on the shutters. Their numbers seemed to grow.

Darmin killed more of them. A dozen. This time he skinned them and strung their corpses up by their ankles.

The next day a worker who forgot to lock his window was attacked by a pair of them in the middle of the night. His face was badly gouged out, and one of his ears ripped clean off.

Darmin shot twenty-three more monkeys. He chopped off their heads, then impaled each on the tip of a spear. Then he lined the spears up along the edge of the forest.

The monkey army kept coming.

After a while Darmin stopped counting. Every week the company delivered more bullets with the provisions.

A month or two later Agus Maulana came out of mourning. He asked Darmin, 'Brother, is all this really necessary?'

'It's annoying, brother,' Darmin told him. 'But it's my job.' ∎

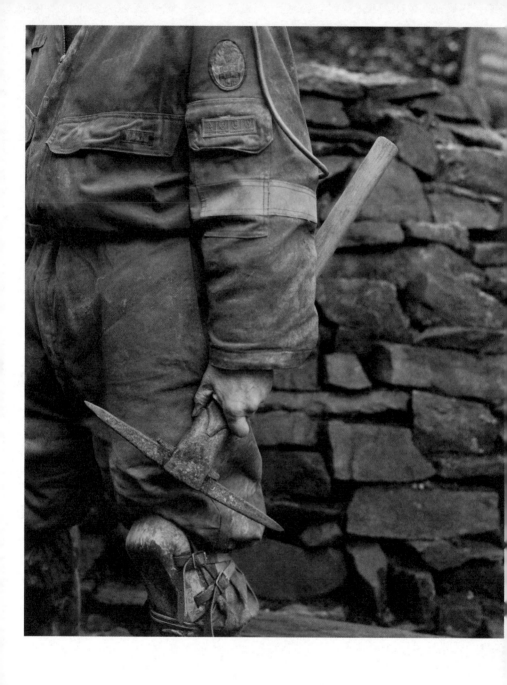

THE LAST FREEMINERS
OF ENGLAND

William Atkins

Photography by Tereza Červeňová

I *'ll tell you a true story now.*
I was just outside the house one day, I was throwing a ball up against the edge of the mill house. I'd say it could have been about the end of the war, about '45, '46. I might have been around five or six, I reckon. I was throwing the ball, and I looked round and there was a car coming up the old track. It pulled in by the garden wall. Two men got out of this black car and they armed our dad out of the back seat. He was on afternoons, and this would have been about teatime, about five o'clock. And them two chaps brought him home and armed him round – it was a nice day – and let him sit on the front doorstep. And they said, 'Cheerio, Harry,' and off they went.

Our dad was laid on our couch all night. He was paralysed. Now this is where the story starts.

He had gone to work, and as soon as he had knelt down and started to work, a big stone come down – wallop – massive stone, from near the top. And he was under that stone. One of the men he was working with said, 'Looks like we better get some help,' and the other man said, 'Don't rush, 'im've bloody had it.' But he did go and get some help, and the other man sat on this big rock with a roll-up fag, and all of a sudden he heard somebody say, 'I be'n't bloody dead! I be still here!'

(Gordon Brooks, retired collier, Northern United Colliery, Forest of Dean)

T hat night I saw it softly blazing out of the darkness: *nothing.*
The aperture contracts: five feet by five, four feet by four,
three by three, all fours, head down, iron rails under your hands.
Phil is pushing a cart containing three lengths of old telegraph pole
for roof supports: each is about three feet long – two posts and a
'cap'. The eternal drip of water, like something inside your brain. A
whiff of hydrocarbons – winch grease, chainsaw oil, oxidising coal.
Newcomers are told not to look up, just as novice rock climbers
are told don't look down. Up you look: a roof of jumbled planks,
offcuts and wedges packed between pairs of supports, above which
are maybe 10,000 tonnes of sandstone, shale and clay. The forces at
work upon the level do not only bear downwards. The Coleford High
Delf, which is the coal seam being worked here, is prone to 'heave',
the clay floor surging up to squash a working out of existence. Leave
your mattock at the coalface and you might come back tomorrow to
find it half swallowed. Nature, which it seems doesn't want a mine
to exist, is constrained only by the care of those who work here and
their desire to make it home for dinner. After twenty minutes, we've
crawled about 170 yards. Your neck goes, your back goes; you feel it,
weirdly, in your flanks. You are, in a particular sense, debased. Then
a spectral paleness, as if daylight is somehow percolating through
the vast overburden: what the Old Men called 'nothing', *Fibroporia
vaillantii*, a fungus that coats rotten timbers in cobwebby white wefts
of mycelia.

Touch it and – *puff* – gone – nothing.

Finally real light, and you realise how hungry you have been
for it – for light other than that projected by your own headlamp.
Here, on his knees at the end of the tunnel, is Mike Howell. 'He's
riddled with arthritis,' his son had told me, 'but put him underground
and he's a completely different person.' Mike and his friend Phil
Schwarz have been working side by side since about 1975, mostly
here at Wallsend, a former colliery in a valley on the south-western
edge of the Forest of Dean. They are both seventy-four and had long
careers in engineering. For the past six years, they've been working

to reopen part of a level that was originally established in the 1860s. This involves shoring up the roof and walls and clearing many tonnes of spoil. Finds in the mine: one nineteenth-century oil lamp, one clay pipe, one tallow-dip candle, '1898' painted on a section of roof. Losses: one £3,000 watch, innumerable tools, various intangibles. According to the old mine surveyor's plan, the level is likely to lead, eventually, to a large area of unmined coal. 'We've brushed past some coal that was left,' says Mike, 'and it's some seriously thick coal. Black from top to bottom. Black, glassy coal.'

He's using a long crowbar to lever a half-tonne boulder of sandstone from a sloping blockage of rubble and clay. This is how far they have got after six years of on–off digging: 200 yards, equivalent to tunnelling under the length of a football pitch and most of the way back, much of it through collapsed workings, putting in a timber support, or 'setting', every foot where the roof is particularly bad. 'Mining the Coleford High Delf is a game of patience. If you're nosy and you poke your nose out, something is going to fall on it. If we can make a metre a week, we're lucky.'

However closely you have consulted the old surveyor's plans, however pointed your instincts, you can never be certain that a panel of coal marked as intact will be there when you break through. The Old Men were not reliable record keepers, especially when a royalty was payable to the Crown on every tonne. Mike and Phil's objective is still 120 yards away. They'll both be into their eighties by the time they reach it, at the present rate. But you never know. Maybe we'll break through this fall and the level ahead will be as clear as the day it was dug.

The fields around Gloucester were flooded, field after field, but the sky was a pure, arid blue, and when I reached the Forest, steam was being driven from the roadside trees by the winter sun. It is in the nature of forest to hide the contours of the land from which it rises, even in leafless winter, but sometimes a surprise vista would open up as the road mounted the brow of a hill, and for a few seconds

you were looking across a valley to a conifer-toothed ridge a mile or more away, and at those moments, the Forest of Dean – which at its widest is ten miles from edge to edge – felt as boundless as the Siberian taiga. A Forester could be forgiven for having an inflated sense of its significance.

On the car radio they were talking about COP28, the UN climate conference in Dubai. The agenda was partly devoted to coal. Accounting for about 40 per cent of fossil-fuel emissions, coal has been responsible for over a third of the average global temperature increase since the Industrial Revolution. The showpiece announcement, on what was called 'Energy Day', came from the United States: along with nine other new member states, it would be joining a UK–Canadian initiative called the Powering Past Coal Alliance, whose signatories commit to phasing out coal-fired power stations by 2035. Britain's only such facility, in Ratcliffe-on-Soar, Nottinghamshire, is set to close this year, but as of December 2023 coal mining continued commercially at six UK sites, and planning approval has been granted for a seventh in Whitehaven, Cumbria. Since 2020, revised air-quality regulations have banned the sale of coal as a household fuel in Britain.

The Forest of Dean lies cornered-in by the rivers Severn and Wye on the far western edge of Gloucestershire, not far from the Welsh border. Historically, it was forest in both senses: an unenclosed hunting ground for the 'princely delight and pleasure' of the king; and forest as we know it, a place dominated by trees – oak, beech, ash, birch, holly. The oaks, broad and straight and strong, were so valuable to the Royal Navy that, according to the diarist John Evelyn, the commander of the Spanish Armada was ordered to raze the Forest upon making landfall. Its residents have always enjoyed certain common rights over it: to gather timber, to graze sheep, to quarry stone, and to mine iron, ochre and coal. *The Lawes and Privileges of the Freeminers* were first written down in 1610, having been granted, so tradition has it, by Edward III, in gratitude to the Forest miners who'd aided him in sacking Berwick by undermining the town's

walls. Subject to a royalty payable to the king, and the approval of the Crown, a freeminer was entitled to mine whatever ground he wished, except for orchards or graveyards, within an area roughly coterminous with the Forest. Since 1838, when it was decided that the customary rights should be codified in law, freemining has been governed by the Dean Forest (Mines) Act.

Under a unique exemption from the Air Quality Regulations, about thirty miners continue to work half a dozen Forest freemines, ad hoc and mostly at weekends, selling coal to anyone who drives up. In its localism, the practice preserves something of the pattern of coal use before industrialisation, when it was a peasant fuel, considered inferior to wood, and rarely burned in hearths more than a mile or two from where it was dug. Today you might come upon a freemine, hidden in a woodland valley, while walking. The surface infrastructure has a shanty-like, squatted feel, suggesting an outlaw hideout. It wouldn't be surprising if you returned the next day and found nothing but a scattering of coal grit and a pair of iron tracks leading down into the black mouth of the 'dipple', as the sloping mine entrance is known. Each freemine has its 'bread hut', enclosed or partly enclosed, with a kettle and a stove and hooks for drying overalls and gloves. There's a lot of corrugated iron and tarpaulin. White plastic lawn chairs are scattered about. It is a principle of freemining that you leave nothing of value on site, nothing other than the mine itself, which is of value only to a freeminer, and not always to him. Water runs downhill, warm air rises, and anything that can be sold will be purloined. *Bangernomics*, another principle: never spend more than 500 quid on a car and you'll never lose money. Everything is jerry-rigged, strapped, taped, patched, rewelded. A steel oil tank repurposed as a secure store. A radiator forming one wall of a coal bay. Chopped-up telegraph poles as pit props. A sleeve of tarp bungied round the mouth of a duct to channel the graded coal into its bay.

The freeminer, at least within living memory, has been a scavenger, rummaging about in the leftovers of the Old Men – not

only earlier freeminers, but colliers in the Forest's large nationalised mines – never going very deep, but scratching and scraping and pecking away at what was missed or not deemed worth getting. These are the words – *scratching, scraping, pecking, nibbling* – the freeminers themselves use with a sort of ornery pride. One of them told me that, when he was a boy, his family was so poor they had to glean potatoes from a neighbour's field. He didn't mean it as a metaphor, but it describes what the freeminer does. His inheritance is a chest that is empty – his forefathers were handed down the same empty chest, and it was their job to show it was not empty. A gleaned potato bakes as nicely as a harvested one. Work is work.

The modern 'statutory' Forest, still owned by the Crown, covers thirty-six square miles. Of more concern to freeminers is the ancient administrative district in which the Forest lies, known as the Hundred of St Briavels, which is more than twice as big. 'The Hundred is really the Forest of Dean that people think of in their heart,' one freeminer told me. In 2024, certain qualifications, specified in the Act of 1838, must still be met by anyone who means to register as a freeminer. He – he – must be at least twenty-one years old and born and dwelling in the Hundred; and he must have mined in the Hundred for a year and a day. For all other purposes, the Hundred of St Briavels is as redundant as a wapentake or a bailiwick. Anyone is entitled to work in a freemine, registered or not, and anyone can sell or buy a 'gale' – a licensed underground holding – but only a *registered* freeminer is entitled to claim a new or inactive gale from the Deputy Gaveller, the Forestry Commission official who regulates the practice.

In 2008, Elaine Morman, who had well over 366 days' experience mining artists' ochre (iron oxide) in caves on the edge of the Forest, applied to be registered as a freeminer. 'The principal obstacle to your application is that of gender,' the Deputy Gaveller confirmed. It was brought to Morman's attention, however, that any act passed before 1975 was nullified by the Employment Act of 1989 if it barred

a woman from membership of an organisation that could 'facilitate' employment in a particular profession. She reapplied, and the Forestry Commissioners directed the Deputy Gaveller to register her. The other 4,370 freeminers registered since 1838 have been male.

During the Upper Carboniferous, 327 to 299 million years ago, the whole area was swamp. Water coming and going over 60 million years. Tree ferns, seed ferns, clubmosses, horsetails, rising from the morass, dying, slumping back into the anaerobic depths. Out of this ooze, peat formed; out of that peat, under tremendous pressure over millions of years, the coal measures. Everything – its mineral wealth, its appearance, its wetness especially – begins to make sense when you know that the Forest of Dean lies in what is known by geologists as a synclinal basin, a kink in the earth's surface. Picture a set of bowls, dozens of them nested snugly one inside the other, from largest to smallest. This is the Forest of Dean basin. Most of the bowls are made of sandstone, limestone or clay, or a mixture, but some of the larger, outer ones are iron, and some of the smaller, inner ones are coal. On the edge of the statutory Forest you find the old, long-redundant iron mines; within the perimeter, the coal mines.

The names of the Forest of Dean's coal seams are as deeply embedded in local memory as the names of towns and villages: the Woorgreens Upper, the Woorgreens Lower, the Twenty, the Rockey, the Breadless, the Brazilly, No-Coal (*No-Coal!*), the Yorkley, and, most lucrative, the Coleford High Delf, which can be as much as twenty feet thick. What is unusual about the Forest's coal seams is that they extend right to the surface (the bowls' lips), meaning they can be drift-mined, that is, accessed via a short sloping adit, your dipple, from a valley side. This is one of the things that made small-scale mining possible here, since a dipple is cheaper and easier to dig and operate than a vertical shaft. The base of the Coleford High Delf, for example, 230 yards down, could only be reached by shaft – a hole bored through our bowls. Because it lies well below the water table, it had to be subjected to constant pumping to remain workable.

But the deeper you go, the thicker the seam. In 1904, forty-one of the deeper gales were amalgamated into five commercial collieries: Waterloo, Northern United, Cannop, Eastern United and Princess Royal. Employing thousands of men, these collieries went far deeper than any solitary freemine, and in 1947 were nationalised along with every other pit in Britain – every pit, that is, except for the remaining freemines. At the time, 508 men were employed at Northern United Colliery alone, pulling out 90,000 tonnes of coal per year. Just eighteen years later, all the big collieries were economically exhausted. However much coal still lay beneath the Forest (millions of tonnes), pumping water from the deeper levels was no longer cost-effective: at Cannop, one of the largest collieries, it was said that 100 tonnes of water had to be extracted for every tonne of coal. When the last colliery closed and pumping stopped in 1965, the entire Forest basin began to refill, level by level, and many of the deeper mines were flooded forever.

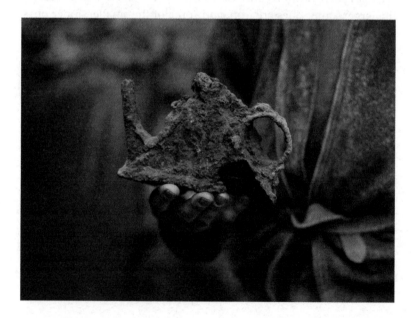

Foresters have never been unworldly, even if they sometimes play at unworldliness. ('They like to act thick,' I was told, 'so they have a reputation for being stupid. Because it suits them.') There is a feeling, not unfounded, that the rest of the county – especially the Cotswolds, with its tourist honeypots and second homes – views the Forest with disgust and, yes, fear. But any place has its own beaten tracks, and anywhere that has supplied millions of tonnes of coal to industry and electricity generation is no backwater. The Severn and the Wye might serve to sever the region from England proper, but any river is a road as much as it is a moat. It was via the Severn that most of those tonnes were conveyed away to the wider world.

Few of the freeminers I met were of families whose roots in the Forest went deeper than a generation or two: someone – a grandad, a great-grandmother – had come from elsewhere. Was, in other words, a 'foreigner'. What is true is that the *practice* of freemining, irrespective of the miner's credentials, seems to go with a certain unease with authority, a certain attachment to independence, and a certain disregard for material wealth. It also, in 2024, attracts those with a reverence for the Old Men, the miners of the past, who being for the most part dead have become as mythical as satyrs.

What is freedom? Not to be bullied. This is what I was told by the man who'd gleaned potatoes as a boy. He didn't believe freemining needed 'publicity'; he didn't want to see his name in print, thanks. He was a former rugby player and his mind and body appeared poised in a shaky equilibrium – it was hard to know which would strike first. There were stories of righteous violence. He was what people called a 'real Forest character', but he wasn't a performer. He was, more or less, whom he seemed to be: someone who had been battered by life and had battered it back, who'd worked seven days a week for years, had made some errors, and might have ended up in a prison cell had he been less fond of being underground. As a young man he had often played against the prison side at rugby, and had observed that they did not tend to play away fixtures. He was respected and feared in equal measure and often by the same people, had many friends

and some enemies, and after fifty-odd years had earned enough independence to make a going concern of freemining. He'd had two housekeepers, he said, and they both kept the house. 'You know what happens Friday? Friday is favourite tea. Don't want to miss my favourite tea.' In other words, don't get killed, install a support when one's needed.

We'd been talking for an hour when he said, 'It's over.' Not our conversation: Nature. The River Wye, for instance, where he used to fish, has been destroyed by the phosphates from chicken factories. Once, its salmon were so populous they were paupers' food, a greyish meat sold to HMP Gloucester. What was also over was the old Forest life – the life that was ending when he was a teenager. Did you know, for example, that there was a proposal by newcomers to plant street lamps the length of the main road through the Forest? Stock fencing along either verge to keep the wild boar from bloodying your Land Cruiser!

But freemining, freemining was not over.

If some freeminers' guardedness shades into xenophobia, it may be because they have found they have reason to distrust foreigners, a 'foreigner' being anyone from outside the Hundred of St Briavels. 'No Stranger of what degree soever hee bee,' read the *Lawes and Privileges*, 'shall come within the Mine to see and knowe ye privities of our Sou'aigne Lord the King in his said Mine.' Tradition has it that in 1777 the mine-law court, which for centuries regulated mining's customary rights, was disbanded after its records were stolen by foreigners or their collaborators, making its work impossible. The consequence, according to a petition submitted by the freeminers to a commission of inquiry in 1832, was 'that foreigners, who had originally no right to enter the mines, have gradually possessed themselves of property therein, and again sold the same to other foreigners, to the exclusion of the freeminers themselves'. It was not only the freeminers' trade that the 1838 Act secured: its protections extended to outsiders who had bought gales from freeminers,

ushering in a new era of deep mines. As the historian Chris Fisher has written, 'By embodying a version of the rights in a statute, the Crown overrode their basis in custom . . . Title in coal was dislodged from the community of freeminers and made a marketable commodity.'

Freemining has continued to face sporadic attacks. After the threat of nationalisation in 1947, it seems like a legion of foreigners lined up to put an end to the practice, by design or accident: a proposal to dump nuclear waste in abandoned pits; a proposal to privatise Forestry Commission land (two proposals, in fact); most recently a proposal to frack for shale gas . . . In each case, as a result of campaigning, lobbying and litigating, freeminers emerged with their rights intact. The legacy of Nonconformism here is persistent: the Forest belongs to the Foresters, and freeminers have often been its most vigorous guardians.

For the purposes of the Air Quality Regulations 2020, coal from freemines was, uniquely, deemed 'exempt coal', meaning it could still be sold. It is, nevertheless, understood that the stuff is regarded as wicked by many people, and freeminers take that personally. There is a widely held fear of Extinction Rebellion. The Forest's annual coal yield – 375 tonnes last year, according to Coal Authority returns – is not nothing, but it is barely a smut on the cheek of the new mine planned for Cumbria, which is expected to produce 2.8 million tonnes of coking coal per year for the global steel industry. The main burners of coal – India, which has almost doubled its use in the past year; and China, which is building two coal-fired power stations every week – will not be joining the Powering Past Coal Alliance. 'It's all relative,' I was told. 'What we're doing is incalculably small. Don't worry about *us.*'

Smoke rises, leaves fall, the Forest's reigning dimension is vertical. As distinctive as the seam names are those of the mines: Go On and Prosper, Long Looked-For, Strip-and-at-it, Never Fear, Stay and Drink, Favourite, Fancy, New Fancy, Small Profit, Work or Hang . . . This freemine is called Hopewell. From a flue welded to the wall of a

rusting van-body, smoke blooms into a grey sky. This is how you know someone's in. Access to the bread shed is via an adjoining shack, the winch-house-cum-sawmill. Chalked on the side of the winch are the words QUEEN DIED YESTERDAY, denoting the date on which the cable was last changed. You grope through the oily dark towards a door. Here, in the light, is Rich Daniels, MBE, chairman of the Freeminers' Association. Two hoodies, one on top of the other; a bobble hat pulled over his ears; a long greying beard and questioning eyes.

In one corner is a heap of logs; next to the logs is a stove overflowing with ash; next to the stove are three buckets of small coal. Drying on the wall above, on a hanger, is a set of overalls rigid with cracked dried clay. A kettle sits on the stove, tannin-blackened mugs warming next to it.

There was, he believed, what could be called a 'Forest identity'. 'A lot of people express a quite independent view. "Rebellious" is probably a bit strong. But if something's going to happen to affect the Forest, you'd certainly get a reaction from most people who live here.'

Daniels wasn't born to freemining; his grandfathers were miners, but not, as it happens, in the Forest of Dean. Twenty-odd years ago he thought he'd missed his chance, but then one of the Old Men made some phone calls and he found himself early one morning, very early, at a freemine in the Bixslade Valley. 'I wouldn't say they make it hard for you. But they don't make it easy. It's hard enough anyway.'

First things first: never stand on the lower side of the cart in case it tips and crushes you; number two: don't go back into the *gob*, the area from which coal has been removed; three: don't stand on the inside of a cart cable as it rounds a corner – 'when the rope comes over, it's going to catch you, and then obviously that could be very, very serious – saw a leg off, pinch you against the side of the wall'.

To describe a mine, to describe the manoeuvres of mining, is to describe a series of lines intersecting in three dimensions. A miner, in his confinement, enjoys some of the liberties of flight. The critical angle in the Forest of Dean is 15 degrees, because that's how most of the seams lie (the sides of our nested bowls). In the case of a seam like

the Yorkley, which is maybe 2.5 feet from top to bottom, you might drive your dipple from the side of the valley, then dig two parallel levels from the dipple into the seam: a lower, larger 'roadway', big enough for a coal cart; and a higher tunnel, thirty yards away, for ventilation and as an escape in the event of a roof collapse. Joining them, you dig a third tunnel the height of your seam, like the rung of a ladder. You have established your face: a wall thirty yards long, 2.5 feet high, on a fifteen-degree slope. Lying on your side, with your feet maybe ten inches lower than your head, you use a thirteen-kilo pneumatic pick to eke out the coal, packing the gob with spoil as you progress, to keep the roof up.

'The Yorkley is a good coal,' said Daniels. 'Pretty volatile. It combusts easily, burns hot, reasonable ash content. Volatility, ash and sulphur content, those are the three important factors. The Yorkley runs to about thirty inches on average. Thirty-two is good, the lowest I've ever worked the Yorkley is down to about seventeen inches. It's pretty consistent. Sometimes it wibbles about a bit, but nothing too drastic.'

Outside, a hopper was emptying Yorkley coal onto the foot of a conveyor belt that carried it up to a stack of grading screens, which shook it into its bay: small coal, which is mostly grit and dust; peas, which are as big as a fingertip; rubble; then the largest, lump, which can be anything between a thumb and a fist, depending on the seam. Small coal burns OK, but, being messy and crackly, isn't wanted. It's what used to go to the power stations, where it would be ground to powder and blasted into the furnace; these days it's compressed into briquettes. What comes out of freemines like Hopewell tends to be crumbly and small. 'Sometimes when coal has been worked in a vicinity,' Daniels told me, 'the weight is thrown onto the remaining coal and causes it to crush.' A stack of a dozen spruce trunks lies by the mine entrance shorn of their branches. In pre-worked – or 'robbed-out' – gales a lot of time is spent trimming and installing roof supports. Any mine is in a constant state of collapse. It's not like a cave, which may evolve but has opened up over aeons. A mine is a relatively sudden intrusion – a knife puncture, in terms of geological

time. Which means the miner is constantly battling the mass on all sides waiting to reclaim the void.

E ach gale is outlined on the earth's surface by marker stones and on a map held by a person bearing the title Deputy Gaveller, who is employed by the Forestry Commission. (There is no 'gaveller in chief' any more, that role being invested in the Forestry Commissioners as a body.) The current Deputy Gaveller is Daniel Howell: sheriff, mediator, surveyor, regulator, museum custodian and registrar of freeminers.

'Since I've taken office in October 2011, I've registered three.' That's one every four years, among them a man who wished to be registered before he died, which he did a week later. 'He wanted his name in there – for posterity.' We were sitting in Howell's office in Coleford. His grandfather, Albert, was also Deputy Gaveller – Howell pointed out his neat cursive in the register of freeminers – and his father, Mike, is the owner of the gale at Wallsend. A shelf held dozens of scrolled gale plans sheaved in conservators' muslin. He showed me the plan for Wallsend, the sprawling gridwork of levels resembling so many city blocks. ('There's more tunnels down there than under Gaza,' was how Mike put it.) While Howell himself owns a gale, and has spent more than his 366 days underground, he can never call himself a freeminer. 'I fell short, or long, depending on how you look at it. I fell outside the Hundred line. I was born in Gloucester. That was because of, simply, complications with birth.' Mike was employed at the huge Rank Xerox plant in Mitcheldean, which was opened after the big collieries closed, before going to work in America for the firm's parent company. 'Basically he quit what he was doing so that they could come back to the UK to have me Forest-born. But it turned out it wasn't to be.'

If the future of the freeminer is doubtful, it is partly because of the stipulations of the 1838 Act. 'It's very black and white,' said Howell. 'It's going to be its undoing eventually.' Because hardly anyone qualifies. Paragraph XIV: 'All male persons born or hereafter to be

born and abiding within the said Hundred of Saint Briavels, of the age of twenty-one years and upwards, who shall have worked a year and a day in a coal or iron mine within the said Hundred of Saint Briavels . . .' Since the right to open a new gale can only be claimed by a registered freeminer, mining in the Forest is dependent for its perpetuation on new blood – and blood of a vanishingly rare strain.

The town of Mitcheldean and the village of Longhope, for example, separated by less than a mile, both lie within the Forest of Dean local government district, but while a man born in Mitcheldean can, if he wants, register as a freeminer, his cousin born in Longhope can't. There is no maternity unit in the Hundred's seventy-five square miles. Assuming a home-birth rate of 2.4 per cent, the national average, the number of male children born in the Hundred in any given year is likely to be close to nil. Of that tiny number, how many will still be 'abiding' in the Forest – and want to be a freeminer – by the time they are twenty-one? Who among that fraction will be committed enough to see through a year and a day of on-the-job training, assuming any gales are still open by then? Howell opened the Register of Freeminers at Elaine Morman's entry: 'By order of the Forestry Commissioners' had been scratched tersely alongside her name, by his predecessor. 'He purposely defaced the book to make the point that he didn't register her. If you speak to the purist freeminers they will still argue she's not a freeminer.'

The interpretation of the Act continues to divide freeminers. There are, broadly, two factions, which are increasingly unhappily opposed: those who believe in a loose interpretation of the Act, in the interests of broadening the pool of potential freeminers; and those who maintain that the word of the Act is unambiguous, that it must be honoured: that 'born and abiding within the Hundred of Saint Briavels' means just that, and 'male' means male.

'There's an old expression,' Howell said: ' "Freeminer against freeminer, and freeminers against all other men." ' I'd heard it before, recited with a sort of ironic portentousness, but the more fundamental fault line went deeper than factionalism. Every level, every roadway,

was dug on the same bearing: back in time. But then that had always been the way. What, after all, is the burning of coal but the recovery of ancient energies?

I met one of the surviving Old Men, Gordon Brooks, at his home on the edge of the Forest. He had worked at Northern United Colliery until it was closed in 1965. The fireplace was neatly lain, not for daily use but in case of power cuts, and lain not with lump coal from the Coleford High Delf or the Yorkley, but with Taybrite smokeless. Volatile, clean-burning, minimal ash.

'Our dad, he was a miner, and he and all his brothers worked at Cannop Colliery. I was born and bred down here' – he pointed down the street to the valley bottom – 'right opposite Waterloo Pit. The pit was my playground. And that's all I wanted to do, I suppose. It's just one of them things, you follow the family tradition.

'It took nine men to prise that stone up to pull him out,' he said, going back to his father's accident. 'Some reckon that stone was three to four tonne. Some reckon it were more like five to six tonne. He was under that stone, but they reckon there was a slight dip in it. There was a timber trolley on the rails just by him, and that big rock flattened that thing out.

'The ambulance come up and took him up to Gloucester City General. He had a fractured spine and pelvis. All the other men in that ward were soldiers from the war. An army officer used to visit, and he asked them soldiers what regiments they were in, and when he said goodbye, this officer would give these soldiers three quid. When he got to our dad, he said, "Well, what regiment are you in, then?" and he said, "No, I ain't in the army, I'm a miner who've had an accident," and he said, "Well, that's all right then, you've earned that three pound."

'We didn't see him for three months. But he did walk after. And he went back to work. He was lucky.' ∎

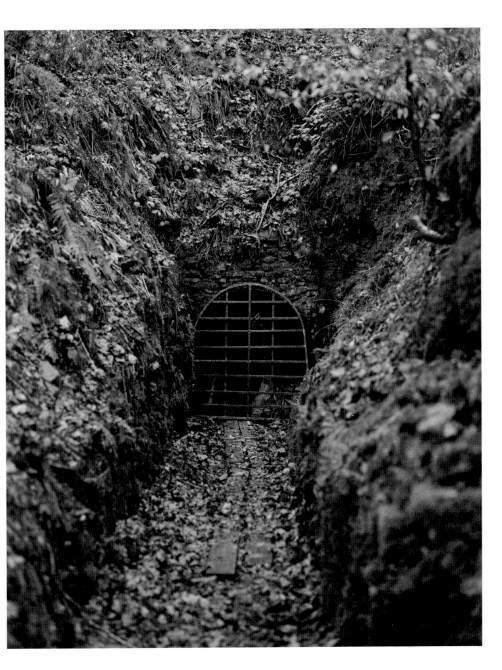

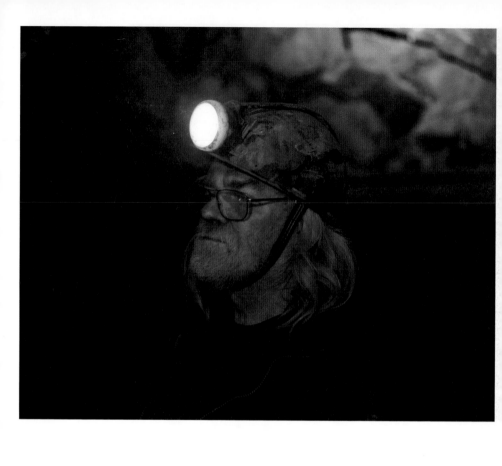

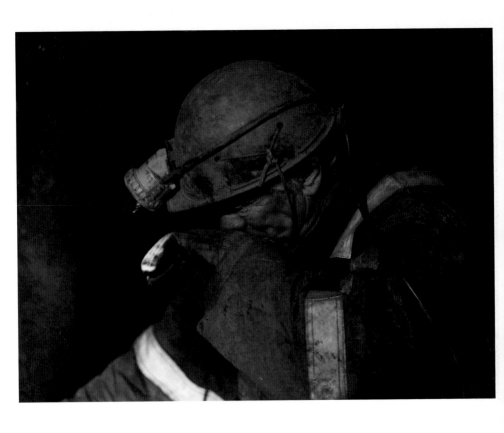

"I don't think my literary career would have survived without this financial aid. Not only did the RLF help patch things up, but the grants also bought me time to write."

MONIQUE ROFFEY

SUPPORTING
WRITERS
SINCE 1790

The Royal Literary Fund offers financial support, advice and earning opportunities across the UK, enabling writers to keep writing and to share their skills with others.

If you think we could help you, contact our Grants team today

+44(0)20 7353 7150
www.rlf.org.uk

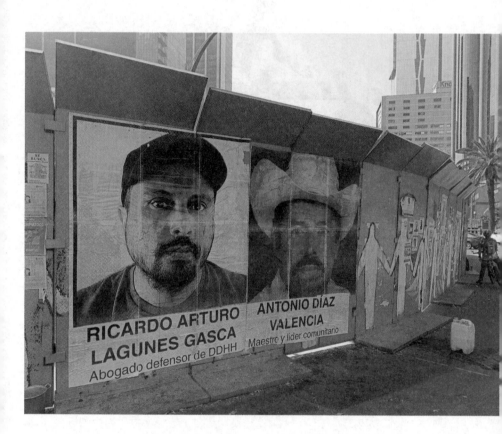

ADRIÁN ITURRIAGA ARANDA

DRONE WARS FOR MEXICO'S GOLD MOUNTAINS

Anjan Sundaram

I first learned about the self-governed community, or *localidad*, of Santa María de Ostula from one of Mexico's posters for the disappeared. It showed two of Ostula's anti-mining activists, Ricardo Arturo Lagunes Gasca – a forty-one-year-old human rights lawyer from Mexico City – and his seventy-one-year-old collaborator, the indigenous leader and teacher, Antonio Díaz. Side by side, in two pictures, the men stared out somberly. Antonio wears a pale campesino's cowboy hat, Ricardo a baseball cap and a Nike shirt. Posters like these are plastered across Mexican towns, and are constantly being shared on WhatsApp and social media. When I'm with my Mexican friends, a phone invariably dings; we look over, and discover another one. Usually it's a woman's smiling face, accompanied by a description of how she was last seen on her way home from a party or work. My friends receive dozens of these posters each month, mostly from families searching for people who are never seen or heard from again. Silently and instinctively, Mexicans come to know these faces. The posters are quiet signs of the low-grade war being waged across the country.

More than 111,000 people have gone missing in Mexico in the past six years. The rate of disappearances has accelerated sharply since 2006, when President Felipe Calderón began his war on drugs

with the backing of Washington. It's a war that, if anything, has been lost. During the five-year presidency of the current President Andrés Manuel López Obrador alone, more than 44,000 people have disappeared. Two hundred thousand have been murdered since 2007. And violence is on the rise – Amnesty International reports a 600 percent increase in torture by security forces across the first decade of the war. Though the Mexican government has arrested and killed hundreds of cartel capos, drug trafficking to the United States from Mexico continues to grow. There are now regions across the country where cartel authority is undisputed by the state.

In the wake of the government's failure to maintain meaningful control, small communities in the heartlands of Michoacán and Guerrero, which were most affected by the cartels, began to form *autodefensas*, or vigilante groups, to defend themselves. The first municipality to receive widespread attention for defending itself was Cherán, which in 2011 used fireworks to fight off illegal loggers linked to the Familia Michoacana Cartel. These *autodefensas* grew increasingly powerful, and their leaders have committed atrocious killings in their own right, sometimes allying with cartels or even joining them. 'The government tolerates certain *autodefensas*, it sustains some of them, and also combats some of them,' I was told by Romain Le Cour Grandmaison, an organized crime expert who for the past decade has been conducting fieldwork in Mexico, most recently for the Global Initiative Network. 'It lets them operate when they serve the government's interests.'

Ostula, on the Pacific Coast of Michoacán, declared their right to self-defense back in 2009. Its population of only a thousand people mostly earned their livelihood through agriculture, fishing and tourism. The two men in the poster I saw, Ricardo and Antonio, had emerged as leaders in the town more recently, as locals banded together to oppose the company Ternium, which owns a mining concession for gold, silver, iron and other minerals – reportedly as large as 5,000 hectares – in Ostula, including a mountain in the Sierra Mancira that is laden with gold.

Ostula and its neighbors managed to block the transfer of over 200 hectares of land to the mining company. Ternium estimated that the loss of access to this land would reduce its projected iron output in the area by 80 percent. Community members in Ostula told me that royalty payments meant for the community had been illegally siphoned off to a group of local residents that offered public support for Ternium's mining operation, and who fraudulently claimed to represent the entire community. Antonio and Ricardo called a meeting to investigate this alleged corruption, and to discuss the ongoing negotiations with Ternium. On 15 January 2023, after the meeting, Ricardo and Antonio were driving north, halfway to Colima, near the town of Cerro de Ortego in the municipality of Tecomán, when they were ambushed and abducted from their white Honda pickup truck. The pickup was found by the side of the highway, full of bullet holes, but strangely, without a trace of blood in or around the vehicle. This was the work, the townsfolk seemed to agree, of the Cártel de Jalisco Nueva Generación. The week before, three members of Ostula's *autodefensa* had been killed by fighters from this cartel.

For several years now, the Cártel de Jalisco Nueva Generación, one of the world's most powerful and heavily armed criminal organizations, has been attacking the borders of Ostula, working to open up the community and the Sierra Mancira to the mining companies. Despite the dangers involved, Ostula has managed to mount a formidable response to the cartels. Firefights rage in the mountains almost daily.

Once the cartels enter a territory, they recruit young people and children as drug dealers. Usually narcotics are sold out of local alcohol shops. The youth are promised riches if they work their way up the cartels' ranks. Local songs idolize the *sicarios*, or hitmen, and leaders of the *plazas*, the territories cartels control. Michoacán's cartels, like criminal organizations around the world, think of themselves as heroes who defend the poor. Their principal recruits

are underprivileged men who see little promise in modern Mexican society. The cartels offer a chance to get even with Mexico's upper classes. Cartels see protection rackets and illegal trafficking as ways to siphon wealth from Mexico's rich to its poor. The cartels' profits allow their members to dine at Mexico's fanciest restaurants, to cut deals with Mexico's top politicians, and party with rock stars and actors.

Since Calderon's war on drugs began, profits and power have only become more concentrated in the cartels as they operate more overtly and combatively on the ground. It is widely understood that many of the private companies working across Mexico pay cartels protection money so they can run their businesses without interference. Mexican cartels invariably intervened whenever community opposition threatened to block a megaproject – a dam, a new industrial park, sand mining from a riverbed, or gold mining. The cartels siphoned profits from these projects by charging *derecho de piso*, or 'dues'. Companies paid to be protected from the cartels. Cartels now also support mining companies by displacing people from land those companies wish to explore, clearing the ground for megaprojects. The cartels have taken on a role similar to an ultra-violent local government, aiming to levy hefty taxes with force.

Government officials, too, are often on the take. A federal public security official told me that she had seen a long list of government officials in the state of Guerrero who had been bribed – with sums several times their salaries – by cartels who wanted their support. She had been investigating the disappearance of forty-three *normalistas*, or students, in Guerrero's Ayotzinapa municipality. 'The government was complicit in the students' disappearances,' she told me. The high-profile Ayotzinapa case, as it's called, the subject of several books, remains officially unresolved. A reconstruction of the students' disappearances by Forensic Architecture showed remarkable coordination between local, state and federal police forces, as well as armed units belonging to organized crime groups.

That so many public officials were being bribed in Guerrero is no

surprise. In 2023, the former Secretary of Public Security, Genaro García Luna, the highest ranking Mexican government official tasked with fighting Mexico's war on drugs, was convicted in a New York court of trafficking drugs and receiving bribes from the Sinaloa Cartel. The *New York Times* reports that American law officials have spent years looking into the possibility of payments in the past between drug cartels and President López Obrador. ProPublica alleges the Sinaloa Cartel helped finance the president's 2006 election campaign, in exchange for support for the cartel's operations. The leader of the Los Ardillos Cartel claimed in February 2024 that he also supported the president's 2006 campaign.

The cartels' aims run parallel with the Mexican government when it comes to promoting the development of industrial megaprojects that grow the government's tax base. It also gives them the opportunity to expand their own *derecho de piso*. The cartels themselves have become a significant component of the Mexican economy. Last year *Science* magazine estimated that they employed 175,000 people, making the cartels Mexico's fifth biggest employer – a giant of the country's private sector, diversified over a range of legal and illegal businesses. In 2010, for example, the Knights Templar Cartel in Michoacán succeeded in taking over the coast's entire iron ore mining business, exporting the iron ore from the port of Lázaro Cárdenas directly to China.

A few days after Antonio's disappearance, he resurfaced in a cartel video, badly beaten up. The video spread through WhatsApp, sent by the cartels to terrorize Ostula. Local news organizations posted the video online and transcribed a fatigued Antonio's words, as he told his cartel interlocutor in a forced 'confession' that he had colluded with a corrupt local official who had bought votes to get himself elected.

Antonio went on to denounce his former allies, the community militia leaders who fought the war against the cartels, trying to protect their land from being opened up for gold mining. Faced

with attacks from the Cartél de Jalisco, the local communities had provided military training for their youth and sent them out to defend the community's frontiers. Antonio now cited the leaders of Ostula's *guardia comunal*, or its military division, by their *noms de guerre*, 'El Chopo', 'El Teto', and 'El Toro', claiming that these community militia leaders were actually in the pay of the cartels. It was a way for the cartels to divide Ostula, and wage psychological warfare by seeding mistrust.

A month after the disappearances of Antonio and Ricardo, Ternium released an official statement, asserting their 'good working relationship with the community' and declaring they had 'publicly denied and rejected any speculation that Ternium or Las Encinas had any involvement or connection with the disappearance of Messrs. Díaz Valencia and Lagunes Gasca'. When I contacted their offices in Luxembourg about this story, they declined to make any other comments.

Shortly after the Ternium statement was released, Lucía Lagunes Gasca, the sister of Ricardo, released her own statement about her missing brother, which emphasized that Ternium had 'relations with different local groups and possibly with the perpetrators of this disappearance'. She called for a full investigation.

Lucía told me it was widely believed that Ternium, like many other mining companies across Mexico, was allied with cartels. 'The company encourages violence against anti-mining activists. My brother's disappearance benefited its business,' she said. This confirmed much that I had already heard. In parts of Mexico – such as the northern state of Chihuahua, which is home to a series of lithium mines – Mexican reporters have told me that I would have to ask for the cartels' permission before I traveled there for reporting, or risk not returning.

Officially, the state government is still looking for Ricardo and Antonio. But a year has passed, and no one has been arrested in connection with their disappearances.

I first met Braulio, a 27-year-old Mexican student of journalism, at a restaurant in Oaxaca City. A mutual friend introduced us. Braulio was studying journalism at Mexico's prestigious Universidad Nacional Autónoma de México, UNAM.

Braulio intrigued me. His parents, both lawyers, had educated him in a private school in Mexico City, and then at an international Italian high school. Braulio could have chosen any career, and he could have lived a comfortable life, but he had chosen to become a journalist in Mexico, a deadly profession. Eleven journalists were killed in Mexico in 2022, and five in 2023 – among the fifty-two journalists killed in Mexico over the past five years.

The two of us decided to report together, and it was with Braulio that I drove through the dawn fog toward Ostula. I was nervous. I had been watching videos that showed the cartels' ruthlessness, their brutality against those who peddled drugs on their turf and cut into their profits. They were brutal to environmental defenders – shortly before Braulio and I departed, a news article declared that sixty environmental activists had been killed over the last twenty years while attempting to defend the forests of Michoacán. Journalists were being killed for investigating the cartels' affairs, or for running into *sicarios* through bad luck. We spent the night in Morelia, Michoacán's state capital, inside a *fraccionamiento*, a gated compound. High walls surrounded the condominium's buildings. We entered the compound through an iron-grill gate guarded by a security officer in a closed kiosk who operated an iron barrier. It rose. Gated compounds were safer and preferred by Mexico's upper class. We crossed the city in the morning to meet Keyvan Díaz, a journalist and the son of Antonio Díaz.

Keyvan lived in an apartment block with a large black garage door, which he opened to let us in, looking out at the street in both directions as we entered. He checked if we had been followed. Keyvan was lithe, and when he extended his hand, I noticed his slim wrists. He was also young – just graduated from a journalism program. Keyvan showed us into his father's bedroom. Antonio's *campesino* hats lay

on a table; his photographs and notebooks, jackets and shirts still hung in his wardrobe. Keyvan had left them all in their places, nearly half a year after Antonio's disappearance, hoping for his father's return.

Since his father's disappearance, Keyvan had been placed under military surveillance for his safety. He showed me a little white button kept on his work desk.

In theory, it summoned soldiers.

'I'm not sure the button helps,' Keyvan confessed. 'The government doesn't want me to speak out about my father, but I don't think he'll come back if I stay silent.'

The government was concerned that Keyvan would make himself a target for the *sicarios* if he spoke up about his disappeared father. A government spokesperson had promised Keyvan that they were quietly negotiating with the cartel. But Keyvan had grown frustrated. 'Are they really negotiating? They don't give me any updates.' Many Mexicans professed little faith in the government's ability to recover those who disappeared, with over a hundred thousand people still missing, and many of the perpetrators likely colluding with local public officials.

It was in the first forty-eight hours after someone disappeared that they were most likely to turn up. After that, the chance of reappearance decreased drastically.

'I'll do whatever they want,' Keyvan said. 'I'm prepared to pledge my silence, to not pursue justice. I just want my father to come home.'

Braulio was sleeping in the next morning, a cold day, when I heard from an NGO worker at Servicios y Asesoría para la Paz (SERAPAZ), our liaison with the community of Ostula. León Pérez called me up.

'You had better turn back,' he said.

The cartels had attacked Ostula again, ambushing its frontline bases. The community was fighting back – mostly through *guardia*

comunal fighters, who had been sent as reinforcements to the small community's borders, where they were preventing the cartel fighters from infiltrating their mountainous territory. There was no way they could receive a pair of journalists or show us around. It would be too risky. The cartels could ambush us. And yet, this was exactly what we wanted to do. This was the fighting we wanted to document.

Ostula is almost entirely indigenous, and governed using *usos y costumbres*, literally 'customs and habits', a constitutionally protected indigenous mode of governance through local assemblies where unanimity is required on major decisions. Ostula's local assembly, incorporating all its community members, was its highest decision-making body. They were the ones who had asked us not to come, and that was a decision we had to respect.

Dr Orlando, a constitutional lawyer, who helped the indigenous city of Cherán negotiate legal self-governing status, talked me through how it all worked. Cherán approached Mexico's electoral tribunal in 2011, which canceled municipal elections and permitted the city a form of traditional autonomy. Dr Orlando pointed me to a score of local communities that had successfully claimed autonomy from the central government, and proceeded to evict the cartels and preserve their forests and rivers. The stories from each of these towns was similar: the cartels arrived, killed children and the elderly, sometimes backed by the state's police and army. Communities then evicted the police, the army, and the cartels in one go, trusting only in their neighbors.

The next day Braulio and I stopped in a lakeside town called Pátzcuaro, the site of a former utopian project modeled on Thomas More's ideas, where a sixteenth-century Spanish archbishop had tried to provide shelter for persecuted indigenous populations in so-called 'hospital towns', or *Republicas de Indios*. That the indigenous could co-exist in peace with their Spanish colonizers was considered by the bishop as a utopian project. Pátzcuaro was now overrun with tourists, who also visited the picturesque island Janitzio.

The radio reported nothing about the outbreak of fighting in Ostula.

'Surely someone is covering the attack?' I said. Braulio knew a reporter named Beto in Pátzcuaro. Braulio said he had only met Beto once, in Oaxaca, but that he might be able to update us on the cartel's latest incursions.

Pátzcuaro had once been the capital of the Purépecha Empire, founded in the fourteenth century and conquered by the Spanish around 200 years later. Fiercely independent, it was an adversary of the powerful Aztec Empire, and known as one of the first Mesoamerican civilizations to master metalwork for weapons and art. Now, it was one of Mexico's 111 *Pueblos Mágicos*, or magical cities. Its name meant 'happy place', 'place of bullrushes', or 'place dyed in black', depending on the translation.

At a café, Beto, eating *chilaquiles*, nodded when we mentioned the attacks on Ostula. A tall man, he arrived at lunch with his girlfriend, a Texan woman, whose neck he caressed as he listened to Braulio and me present ourselves. There was a force to the way Beto spoke. He had reported on Michoacán's coast for years, and straightaway called up a member of Ostula's council, a senior officer named El Goyo. El Goyo said any friend of Beto's was a friend of his. We would be welcome to visit Ostula, but we would have to wait until there was a pause in the fighting. El Goyo guaranteed our protection.

'I will prepare our visit,' Beto said. 'We will have access to all of Ostula.'

Community protesters had forced Ternium's iron mine in Aquila to shut down a week after Antonio and Ricardo disappeared in January, mounting roadblocks that prevented terrestrial access to the mine. Ternium said it had closed the mine, responding to 'a request from community members'. But the cartel was still active, and, perhaps for revenge, perhaps to reopen the mine, it was continually attacking the community.

When we arrived in Ostula, we entered from the south. The

Cártel de Jalisco attacked Ostula from the north, from the municipal capital, Aquila, where the iron mine was situated, and from the narco strongholds in the violent neighboring state of Colima. We drove in through the small town of La Ticla, ten kilometers away from Ostula, on the coast. Three species of turtles – the leatherback, Olive Ridley, and black – nest on this coast, swimming in the night beneath drug-laden *lanchas*, and landing on the beaches, where they crawl up the sand to bury their soft spherical eggs in luminescent white clusters. By day it's the preserve of surfers, and we saw a group of young men watching the tide with their boards in hand. A beach shop sold surfing and swim gear, and at a restaurant on the sand we dined on divorced eggs and copper-colored *mamey sapota* smoothies. The strip by the shore was set up for tourists, the walls of the buildings painted in bright pastel colors, with roofs of fresh palm, a contrast to the faded brick and corrugated iron inland. Some of the surfers' skin was worn by the sun; a tanned Quebecois man in his fifties told me he had taken a room at one of the beach hostels for a month of surfing. He and his local girlfriend made a conspicuous couple. It was hard to imagine this place as a site of violence.

Ostula itself is a small town up a winding road into the mountains. A white building with a courtyard at its center houses the locality's political and military headquarters. The buildings are low, many of them windowless, though most of the houses have a porch graced by two chairs and a small table where visitors are welcomed by a jar of *agua de jamaica*: water distilled from a red hibiscus flower called roselle. From every part of the town you can see the surrounding lush green mountains. Children lounge in the shade, and the cracked paint on the houses is dotted with slogans and graffiti advertising local festivals, the opposition to Ternium, and health programs such as vasectomies.

We arrived to wide piles of tamarind at the home of El Goyo, the community's communication officer. It was high season for the tamarind harvest, which he prepared for export to Guatemala. Part of his earnings he kept, and a part went to the community, as a

communal contribution that provided services for Ostula's residents. Such contributions are commonplace in indigenous communities like Ostula, where the land is not privately owned and residents are required to perform voluntary services for the community. I assumed that a part of El Goyo's contribution funded the *guardia comunal* – and its weapons – though he wouldn't explicitly say so. Although I was there under El Goyo's protection, I was still an outsider. And the small community was reluctant to show off its weapons in case the Mexican government got wind of their bravado and sent in the Mexican army, whose base, along with marine bases, was located within two hours of Ostula.

At midnight people were still bringing in sacks of tamarind in the backs of their cars. Some arrived on motorbike, with the bags balanced across the pillion or a passenger's lap. El Goyo weighed their loads, paid them a fixed rate, and disinfected and deseeded the fruit to extract the pulp.

From his last container of tamarind exports, El Goyo had bought his wife a new speaker. Beto turned on one of Peso Pluma's tunes. It was a *narcocorrido* – a ballad praising the cartels, set to popular folk tunes, the kind that were so popular in Mexico. The music was catchy, and it was probably out of ignorance that Jimmy Fallon had just invited Peso Pluma onto *The Tonight Show*, to sing to US primetime audiences.

'What is that?' El Goyo asked, cocking his head.

'Listen,' Beto said. 'It's a *corrido*.' Peso Pluma crooned about 'little girls' and crystal meth. El Goyo listened for all of thirty seconds before he brusquely said, 'Change it.'

Beto scrambled.

'I lost my brother to the narcos.' El Goyo shook his head. 'This younger generation doesn't know what this kind of thing means. They'll listen to anything.'

That night a haunting church vigil passed by the gates of El Goyo's house, in solemn song. People carried effigies of the Virgin Mary, enveloped in smoke from tabernacles swinging from their arms. I followed the crowd to the road's end, where I spotted three white crucifixes in the ground. The crucifixes carried no names. A woman standing by a *tienda*, a local shop, informed me that the crucifixes had been put up to remember three residents of Ostula who had turned into Knights Templar Cartel members. The community had executed them.

'Their funerals were strangely lonely,' she said. 'One's wife showed up to mourn, and the other man had only a chicken beside his coffin.'

That afternoon, as we drove to one of Ostula's military bases up in the mountains, El Goyo pointed out the house of Semeí Verdía, the man who had preceded El Toro as the head of Ostula's *guardia comunal*, and had served as the head of the combined *autodefensa* forces along Michoaocán's coast.

Semeí had led the military operation that flushed the Knights Templar Cartel out of their communities. Armed with only basic weapons, compared to the Mexican army, they had succeeded. In the communities' eyes, their victory had shown the army's complicity with the cartels. Semeí had been celebrated as a hero.

But Semeí's house was now only a shell. The roof had been destroyed, burned after Semeí had defected to the Cartél de Jalisco, probably lured by promises of quick wealth. After that, the cartel regained the upper hand against Ostula. Semeí was now the cartel's number one officer in Colima, recruited to fight the very community whose security he had once ensured, and whose military secrets he had guarded.

The nameless white crucifixes and Semeí's burned house showed Ostula's complex relationship with the cartels. Brothers and cousins fought each other in battles that had long divided families. We traveled along the same road Antonio and Ricardo had taken after their anti-mining meeting, when they were abducted. El Goyo pointed out

the branch of the Kiosko chain of convenience stores, colored red, blue and purple, where they had last been seen, recorded on CCTV cameras, buying snacks with a friend who, seemingly suspiciously, had decided to stop traveling with them at that dangerous point, though it was already dark. El Goyo showed us the spot by the bushes on the side of the highway where their white Honda pickup truck had been found, empty, riddled with bullets, and the cartel had snatched them.

Now, months after their disappearance, the case was cold. Though Keyvan and Lucía didn't want to admit it, it was unlikely they would ever be found. Their bodies were probably in an unmarked mass grave, somewhere in the mountains. Family members of Mexico's disappeared, called *rastreadores*, are constantly scouring the countryside – sometimes with soldiers as protection – searching the landscape for anomalies that might reveal their disappeared loved ones, or their remains.

El Goyo entrusted us with an escort and security detail: a young man named Pedro who was a member of Ostula's *consejo*, or council, the small town's executive body. Though Pedro was only in his twenties, he was among those tasked with guaranteeing Ostula's security. This made Pedro a prime target to Ostula's enemies.

Beto and I met Pedro on the sidelines of a local football match, when Braulio had gone to El Goyo's home to sleep. Ostula's chief of the *guardia comunal*, El Toro, whom Antonio had accused of being a cartel fighter in the video the cartels had released, was playing for Ostula against another indigenous community called El Coire. Black bulletproof pickup trucks stood around the football field, and beside them were armed fighters. Attacking the football match would be an easy way for the cartel to cripple Ostula.

Pedro was quiet. He wore Ray-Bans so I couldn't read his eyes. I sipped from a beer; he offered me another. He was deciding if he could trust me enough to take me to Ostula's frontline.

El Goyo had received a report that the Cártel de Jalisco had killed some of Ostula's boys in a raid on a border checkpoint. He showed us the video the cartels had sent to Ostula afterwards. Ostula's boys were half alive, in their jungle hammocks, already shot and bleeding. The cartel fighters then peppered them with bullets, so their bodies shook as they died. These were friends of El Goyo and Pedro.

Rosario, El Goyo's wife, grew up in the northern city of Tijuana. She told me El Goyo had once fought on Ostula's frontlines.

'He left me with the kids and fought for days, and came home drunk. The fighting messed with his head. One morning when he returned at 5 a.m., he stood in our bedroom doorway and said "Sorry I brought you here." I told him, "Then get your act together. I'm with you, and we're in this together".'

El Goyo quit Ostula's *guardia comunal*, sobered up, and took on a council communications job.

After four days in Ostula, I asked Pedro which mountain Ternium and the cartels wanted.

He pointed at a wide green mountain that rose to a point. 'Cerro de Mancira.' It was in the Sierra Mancira Mountain range, whose ample gold Cortés had mined five hundred years before.

'Ostula has decided the gold, titanium and whatever else is there will stay inside the mountain,' Pedro said. 'Our jaguars will continue to live peacefully. Ostula has decided, and we will keep our community's pledge.'

The community wanted to avoid the arrival of cartels, and the prostitution and drug addiction they brought with them. That pattern has been repeated at the site of megaprojects across Mexico. El Goyo cited the case of the US–Mexican border city of Ciudad Juarez. When the NAFTA free trade agreement came into effect, Ciudad Juarez quickly industrialized, and turned into one of the world's most dangerous cities, rife with narcotics and gangs of human traffickers.

Pedro told me Ostula was armed heavily enough to fight off the cartels. But Ostula's residents were reluctant to tell me where they had bought the heavy weapons they were using to defend themselves. Some said they had stolen them from the cartels, which was likely true to an extent. But the lawyer Dr Orlando had told me that elements of the army were in the habit of selling high-powered rifles to both cartels and communities like Ostula, profiting from both sides of these wars.

Ostula had taken charge of its own defense, and so it operated largely autonomously and in isolation from the rest of the state, but from time to time it met with other self-governing indigenous communities in Michoacán at conferences in the state capital, Morelia, to build regional networks.

I asked Pedro, again, to take us to the frontline.

We left El Goyo's home early the next day and headed to Aquila, the main urban center beside the mine. On the way we stopped at a beach called Xayakalan, overgrown with tall palm trees, where according to Ostula lore, its residents had once run at the *sicarios* of the Knights Templar Cartel, attacking them with only machetes and shotguns, spurred by a racial slur a *sicario* had used against Ostula's indigenous townspeople.

The near-ruined streets of Aquila shocked me. Paint peeled off houses. Walls crumbled. The mine's wealth was visible only in the cars: BMWs and Porsches roamed Aquila's potholed streets. It showed the nature of the extraction from the next-door Ternium mine that the immense wealth in exported iron ore hardly reflected on the city's facade. A woman blocked our road using a skipping rope and asked for our *cooperación* of five pesos, for Mother's Day.

Pedro had us park outside an orange-walled compound that looked like an empty parking lot. The sun was harsh. We entered the premises and turned a corner, and as my eyes adjusted, I discerned a room. Two walls on either side of me were lined with anti-aircraft guns, assault rifles, drones and walkie-talkies.

The wall was built of brick. The bricks had not been laid sideways, as in a normal wall, but each brick presenting its smallest face to the world outside, to construct a thicker wall. This base, which had looked so ordinary at first glance, was built to withstand an attack. I looked up: the ceiling had three layers. A man in military fatigues sat in the sun, while a worker halfway up a ladder built another new multi-layered ceiling.

'Reinforcements every day,' the commander said.

He shook our hands and gave his *nom de guerre* as 'El Chopo'. He too was among the Ostula commanders who Antonio had accused of being members of the cartels in his hostage video.

Braulio asked if he could take pictures. El Chopo shook his head uneasily. We sat at a long wooden table under the three-layer roof. 'What would you like to know?' El Chopo said, squinting at us.

'Where does the cartel attack?' I said.

'Here.'

'You mean, where we are right now?'

He nodded. When he did speak he remained terse, and to the point, and I got the sense he was unhappy about our presence here on the frontline. El Chopo wiped his forehead, and looked about us nervously, as if burdened by our visit at this time of war. His men scanned the horizon and valley for any sign of attack.

But he grew animated when we asked about Ternium, and pulled out from a manila folder photocopies of documents that he said had been forged by the mining company's agents. The documents stated that the community granted Ternium permission to mine these surrounding lands.

El Chopo smiled. 'See what they do?'

I looked out into the valley, and at the forested mountain facing us, where the cartel fighters were presumably hiding. Maybe they watched us.

'How often does the cartel attack?'

'Every two days.'

'And the last attack happened when?'

'Jalisco sent four drones this morning, carrying C-4 explosives mounted on mortar heads. They didn't drop them. But they'll be back. Later today, probably.'

El Chopo let me tour the base and peer into its doorless rooms. In one room an immense black drone sat on the ground. It could carry a heavy payload. Beside it, on a naked mattress on the floor, lay an odd-looking gun with silver buttons along its sides showing different frequencies.

'What's that?' I asked.

'It brings down drones by overriding their control frequencies.' El Chopo made his hands as if to point at a drone and bring it down to the earth, away from his base.

Pedro waited for us in one of the side rooms, sitting in a cloth easy chair, probably brought in from the beach, chatting with some of the fighters. He wore his Ray-Bans indoors, and I wondered if he was deliberately hiding his face. I sat beside a man whose long sniper rifle leaned against a wall, on a mattress on the floor. Another fighter scrolled on his phone.

I asked what he was looking at.

He smiled. 'I'll show you.'

He clicked on a video of Ostula's fighters under fire and shooting at the cartels. One man yelled; machine guns fired, so you couldn't hear them talk anymore; the men took cover behind a truck, evading the cartel fire; a man stood, fired while yelling incomprehensibly at the cartels; the video suddenly cut.

The fighter looked at me. I must have seemed sufficiently impressed.

He clicked on another video. It showed a souped-up armored truck bearing a giant red skull on its front. One of Cártel de Jalisco's. Its driver had been shot and lay dead on the grass. The camera moved closer to show that the driver was only a boy, not older than fifteen. His head had been blown off. The cameraman kicked the boy, whose brain fell out of his head, spilling onto the grass.

'Two weeks ago,' he said. 'That was two weeks ago.'

'But I know the names and details of everyone killed here over the past two months. That boy didn't show up on the list.'

'He's a narco,' the fighter said, shaking his head.

I looked at him.

'Narcos don't count.'

O ne road leaving Aquila led directly to the Ternium mine. We took a second road that took us to a valley across from it. Beto had traveled here once before and deployed his small drone to obtain footage of the mine and the valley.

Pedro groaned in the car, seeming suddenly uneasy.

'Are you okay?' I said.

'No.'

'Should we turn around?'

'Don't turn around. Let's go.'

Pedro had never visited the mine. He wanted to reach the place that had been the origin of such violence, the place for which the cartels had fired at those boys in their hammocks.

We wound our way through the valley, and then it came up on us. A giant hillside, of a sandy gray color, the color of the iron ore. The large-wheeled trucks, meant to carry earth, stood still. Mexicans say the mining companies work to *licuar las montañas*, or 'blend the mountains down'.

I stood against the railings and looked into the valley beneath me. Before I could say anything, Beto had pulled out his telephoto lens from the back of our SUV. I moved to stop him: 'Man, that's dangerous.'

But Beto wasn't listening. The cartels might mistake his long lens for a gun, and shoot at us. 'Put it away, man!'

Pedro turned to face me and held his fingers close. 'You are now one centimeter from the Cártel de Jalisco.'

'Where are they?'

'On the hill in front of you,' he said. 'On the Cerro la aguja.' The hill of the needle.

'It's a well-known *sicario* base. They use it to guard the mine which makes them so much money.'

He waited while I looked.

'They're there in the mine?'

'Yes. And behind you, too.'

I turned and scanned the mountain range. Off in the distance, barely perceptible, I noticed a small shack.

'They're inside there,' Pedro said, adjusting his Ray-Bans. 'Guarding the mine.' ∎

POSTSCRIPT: A few months after Anjan Sundaram traveled to Ostula, in November 2023, the indigenous anti-mining activist Higinio Trinidad de la Cruz was found dead near Ternium's other mine, the Conscorcio Peña Colorada, the 'Red Rock Consortium'.

Update your nightstand.

The Adventures of Dragons Den
Ann Allison

A family of dragons has come to stay. They wear a disguise so they can blend in hoping no one will notice their beautiful green skin. Will they succeed?

£11.95 paperback
978-1-6655-9308-3
also available in ebook
www.authorhouse.co.uk

Staplewood Park
Michelle Grahame

Will everyone's expectations come to nothing, when a man arrives at *Staplewood Park*, claiming that he is the rightful heir to the title and estate? And does the "fortune" still exist?

£10.99 paperback
978-1-7283-7549-6
also available in hardcover & ebook
www.authorhouse.co.uk

Eight Skulls of Teversham
SR Sutton

Combining history and fantasy, *Eight Skulls of Teversham* traces the origin of witches, witchcraft, and the ancient art of divination.

£9.95 paperback
978-1-5462-9426-9
also available in ebook
www.authorhouse.co.uk

A Tigress in the Chapel
Jimmy Chasafara

This is the eye-opening story of a young girl's journey through sexual abuse as she battles to survive and claw her way out of the darkness.

£13.95 paperback
979-8-8230-8112-2
also available in ebook
www.authorhouse.co.uk

Using Japanese Paper for Digital Printing of Photographs
Carl-Evert Jonsson

Find out how to use a method that will give new life to photos with the insights in *Using Japanese Paper for Digital Printing of Photographs*.

£11.95 paperback
978-1-6655-8881-2
also available in ebook
www.authorhouse.co.uk

Challenges of Christian Marriage In African Culture
Sylvester Oyeka

Father Sylvester Oyeka reflects on the challenges encountered by Christian marriage in a communitarian African culture of kinship and presents a reconciliation between these marriages where the moral values could be adopted.

£9.95 paperback
978-1-5049-4693-3
also available in hardcover & ebook
www.authorhouse.co.uk

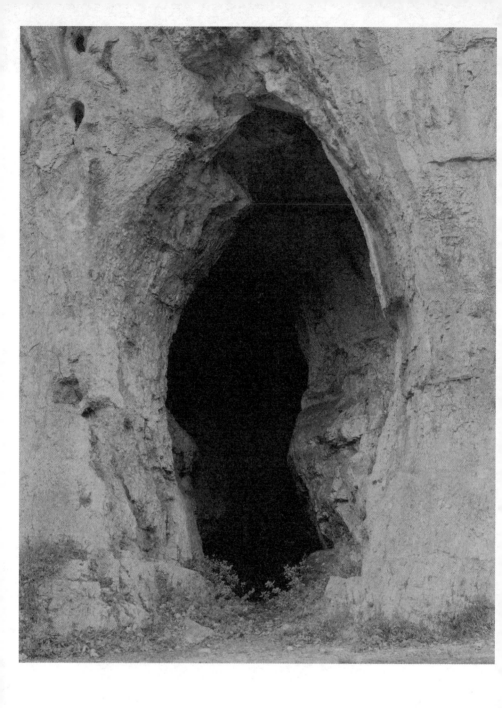

MAX FERGUSON
Cave in the Lot Valley, France

THE TRUE DEPTH OF A CAVE

Rachel Kushner

B runo had always known the caves were there, he wrote to Pascal and the Moulinards, but the depth of them, their spatial complexity, had stunned him.

We never expect the true depth of a cave, he said, on account of our indoctrination, our enslavement to the aboveground, which is scaled to us and above us, scaled to trees, to high-rise buildings, to the industrial dreams of twentieth-century man, and to his military imagination, scaled to fighter jets, and to heaven, to our need to claim something in the blue beyond, a thing we might call 'blessed'.

This vertical arrow aiming from ground to sky constitutes modern man's entire spatial reality, Bruno wrote. It excludes the other direction, he wrote, the down-into-the-earth. This is an incredible blind spot, he said, and he himself had not understood how blind, until he one day squeezed himself into his own cave, on his own little property in the Guyenne.

When he had purchased the land, in the early 1970s, the previous owner had shown him the cave as a curiosity. That owner had kept a board over its entrance. Beyond the board was an opening, a cavern five feet shallow, at the end of which two rocks angled together into a narrow crevice. For years, the board remained there. One day, in the period after he'd left the farmhouse, and the barn, and was

sleeping in his little stone hut, Bruno removed the board and went in. He put his hand through the crevice in the rocks and felt wind. He understood that beyond the crevice there must be a large open space. He returned with ropes and a headlamp and pushed through the crevice and lowered himself. He did not hit bottom for quite a while. When he did, he was in an enormous room, its ceiling perhaps three meters high. He found multiple openings off this main room leading in different directions.

One particularly magnificent discovery was a chamber that was flocked white like a snowy landscape. Is this a dream? he wondered. It was not a dream. The walls were coated with magnesium crystals. They were blanketed in sparkling white, a natural geologic phenomenon. Some call this moon milk, Bruno wrote. It coated the floor. In that moon-milk floor were indentations that he believed were records of human presence, and in particular, shapes that looked, and felt, like the footprints of a child. There were regions of the underground network where water ran through, he said. The water was very cold. In some places it was neck-high, he said, and in the water lived strange crustaceans with translucent shells that seemed to thrive in absolute darkness.

This entire valley, he said, was laced with underground springs and rivers and lakes. Because Bruno's adult son studied hydrology and currently worked in that field, he had helped Bruno to better understand the caverns and the water table and especially how to remain safe, because in winter, he said, caves could fill and quickly.

One day my son took me to a lavoir fed by a spring, Bruno said. The water is clear, my son pointed out. When the water is cloudy, he said, you know that someone has been in the cave whose spring fills this washbasin. The underground waterway, my son explained, has thick silt in its bed. When it is disturbed by footsteps, silt is kicked up.

The cave in which Bruno slept was dry year-round, if a good deal cooler in temperature than a modern Frenchman might prefer. He planned to stay in the home he had made for himself underground. Although he did exit the caves regularly, as he indicated in the emails. He got fresh air. He tended to his permaculture, having renounced modern farming techniques. He took walks on shaded forest paths. And he wrote to Pascal Balmy and the Moulinards at a computer terminal that belonged to his adult daughter, in the kitchen of the old stone farmhouse. Bruno's son had pointed out to him that the French government had more than clouded the waters of the communal washbasins. They had desecrated the entire subterranean world of southern France with tunnels for their high-speed trains.

I can hear the Paris–Toulouse from down there, Bruno said. I sense its vibrations. I feel the faintest touch of its wind.

Bruno's son was of the opinion that the state's mad plan to leach out all the groundwater and shunt it into industrial bays would wreck the ecological balance of the Guyenne.

When the digging work began for the Tayssac megabasin, Bruno said he was convinced he heard the sound of the excavators. He felt a level of disturbance that seemed to come from multiple directions, and from which there might be no escape. One day, the sound stopped, he said. The subterranean world was quiet, left in peace. But peace was temporary. These days, he said, I hear again the distant groan of machines clawing downward.

And just when I thought we were at last arriving at the main subject – sabotage of trains and of earth-moving equipment – Bruno went off the rails.

He'd been in these caves twelve years now, he said, and still he had not gotten to any definable 'end', the caverns' design instead calling into question the whole concept of an end.

I hear people, he said, whose voices are eternal in this underground world, which is all planes of time on a single plane.

Here on earth is another earth, he said. A different reality, no less real. It has different rules.

You won't understand any of this from me telling you about it, Bruno said. You might even dismiss what I say. The little I myself understand has taken patience, he said, and rigorous deprogramming.

For nine-tenths of human time on earth people went underground. Their symbolic world was formed in part by their activities in caves, by modalities and visions that darkness promised. Then, this all ceased. The underground world was lost to us. The industrial uses of the earth, the digging, fracking, tunneling, are mere plunder and do not count, Bruno said. Modern people who build bomb shelters, planning to survive some version of apocalypse, also do not count, he said. Yes, they go underground, but not in mind of a human continuum, a community. They think, I'll be the clever one, the one who survives mass death. But why would you want to survive mass death? What would be the purpose of life, if life were reduced to a handful of armed pessimists hoarding canned foods and fearing each other? In a bunker, you cannot hear the human community in the earth, the deep cistern of voices, the lake of our creation.

In my cave, he said, under my cave, welling up from deeper passages, I hear so many things. Not just the drip of water.

I hear voices. People talking. Sometimes it's in French, sometimes Occitan, or older tongues of the Languedoc, many languages I do not recognize, sounds of which I cannot understand a word, but I know that what I hear is humans, it is human talk.

Did we always have language? We don't know the answer to this.

Linguists try to chart what they call 'glotto-chronologies'. They picture language like a tree, with a trunk. The first language, at the base of the trunk, being simple and common, what some call 'nostratic'. This is a fantasy. But who can refute them? They cannot escape the chains of their telos, the sad idea that they are the logical outcome, the advanced form of human speech, and that what came before must have been simple and crude.

They never imagine that if language is a tree, they must look not

at its trunk, but at its roots, which, like a tree's roots, might form an upside-down chandelier of extravagant complexity, reaching and spreading deep into the dark beyond. But most people are unable to grasp how far down the physical world goes. And they would not know that voices are stored in its depths, unless they were to hear those voices.

It is hard to explain, he said. You would have to have lived as I live, done what I have done, learned what I have learned, in order to hear what I hear. You would need a different consciousness, he said.

When you live underground, among the things you discover is that you are not alone. You're in a world richly peopled. Occupied by legions.

Homo erectus, who stood up and cooked, Bruno said, he is here.

Homo neanderthalensis, who huddled modestly and dreamed expansively: here.

Homo sapiens, gone into caves to paint, to render his capture with extra legs, extra horns, so that these beasts canted and ran over cave walls, or butted heads, clashed and fought, all in the light of a torch, *H. sapiens*'s underground cinema house: that resourceful and ruinous forebear of ours, he is here.

Cathars and other heretics, the few not slaughtered, gone deep, living in darkness: yes, present.

Cagots, after the war of 1594, hiding to survive. Surviving in secret. Here.

Cavers, nineteenth-century men and boys, killed by curiosity, fallen in, unable to make their way out: here.

The partisans, men of my own boyhood, who retreated underground to hide from rampaging Germans: they, too, are here.

For a long time, he said, you cannot tune in. Then, you might sense a current or buzz of telluric energy. This sound transforms, the more time you spend in caves. It becomes voices. You hear these voices but are unable to isolate them. It takes years to learn how to listen, to differentiate, to adjust your inner tuner to a position on the atemporal bandwidth of the underground world.

Remember shortwave transmission? he asked them. Probably you don't, he answered. Tuning into shortwave programming used to be an art, Bruno said. Depending on the bandwidth, it worked best at night, on account of how radio waves travel back from the ionosphere. There was a book, he said, that listed programs by calendar schedule and megahertz. Some of the programs came in stronger than others. You learned to listen for where to put the shortwave dial, between two points of static, and how to position your antenna, in order to hear a Bulgarian choir or news from Senegal or Venezuela's Radio Juventud.

Shortwave is real, of course, he said. It is also a metaphor. I bring it up not to reminisce over dead technologies, but to help you understand. Cave frequencies, he said, are not three to thirty megahertz. Cave bandwidth crosses moments, eras, epochs, eons. You have to learn to get inside the monophony, to tease it apart. Eventually, you encounter an extraordinary polyphony. You begin to sort, to filter. You hear whispers, laughter, murmurs, pleas. There's a feeling that everyone is here. A wonderful feeling, I should add. Because suddenly you realize how alone we have been, how isolated, to be trapped, stuck in calendar time, and cut off from everyone who came before us.

I never want to be that alone again, he said. ∎

DEATH BY GPS

Salvatore Vitale

Introduction by Granta

The old romantic warning not to trust a machine more than one's own intuition has renewed urgency in the digital age. When Salvatore Vitale began working on the project 'Death by GPS' in 2022, he wanted to pursue the pitfalls of automation bias: those accidents where drivers blindly follow their GPS off bridges and cliffs. Gradually, Vitale's focus became the human labour that delivers the illusion of automation in the first place: the people driving camera-equipped cars to populate Google Maps, the Amazon Mechanical Turks who complete online tasks for employers. 'We believe that these systems are fully automated,' Vitale told us, 'but we're not there yet.'

'Death by GPS' includes photography, text and video, all shot, filmed and composed in South Africa. Most of the material was created by freelancers Vitale hired on the online platform Upwork. Without giving them any specific direction, he requested the freelancers document their daily lives and working routine using video and photography. He offered an hourly wage of between $25 and $30. Although the job vacancies were geolocated in South Africa, soon he was receiving offers from freelancers willing to relocate from Switzerland, Italy, the UK and the United States. Such was the pull of a decent wage, even among Western countries.

Vitale worked with around fifty people, young and old, and from various social classes. Participants – primarily from the Gauteng province – provided footage of themselves at work: they filmed their desks, their computer screens, their commute. Illustrating the common elision of the professional and the private, there were also clips of freelancers sleeping, clubbing, golfing. Interspersing his own imagery with the material the freelancers had collected, Vitale created the speculative documentary film *I Am Human*. He also photographed the freelancers he had hired in their personal environments, which often overlapped with their workplace. The material that follows is a combination of stills from *I Am Human*, and photographs taken by Vitale.

Vitale organised his project in South Africa because of the country's continuous history of hard labour and exploitation. From the colonial period to the present, South Africa has been a major source of diamonds, gold and platinum. Under apartheid, it added uranium to its inventory, which it supplied to Taiwan and Israel. In post-apartheid South Africa, forced and pittance-level labour persist in mines around the country. Illegal miners, known as 'Zama Zamas', have flourished around dismantled, close-to-exhausted sites.

'When you speak about mining, especially of gold and platinum, you are talking about a very old form of colonial exploitation,' Vitale explained. 'But the material extracted from many of South Africa's mines fuels technological life – it's what enables IT workers to operate online.' In a series of deceptively soft images that span from miners breaking earth to tech workers breaking their phones, Vitale juxtaposes the opposite ends of the supply chain: two parallel trajectories of destitution and precarity that each depend on the other, but hardly ever meet. ■

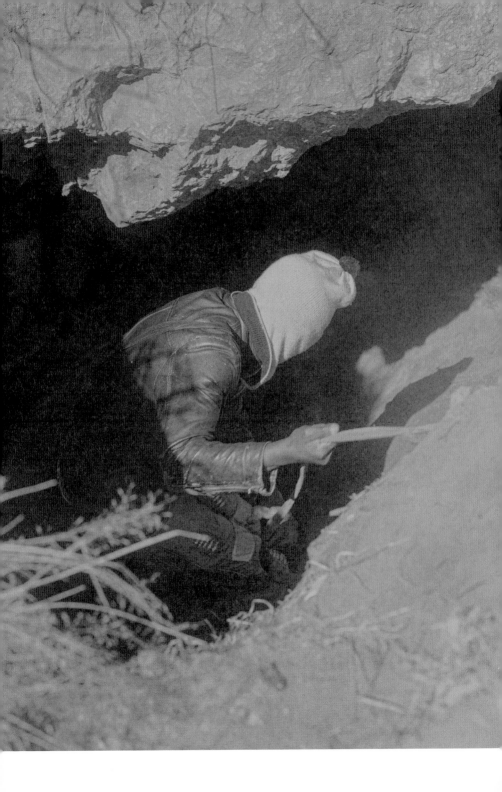

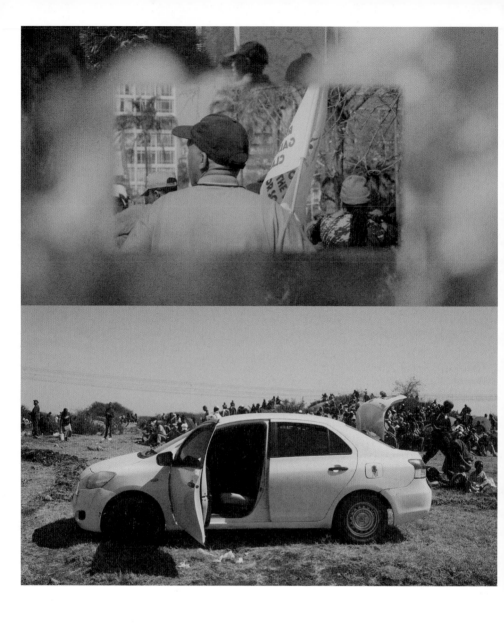

Reboot and Select proper Boot device
or Insert Boot Media in selected Boot device an

Izinguquko ezinkulu zizofika maduze emnothweni we-gig.
Big changes might soon be coming to the gig economy.

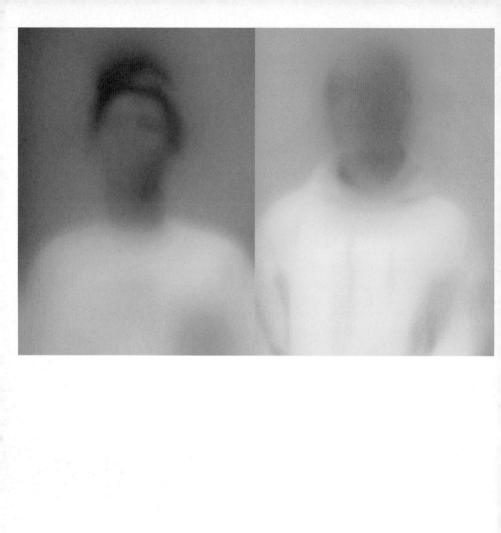

THE LONDON MAGAZINE

Est. 1732

Founded in 1732, *The London Magazine* is the UK's oldest literary periodical, having published original writing by the likes of T.S. Eliot, Ted Hughes, Sylvia Plath, Jean Rhys, Evelyn Waugh, H.G. Wells and Virginia Woolf. Today, we pride ourselves on publishing the best new voices in literature, ranging from poetry and essays, short stories and reviews.

Subscribe to *The London Magazine* for only £30 a year. Visit our website and enter code: **grantareader**

1194

THOMAS GODART / WELLCOME COLLECTION
Man with diffuse lipoma of the neck
Courtesy of St Bartholomew's Hospital Archives & Museum

NETTLE TEA

Camilla Grudova

I went to see Dr Hamori on the recommendation of a friend who had suffered the same ailment as me. I could not get over or out of love with a man who had told me he no longer wanted a romantic relationship with me and had started to see other women. Dr Hamori's clinic was in a well-to-do, sleepy suburb of the city of London, a narrow, tall brick Victorian end-of-terrace with a simple sign which said CLINIC on the door. I took a train down from Edinburgh, having booked my stay for four weeks. In our correspondence they said not to bring clothes or entertainment as these would be provided, but to pack a swimming costume if I had one.

Dr Hamori wore a colourful paisley shirt, high-waisted brown corduroy trousers and a yin-yang necklace. He was bald except for a string of braided grey hair protruding from the base of his skull. His office was on the first floor. I heard many sounds from above, screams and dancing. There were marble statues of nude women, abstract paintings and modern-looking furniture on which he told me to sit down. He pointed to the paintings, 'These were done by former clients of mine, women who have been cured of unrequited love and can now focus on being creative and productive citizens. May I ask you some delicate questions? You said in your application it was a man you love. Did you have intercourse without protective methods?

Was his penis uncircumcised and not especially clean?'

Yes, I answered.

'Do you feel as though there was a black, poisonous liquid flowing through your body?'

Yes, exactly, I said.

'Love is a matter of yeast,' he said. 'Come with me.'

He took me to a room upstairs. A woman lay in the bed. She was cradling a piece of dirty rope, singing to it. The floor was covered in crumpled, unused nappies and toys. 'Love is a yeast and a psychic phenomenon in the genitals and bowels,' Dr Hamori said. 'The creature you see her holding is born of this yeast, and from bacteria from the beloved's genitals, and as such feeds on fantasy, delusion and crumbs of affection. I am the only clinic that has learned how to expel this creature. We offer a heavy rota of culture and physical activity – opera, ballet, badminton, Pilates, invented by a German soldier while in prison. It is the ideal exercise for someone like you, who has become a prisoner in your own body. We often hold emotion in the bowels and a specialised diet will lead to the expulsion of these unwelcome feelings. It will take a lot of hard work on your part, not just mine. Now this expulsion *is not a baby*. I must make this very clear to all my patients. It is not a baby and believing it might be will bring forth a descent into madness. When you are near your expulsion, you are not allowed to leave the house. The woman you see here expelled her creature alone in the splendid toilets at the Orangery in Kew Gardens and formed an attachment to it that we cannot break, as of yet.'

I thought of scraping the residue of a yeast infection with my fingernail and smelling it. Is that love?

He showed me another resident in another room, who came rushing to her door as soon as she heard us coming close. She walked with an odd sway. I noticed, growing on one of her thighs, a giant lump, like a hernia. Her curly blonde hair was unbrushed and cut in a short, hazardous way. She had drawn rings on her fingers using

blue ballpoint pens, which had smeared, and in places the ink was embedded so deeply into her skin that the lines had become cuts.

'Has Harry been here today?' she asked. 'Abandon all hope ye who enter here,' Dr Hamori said to her, and took me down to the kitchen where he made us lapsang souchong tea in an antique pot.

'Elspeth is a particular challenge for me, because her beloved, this Harry, meaninglessly contacts her now and then,' said Dr Hamori, taking two postcards from his pocket. 'Hi, how are you x' was written on the back of a picture of a Kewpie doll that was peeing and giggling. The other was a picturesque postcard from the Isle of Skye. 'Splendid day, lovely jubbly x.' The handwriting was childish and hurried, a thought given and quickly forgotten.

'He is married, with children, and has no romantic interest in our Elspeth. He likes to stay in contact with her, says she is a great chum. We try our best to cut off all contact. She was near expulsion but he sent her a hamper from Fortnum & Mason that we did not catch, and she devoured it – biscuits, chocolates, champagne – hence the unsightly lump on her leg, which we have been trying to drain and forcibly expulse, though yeast remnants remain and regrow. We have a high rate of success at our clinic, but not perfect – it will take willpower from you for an expulsion.'

I signed a contract and started the expulsion regime. We ate a diet with no gluten, sugar or alcohol: potato soup, shredded carrot, unsweetened cranberry juice, tofu, high fibre, mild curry, many greens such as kale, cavolo nero, cabbage, spinach casserole, carob-based desserts, brown rice with rehydrated nori, yogurt with maple syrup, avocados, stewed and dried fruit. We drank cup after cup of nettle tea, which cleansed and detoxified us and pushed the yeast from our bodies.

We were given our own rooms. They were cleaner than any place I had ever lived in, though after a few days I learned that I would have to clean it myself, that this was part of the regimen. On the nightstand was a booklet of postcards. A nude woman having her bum slapped, a topless man wearing revealing swimming trunks,

copies of Renaissance paintings, and so forth. I didn't know what these were for until another patient, Frederick, told me they were masturbatory aids, and that the drawer below was filled with all sorts of implements. It was encouraged, he said, as orgasms were yeast-cleaning and balanced the pH levels, as long as we did not think of the people we were supposed to forget. We had communal bathrooms with signs that said not to leave anything, not a hair nor a toenail. This was strictly enforced due to one patient, Kay.

'Once I was compelled to eat something rotten from the rubbish bin as a child for good luck and something good happened,' she told me. 'It's a weird sort of witchcraft I invented, if you are brave enough to eat nasty things, you are given a reward. It's how I found George. I ate a urinal cake at a pub then met him there later in the night. I stopped doing it when we were together, and now that he's left me, doing it again might bring him back.'

If one of us left something half chewed on our plate or coughed up a grain of rice, she tried to eat it. If she managed to – she made repulsive faces – this wasn't fun or pleasant for her but something she felt she had to do. Afterwards, she would impatiently wait, pacing the house, for George to come pick her up, or call the clinic, and then when there was still no word from him, she would decide that she hadn't gone far enough.

'Oh no no, I just haven't eaten enough. Love is an enormous thing rather, so it will take a lot,' she muttered.

Kay smoked a lot, and strangely this was encouraged by Dr Hamori, who left antique glass ashtrays everywhere around the house for her, since, as he saw it, nibbling on her own cigarette butts was better than pubic hairs left in the bathroom or bits of nori found in the sink after washing dishes. She was temporarily banned from outings because of this: she was found drinking the water from a toilet in the Victoria and Albert Museum and eating scone crumbs off the floor of the magnificent cafe, but we could bring her presents and sugar-free, wheat-free treats.

Our excursions were carefully planned. Dr Hamori had a map of

Britain with the addresses of our exes pinned to it, along with a brief list of their interests. I was fortunate, mine was far away, up in Edinburgh, though King's Cross Station gave me a sickly nostalgic feeling because of the north-bound trains, so we avoided the British Library.

We went to the ballet, theatre, opera, classical concerts – all matinees as our beloveds might attend in the evenings on dates. We were given vegan ice cream made from dates and coconut to distract us from these thoughts, which Dr Hamori brought to the theatre in a cold metal case. Frederick and I held each other and wept during the operas – Dr Hamori was pleased as he said this was healthy. 'I always thought I would be the object of affection,' said Frederick, who was tiny with strawberry-blonde hair. His fixation was an older, married MP named Wilfried, who wore ghastly ties and needed to hoist his trousers up at regular intervals when speaking to the public. I had seen photos in the newspapers and on the television, but this was forbidden knowledge. We visited all the museums, big and small, and went for walks in the glass houses of Kew Gardens to admire the ferns. We never left the house on evenings and weekends, though, as we were more prone to run into our desired ones, and instead spent them in the house, watching Ealing Studios films or playing board games. We were allowed as many library books as we wanted – we had to make a list, however. We were banned from going ourselves, as Elspeth would read the peerage encyclopedias to see if Harry had any more children, and a girl named Jeanie would find pictures of her beloved – an actress, wearing clogs on the cover of *Vogue,* or seated with a new girl in *Tatler,* just as Frederick would rip through the business pages of the *Financial Times* and the *Telegraph.*

We were brought to a salon where we all, to our despair, emerged with the same bowl cuts and French manicures; perhaps it was a bulk discount, but Dr Hamori said a new look was vital, though nothing too extreme. I agreed. In the weeks following my break-up, I had wandered around Edinburgh wearing a peculiar coral shade of lipstick and a gigantic waxed raincoat with a Rupert Bear badge pinned to the front.

We were given vintage high-waisted wool trousers to wear. Dr Hamori said these would give us a feeling of determination and independence but I was fat in the thighs, and the wool rubbing against them gave me a brittle and crusty rash. Frederick said, 'My God, I look like Evelyn Waugh in these.'

We had in-house lectures too, on various topics – T.S. Eliot, medieval art, biodiversity, linguistics, and so forth. The lecturers, brought in from esteemed universities around the country, were peppery and dashing, and I realised they were chosen on account of their looks rather than their areas of expertise, so that we would develop childish crushes.

Dr Hamori gave us simple, logical lectures on love and had us take notes. We weren't allowed to talk or ask questions as this could cause yeast build-ups in the tonsils. He told us he once had a client who came in with a white tongue from months of talking to a therapist, cured only with a vow of silence and marshmallow leaf tea. He said he found all forms of talking therapy to be Cartesian, yeast-yielding claptrap.

He told us his own history. 'My father was the British ambassador to a distant country and we travelled widely. Once, as a child, I ate a fragrant pancake which gave me such a horrendous bout of food poisoning, I was hospitalised for a month. It changed the nature of my gut bacteria, and I grew up to be a loving, loyal man – this is unusual for someone of heterosexual persuasions. I have three daughters and dote on my wife. It is a harsh world you will be released back into, but your gut will be strong.'

Although, he admitted that some people have the opposite affliction. 'Their admirers are tough cases, but I have cured them. What causes such an unnatural lack of love in one you would expect to be loving? Or an ability to over-love in someone you wouldn't? I believe the culprit to be poisoning, parasites, medication used to treat an unrelated ailment, too much liquor, little to no fibre.'

I enjoyed the schoolgirlish comradery of our meals and exercises. On outings, if we passed by bakeries, the croissants and cakes looked

claustrophobic and wretched and I had no appetite for them. I enjoyed the Epsom salt baths and the sauna just off the kitchen in the basement, where we sat wearing wool hats and sweating. I even looked forward to my enemas – they left me feeling renewed and light. I took to reading big Vasily Grossman novels in bed, eating carob chips, and admiring how strong my glutes had become from Pilates, which Dr Hamori taught himself, a Mahler record playing in the background as we stretched, breathed and held our balance.

The first upset came in the form of Harry. He came round to the clinic, wanting to give Elspeth a half-eaten piece of cake wrapped in a napkin from a wedding he had attended. Dr Hamori stood in front of the door, blocking his entrance and shouting furiously. 'Away! Out! You cad!'

We watched from the window in a cluster, with the exception of Elspeth who had been locked in her bedroom and was pounding on the door. Harry was a middle-aged man with the shifty eyes and the floppy blonde hair of a teenager.

'She's a special girl,' he said grandly to Dr Hamori. 'A great old chum, can't I see her?'

'But what is your intent, will you leave your wife, your children?' Dr Hamori said.

'I love my wife very much, you really have a bee in your bonnet, Doctor.'

He was eventually shooed away, eating the piece of cake and humming 'The King Is Still in London'.

All of us had the first pangs of sharp cramps and headaches at the same time, with the exception of Elspeth who, since Harry's visit, had taken to kissing and chewing on the lump on her thigh until it was purple and infected. Dr Hamori had a fertility chart for those of us who menstruated and none of us were at the right time of our cycle for bleeding. A nurse tapped us here and there and looked into our orifices with a flashlight. We had to stretch open our legs against

walls and our enemas were increased. While stretching, Jeanie began crying, got up and took off her trousers and knickers in front of us and expulsed what looked like a wet baseball glove that smelled like horrid breath and mouldy bread. Dr Hamori took it away immediately. I believe he burned it in the green Aga stove in his kitchen.

I panicked, against my better judgement. I didn't want to lose him. I stuffed loo roll into my vagina, and my ears, to hold the expulsion in. I bit my tongue, kept my mouth shut, had irrational visions of my beloved on an express train from Edinburgh, the address of the clinic written on the palm of his hand. I stopped going to the bathroom and avoided my enemas. My stomach grew large and heavy and bothered with matter and urine like an overstuffed grocery bag. Dr Hamori and his nurses noticed and sent me to bed. I craved bags of flour and sweet glasses of sherry.

They had to tie my hands down to the bed so I wouldn't press them against my ear from where the thing had begun to emerge. It looked like a long green woollen sock, like the ones my beloved wore while hunting imbecile flightless birds on large Scottish estates; the sodden folds of the wool resembled his face. I screamed as they took it away in a plastic bag, then felt a strange sort of post-coital relief. I regretted avoiding my enemas, for I soiled the bed during the process.

I was to stay at the clinic a few more weeks, to make sure the yeast was completely out of me and while I waited I observed the expulsions of my fellow patients. A nurse syringed liquid into my ears which dribbled out with bits of ear wax, cloth and other mysterious bits in it, then rubbed my ears down with almond oil. Frederick's expulsion took the form of a horrid boil-like thing on his chest which burst. He looked poetic after, his chest bandaged up like a soldier, a cigarette between his lips as he made wistful plans for his future. 'Upwards and onwards,' he said to me.

Kay developed a horrible affliction of burping which could not be stopped, each louder than the last. Her expulsion was due soon. She ate nothing at all but smoked continuously. She was so near the

end when George showed up, as we had all at one point dreamed of our exes showing up. One morning he arrived, in an old silver Range Rover, with flowers and many jewels and boxes of sweets. Dr Hamori would not let him in, but he climbed through the kitchen window, leaving a trail of petals and biscuits. He wore a suit with the shirt untucked and unbuttoned, revealing a greyish-pink belly like a mound of inedible ham and his sparse hair smelled of pomade.

He said, I Am Sorry, I Adore You, What a Terrible Mistake, Mea Culpa, I Will Spend the Rest of My Life with You Dear Beautiful Kay.

She put both hands over her mouth. We could tell the expulsion was there, tickling her tonsils, souring her tongue. We could smell the sick. George licked his lips with his tongue, watching her. She swallowed, and swallowed, clenching her eyes until it was deep inside her again. She went and packed her bags, leaving her trousers behind, and returned to the entrance hall, ready to leave, dressed in a high-necked, frilly Laura Ashley dress I once would have admired but no longer did.

Dr Hamori was horrified by what this twist might do to the morale and stamina of the rest of the patients, but he needn't have worried because we all saw the glum expression on Kay's face. Her trick had worked. She had a life ahead of her of eating slugs, tepid half-drunk cans of beer pulled from public bins, the hair clogging drain holes, the custard splotch left by an inebriated person on a cobblestoned street, the undigested, visible comestibles of canine faecal matter. Holding her flowers, wearing her jewels, she got into George's Range Rover. I saw her despondently chewing on a carnation as they drove away.

Dr Hamori made me rice cakes spread with tahini and fermented cabbage for my train back to Edinburgh and gave me a Thermos of nettle tea. I was frightened to go to the station, but I was pleasingly indifferent to the sight of it when I arrived. Dr Hamori waved with a purple kerchief as my train departed, as in a film of old. ∎

NADIA ABAZI
Heavy with Intention, 2021

THE ACCURSED MOUNTAINS

Christian Lorentzen

When the injection took hold and the drilling started, he began to dissociate. He was no longer himself but merely a dental patient. The events that led to this moment need not be dwelt on. One afternoon during quarantine, there was a tectonic shift in the lower left posterior region of his gums. Disturbing yes, but nothing loose, nothing unfixed. There was, periodically, pain. He self-medicated. All of these alarming private phenomena were unaddressed, ignored, denied, but never entirely forgotten. Like many things, they were put off. A year passed and then another and then another. Sometimes his mouth reminded him of the Acropolis, once glorious and now crumbling, but in no danger of annihilation.

One morning in Tirana he woke up full of hope. He had finished a pile of work. Money was coming in. He was a free man in the world. Then, while he was eating lunch, the top of one of his molars went its own way. Around midnight it capsized, and he placed the tiny shard of himself in his pocket, the little one on the right side of his corduroys that he used for small precious things. That night he got lost coming home. The cab drivers kept taking him to the wrong street, one that sounded like the one where he was living. It was a hazard of being in a place where you only knew the words for 'thank you', 'yes', and 'cheers'. He should never have left New York City.

He woke up on Saturday morning. His appointment with the dentist, made the previous day with the assistance of his friend E, his main informant and guide to the country, was on Monday. Her boyfriend, a novelist he thought of as the Martin Amis of Albania, had assured him that the dentists here were expert, reliable, and non-exploitative when it came to their fees. His social obligations for the weekend vanished. His hope dwindled. He edited somebody's short story. He read somebody's novel. He went to the movies. On Monday afternoon he went to see Dr L.

'You haven't been to the dentist in a long time,' she said. 'Are you frightened of me?'

'Have you seen the film *Marathon Man*?' he asked.

'I haven't,' she said. 'What happens in it?'

'A Nazi dentist tortures a long-distance runner in an attempt to recover stolen diamonds.'

He had never possessed a diamond, stolen or otherwise. She examined his teeth.

'Mostly good,' she said.

'Really?' he said. 'I thought I would have to have all my teeth knocked out and replaced, like the Hollywood producers told William Holden's character in *Picnic*.'

'No, that won't be necessary,' said Dr L. 'No Hollywood for you.'

'I would need my hair replaced, too,' he said.

'Very true,' she said. 'There will be some fillings and a couple of root canals and of course the extraction. There is a lot of tartar buildup in the vicinity of the salivary glands.'

'You mean the geography of the mouth is a cause of tooth decay?'

'The cause of tooth decay is the human body itself,' she said. 'Have you not visited the dentist recently because of the American crisis of masculinity?'

'It's just very expensive there, and I'm a freelancer.'

Dr L began scraping his teeth. 'Tell me if it's painful,' she said.

'It's not painful,' he said. Then he spit blood into a drain next to

his chair. Dr L used a foot pedal to operate a fountain from which he filled a plastic cup to rinse his mouth.

As the cleaning continued, he felt shelves of residue fall loose from the pillars in his mouth. He felt sensations in zones where he hadn't thought sensations were possible. He contemplated all the time that had passed since he'd had his mouth wide open with another person scraping inside it while another held a vacuum tube to suck up his spit. He had fallen in love, had his heart broken, moved to England, and returned, had his heart broken again, and again. The heart was something that healed, but the best you could do with a broken tooth was to keep it in your pocket. His youth had not been misspent, exactly, but it was gone. Above all, he had written many book reviews.

'Do you smoke?' Dr L asked.

'How could you tell?' he replied.

She continued her work. 'Do you feel pain?' she asked.

'I never feel pain,' he said. 'I don't believe in suffering. It has no meaning. How long have you been a dentist?'

'Three years,' she said. 'Before that I was six years in school, since I was eighteen.'

'When did you know you wanted to be a dentist?'

'Since I was twelve,' she said. 'I didn't know it would be so difficult.'

'Did you have to learn a lot about chemistry?' he asked.

'I know the chemical reactions,' she said.

He spit out more blood. He became aware of the radio playing. 'This is a funny song,' he said. The song was 'Gangsta's Paradise' by Coolio.

'One of my favorites,' Dr L said. 'All done today. Let's make you another appointment. Are you free tomorrow?'

'Yes.'

'Come back at the same time.'

'OK, how much do I owe you?'

She typed a number on a calculator. He wasn't sure what currency she meant. He pulled out a wad of cash.

'Oh no,' she said. 'Only twenty euros. This isn't America.'
'Faleminderit,' he said.

He went to a cafe, one of a chain that seemed to have a spot on every other block in the city. He ordered a peanut caramel latte, took a seat at a table on the sidewalk, and lit a cigarette. He had never had that sort of drink before, but he wanted to taste something and he liked peanuts. The taste was odd. The cigarette was excellent. They were all excellent but this one was better than usual. His mouth was full of novel sensations, not entirely unpleasant. The drink and the smoke seemed to be entering his system through his newly raw gums.

He walked home passing the dwelling of Mother Teresa's family on Kavaja Street, where the mother and sister of the saint once lived. He went to bed early. When he woke up he took a biography of Enver Hoxha to the cafe across the street. It was a catalogue of disgrace, infamy, and salacious tittle-tattle. When Hoxha was a schoolboy, his classmates called him the 'donkey'. Aspersions were cast on Hoxha's sexuality. He was said to have seduced the glamorous wives and daughters of powerful men or to have been a secret homosexual. There was no proof that he had written articles he claimed to have contributed to revolutionary periodicals while studying agriculture in France. Those who knew Hoxha in his youth thought of him as a talentless nobody, not even a committed partisan, just a cashier at a tobacco shop, but then, they said, it was always such nonentities who seized power in the end and wielded it brutally. Hoxha's official birthday was the same as his, 16 October, but the biographer said he made it up and was more likely born in the springtime. The biographer, E told the dental patient, was a television presenter who could be categorized as 'an Albanian Wolf Blitzer'. The opening pages detailed Hoxha's death, of natural causes, at age seventy-six, in 1985, after surviving a lifetime of assassination attempts. How many of his teeth did he have left?

He went to join the Californian, a foreign correspondent visiting from Skopje, for lunch at the cafe outside the Opera House. She

was entertaining an invitation from a man at the next table over to his family's home in the countryside. The dental patient ordered a cheeseburger. It was the worst cheeseburger he'd ever had. He only ate half of it. He went home and brushed his teeth and returned to the offices of Dr L.

'Do your gums hurt?' she asked.

'No,' he said. 'You are an excellent dentist. Have you won any awards?'

'Not yet,' she said. 'Today after some additional cleaning, we will do some fillings. I will administer an anesthetic to half your mouth and you won't feel any pain, unlike yesterday.'

She spent twenty minutes renewing her efforts at scraping, then pressed her fingers on his lower front teeth. 'All the tartar and plaque caused you to lose some bone around these teeth, but they're not loose, so it's OK.'

The prospect of 'losing some bone' alarmed him, but soon the needle was in his mouth, piercing his flesh and seemingly making a deep journey into his jaw. He felt the lower right part of his face disappear. He heard the sound of the drill. It sounded like she was playing a musical instrument capable of producing only a single irritating note.

'First, I will drill away the decay,' she said. 'Then I will apply a binding agent to the tooth. Then I will fill the hole and my assistant will shine a UV light on it, causing it to harden immediately. Then I will use the drill again to shape the new teeth.'

'What is the material of the filling?' he slurred, his mouth half asleep.

'It is plastic and something else,' she said. 'I don't know the English for the other thing.'

When she said 'plastic', it sounded like 'plastique', and he thought of Semtex in his mouth, something that one day might explode, not merely crumble.

'You should,' she said, 'try to avoid swallowing because you don't want to choke on this stuff.'

As the drilling continued, he focused on breathing through his nose and suppressing any impulse to swallow. Dr L and her assistant wore paper masks over their mouths and plastic masks over the rest of their faces. He tried not to look into their eyes. He sensed that his tongue was making involuntary spasmodic movements, like a modern dancer with an experimental choreographer whose work was destined not to stand the test of time. He grunted in order to request a chance to spit. The women's heads and hands floated away from his mouth and he spat in the drain.

'Sorry,' he said.

'It's OK,' Dr L said. This exchange occurred dozens of times during his ongoing acquaintance with Dr L.

'What's your favorite part of being a dentist?' he asked. 'Is it the drilling?'

'No,' she said, 'the drilling is not my favorite. What I like is building the new teeth.'

'You're like an architect.'

'Yes, I am.'

Back in the waiting room, he paid her €80 for the two fillings. Then they discussed the extraction. Dr L explained that there were two options for repairing the zone of the missing molar. He could get a bridge, which would cost €300 and require the removal of the molar in front of the one that had cracked along with the molar behind it, and whose roots she would soon extract. Or he could get an implant, a two-part process that would cost €600 and would not involve the gratuitous demolition of any of his teeth.

'What do you think is better?' he asked. 'I trust you.'

'The implant is the best solution,' Dr L said.

'Then that's what we'll do,' he said.

He looked at the wall and saw a poster for children, a jumble of cartoon teeth with bright flowers growing from them and the surrounding gums.

'Are the flowers that grow out on the teeth a sign of health?' he asked.

'Yes,' said Dr L.

He told her he would see her next week after he visited Prizren for the documentary film festival. She told him to visit the castle there because it was beautiful.

He and the Californian met the next morning at the international bus station. The ride to Prizren across the border into Kosovo would take four hours on a new highway that cut through the Accursed Mountains.

They had been told the festival would render Prizren cosmopolitan and hedonistic. They got their bearings at Bar Hemingway – there was always a Bar Hemingway – and checked into their respective rooms. Everyone he knew in Albania had come to Prizren for the festival. He and the Californian went to a Danish film about teenagers in Moscow who were unhappy. They walked out after twenty minutes. She thought it was neoliberal propaganda. He thought it was boring, though it was nice to be able to smoke in the outdoor theater. They got a drink and then went to meet their Kosovar friends, M and V, for dinner.

The dental patient enjoyed the stuffed peppers, which weren't too hard on his tender teeth. After dinner they went to the bar. A few rounds in, a large party arrived, among them an acquaintance of M and V's, the deputy foreign minister for diaspora affairs. She was accompanied by her boss, the prime minister. M, V, and the Californian were excited to meet him. The dental patient was embarrassed to be meeting a head of state, even an only partially recognized one, whose name he didn't already know. The prime minister was friendly and happy to meet an American literary critic. They chatted briefly about Ismail Kadare. The prime minister was in the habit of giving *Chronicle in Stone* to visiting foreign dignitaries. It was not among the several novels of Kadare's that the dental patient had read, another embarrassment. The mood was very festive and pictures were taken, but soon M and V had to drive back to Pristina. They said goodbye and the dental patient promised to visit them in America. The Californian kissed him goodnight and went back to the hotel.

At the bar, a Polish filmmaker invited him to a rave. He walked with the filmmaker and his friends along the riverside until they reached the rave and were issued wristbands. The music was loud and the dental patient recalled why he hated raves. He left and walked along the riverside, looking up the wooded mountain slope at the illuminated fortress of Prizren, and returned to the bar. It was last call. A few of the crowd around the prime minister remained. They invited him to join them at 'the secret bar'. They snaked down the hill into an alley and entered an establishment with a neon sign that read SECRET BAR. He bought a round of drinks. When he finished his Fernet, he walked back to the hotel and went to bed.

The next morning he and the Californian hired a driver to take them a couple of hours to Mitrovica. The bridge that led to the Serbian side of the river was guarded by a squadron of Italian carabinieri. It was quiet on the other side. D, a friend of the Californian's from Skopje, met them and drove them to a restaurant by a lake where they ate a large fish. The lake was emerald green and surrounded by steep wooded hills. D talked about the war. He'd worked for an agency that was meant to save children but wasn't doing a very good job of it, so he quit. Now in a 'post-conflict society', there were too many roadblocks, which were upsetting, but nor were there enough military-age men for another war. The young men were all abroad, seeking their fortunes.

The next day was Sunday, and he spent it reading his ex-girlfriend's new book. The writing was wonderful, but there was so much about the online world, something he didn't believe in. His phone rang, which was a surprise. It was a call from New York City.

'Christian?' the familiar voice of an old man said. 'It's Gordon Lish.'

'Gordon,' he said, 'I can barely hear you. This is a bad connection.'

'Where are you?'

'I'm in Kosovo.'

'What the fuck are you doing there?'

'I'm at a documentary film festival.'

'Jesus Christ, man, don't be a hero.'

'The war is over.'

'Don't be a hero, Jesus Christ.'

'It's fine. I'll call you when I'm back in New York in a couple of months.'

He did not make it to the castle. Two days later in Tirana he was back in the chair at Dr L's office. It was the day of the extraction of the roots. The roots, she explained, had separated from each other years ago.

'As a dentist,' he asked, 'are you very self-conscious when you eat?'

'Eating is not so much a problem,' she said, 'but when I am in that chair, all I can think of is complications. Students can only think of the complications that might happen, even though they happen less than one percent of the time. It has a name, something like student's syndrome.'

'You're all hypochondriacs?' he said.

'We just know the worst that can happen,' she said. 'Don't worry, today you will feel no pain. If you do, I will give you a second injection.' And she plunged the needle into the lower left rear of his mouth. She pulled out her pliers. She pulled out her wrench. His tongue again danced. She pulled out her hammer. She put the hammer in his mouth and knocked around. She pulled the hammer out of his mouth. Now it was a bloody hammer. He grunted and slurred and she delivered the second injection. Once more with the pliers. She said, 'There, I have it!' And he looked up at the long bloody yellow remains of his vanished youth. ∎

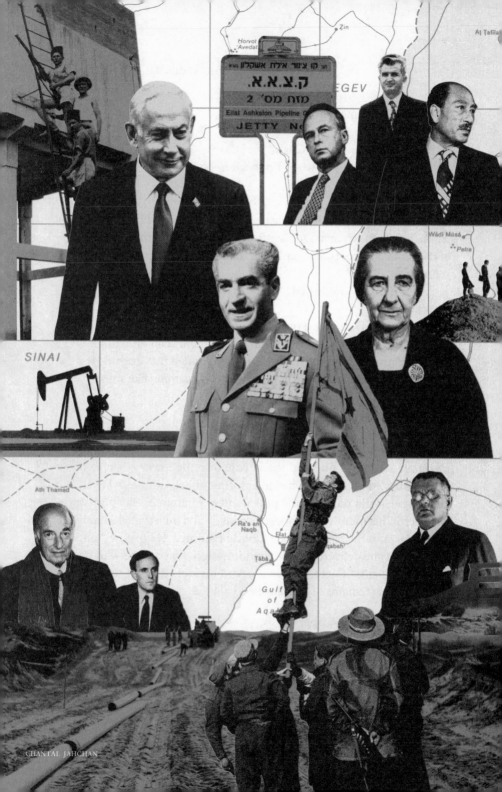

CHANTAL JAHCHAN

AS THEY LAID DOWN THEIR CABLES

Laleh Khalili

G olda Meir visited Iran as Israeli Foreign Minister in July 1965. Her unmarked aeroplane landed in the darkness before dawn at Mehrabad Airport, and she was ushered to a special guest house in northern Tehran. Meir's advisers were keen to publicise her visit but the Iranians insisted on keeping it secret. The secrecy provided the Shah with cover during a moment of upheaval in the world of oil: Iran was expected to present a united front with Arab states in their negotiations with the Seven Sisters, the European and American oil companies that controlled the majority of global production.

At the time, the Seven Sisters were reluctant to openly sell oil to Israel, lest they anger the increasingly assertive Arab states. Given that a spot market in oil was only to emerge more than a decade later, Israel was determined to find a reliable supplier of crude. Meir spoke directly to the Shah. She suggested a joint venture between Iran and Israel whereby Iranian oil, shipped on tankers to the sleepy port city of Eilat on the Gulf of Aqaba, would slake Israel's energy needs. Eilat would be one terminus of a large-diameter pipeline, covertly constructed to traverse Israel from the Red Sea to Ashkelon on the Mediterranean. Trucks, smaller tankships, and narrower pipelines would then carry the oil internally to the refinery in Haifa.[1] What would be of interest to the Shah was the excess petroleum, shipped

on Israeli tankers to markets in Europe. Meir had already visited Romania and secured an agreement from Bucharest to purchase this excess Iranian oil.

The Shah was non-committal about the pipeline suggestion at first, but things changed with the closure of the Suez Canal in the 1967 war two years later. The crisis gave Iran the impetus it needed for the provision of oil *to* Israel and sale of oil to European customers *through* Israel. It would corner a comparative advantage against its Arab rivals by the lower carriage costs that came from not having to transport the oil around the Cape of Good Hope. Iran commissioned a feasibility study. The men in charge were National Iranian Oil Company's Fathollah Naficy and Felix Shinar, who had just concluded his tenure as the head of the Israeli reparations mission to Cologne. In 1968, the two countries incorporated a joint-venture company named Trans-Asiatic in Switzerland and bought the infrastructures of an already existing smaller pipeline between Eilat and Be'er Sheva from the Rothschild Group. Trans-Asiatic also ordered tankers to transport the oil by sea. Hermann Abs of Deutsche Bank met with Shinar and Naficy in Switzerland to hash out the financing for the larger pipeline, with the West German government guaranteeing a more generous interest rate than loans on open markets. Abs had been one of the most powerful bankers to the Third Reich and, as the head of Deutsche Bank's foreign department, had been responsible for the expropriation of European Jewish assets and the looting of European banks in occupied areas. After the war, Abs was sent to unstitch his earlier handiwork: he was put in charge of the German restitution to Israel and in that capacity had developed a cordial working relationship with Shinar.

The Eilat–Ashkelon pipeline went into operation in 1969, on the eve of the nationalisation of oil. The loosening of the grip of the Seven Sisters, and the coming Arab–Israeli War in 1973 opened up a space for independent traders to make deals with buyers and producers. The problem was how to get the oil from the Gulf to its buyers in

Europe and the Americas while the Suez Canal was closed. As Iran did not want to be seen to be trading directly with Israel or shipping its oil through Israel to European customers, middlemen were needed.

Enter Marc Rich, a Belgian-American commodities trader who foresaw the seismic transformation of the oil market and decided to take advantage. Rich's American business partner Pincus Green, who had inked major metals contracts with Iran and spoke Persian, introduced Rich to Iranian oil men. Rich began to cultivate a relationship with the oil technocrats, and with the Shah himself, who took his skiing holidays in St Moritz, where Rich owned a chalet on the Suvretta slope. Rich managed to sign a long-term oil contract with Iran that secured his company Iranian crude at $5 per barrel for the duration of the deal, just as the price of oil was about to skyrocket from $3 to $11.50 a barrel. Rich then sought buyers who were not already in hock to the majors.

Since the Suez Canal was still closed, Rich began negotiating independently with the Israeli government. The French bank Paribas financed Rich's large shipments of oil from Iran. The tankers unloaded their cargo at Eilat, with some of the oil making its way to the Haifa and, later, Ashdod refineries. Rich's ships collected the excess at Ashkelon and transferred the cargo directly to US and European buyers. Refineries, petrochemical industries, power plants, and governments made excellent customers for the Marc Rich + Co trade in oil. Rich even bought substantial shipments of Iranian oil for the United States Defence Fuel Supply Center and shipped it through the Eilat–Ashkelon pipeline. In some years Rich sold more oil than some producing nations. Many years later, Rich told his biographer, Daniel Ammann, that the pipeline had given him 'a big price advantage. The transport of Iranian crude through the pipeline was much cheaper than going all the way around Africa'. Marc Rich became fabulously wealthy from the stealth trade through the Eilat–Ashkelon pipeline. The deal also benefited Iran, whose oil was now more attractive to Europeans because of its lower freight markup; and Israel met its energy needs and bolstered its foreign reserves.

Rich courted Iran even after the revolution that toppled the Shah. While the deals between the National Iranian Oil Company and the majors fell apart in 1979, it continued to honour its deals with Marc Rich, selling him around 70 million barrels of oil per year, a good deal of which made its way to the oil terminal at Eilat. In the twenty years he helmed his trading company, Rich sold Israel up to 20 per cent of its annual oil needs. Revolutionary leaders in Iran were content with symbolic gestures of enmity against the 'Little Satan', but never weaponised the oil trade with Israel.

Rich's lack of scruples in dealing with revolutionary Iran irritated chauvinists in the United States. Rudy Giuliani, then an upstart federal prosecutor looking to make his name in New York, brought charges of trading with the enemy against Rich and Green in 1983. For seventeen years thereafter, their faces appeared on the FBI's Most Wanted posters.

While evading extradition to the US, ensconced in his mansion in Lucerne or travelling to do business, Rich was guarded by former Mossad agents. Then, out of the blue, Bill Clinton pardoned both men on his last day as president in January 2001. Rich's ex-wife Denise had donated hundreds of thousands of dollars to the Democratic Party and to the Clinton Presidential Library; but more importantly, Israeli Prime Minister Ehud Barak and former head of Mossad Shabtai Shavit had both lobbied the Clinton Administration on Rich's behalf. As Ammann writes, Rich had 'organised contacts in places where Mossad had none. He offered money in situations where Israel officially could not'. Rich was dubbed a *sayan*, a helper to the intelligence agency. But far more important than the intelligence work had been Rich's delivery of oil.

E ven before the Israeli state was founded, energy politics influenced the relationship between the settlers of the Yishuv and the indigenous Palestinians.[2] Between 1920 – when Britain and France divided the Ottoman Empire's Arab provinces between them – and Israel's founding in 1948, the World Zionist Organisation

established a number of proto-governmental institutions for the Jewish settler community in Palestine. One of the earliest and most important among them was the Palestine Electric Company, the chief subject of Fredrik Meiton's definitive history of energy and Zionist state-building.

The British mandatory powers in Palestine granted Pinhas Rutenberg of Palestine Electric concessions for the construction of power plants and an extensive electricity grid. A veteran of the Russian revolutions of 1905 and 1917, who would have a hand in founding organisations from the Haganah, the precursor of the Israeli military, to Palestine Airways (later, El Al), Rutenberg planned to produce hydroelectric power, drawing from the Jordan River at its confluence with the Yarmūk River, and at the Auja River (which runs east–west from north of Jericho to the Mediterranean). His plan to expand north and exploit the Litani River, well within Lebanese territory, for the same purpose, continued to shape Israeli policy towards Lebanon until the end of the twentieth century.

To produce hydroelectric power, the company claimed it needed to control extensive tracts of land in the river basins, including some of the most fertile farmland in Palestine proper, as well as chunks of territory across the Jordan River, in Transjordan. The planned power grid criss-crossed the whole of the map of Palestine and would require the possession of land along the routes designated for the high-tension wires. The land acquired for the building of the power stations and the grid infrastructure was also used to build Jewish settlements.

As in other countries, the production of energy went hand in hand with territorial control over geological features – rivers, seas, shorelines, as well as undulations of land that signalled the possible presence of oil reservoirs. Rutenberg's scheme received British approval and support, even as British officials acknowledged that the uneven development and asymmetric utilisation of an infrastructure that extended from the river to the sea gave, in the words of a British colonial official, 'a grip over the whole economic life of Palestine'

to the Jewish settlers. Palestinians, in turn, recognised the territorial ambition, economic import, and political meaning of the electrification plans as foundational to the colonial project that was already beginning to displace them. In a series of protests and uprisings, starting in Jaffa in 1923, and spreading all over Palestine as the years went on, they resisted the expropriation of their lands, the transformations in their lived environments, and the hostile settlements created on the Palestine Electric Company lands. In some places, Palestinians tried to challenge the monopoly of the company by setting up smaller diesel-operated generators. Others threatened sabotage.

To sap Palestinian resistance, Rutenberg suggested deferring the large-scale hydroelectric project in Auja in favour of a diesel-fuelled power station in Tel Aviv/Jaffa, and later a steam turbine in Haifa. The massive power plant at the confluence of the Jordan and Yarmūk rivers came online in 1932. Power was distributed unevenly, with Jewish residential and commercial consumers receiving the lion's share of the electricity. Nocturnal Tel Aviv was brightly lit; Jaffa wasn't. The labour used to construct the infrastructures was racialised, with Palestinian workers earning a fraction of the wages of Jewish labourers. By 1948, Jewish settlers in Palestine constituted less than 40 per cent of the population of the territory and owned only 7 per cent of the land, but consumed '90 per cent of the quarter million kilowatt-hours sold' by the Palestine Electric Company.

The widening economic and political gaps forged by this energy infrastructure has continued to shape Israel's relationship with Palestinians. Within the nascent Israeli state's borders, even as Jewish settlements enjoyed extensive infrastructures, the vast majority of Palestinian citizens who continued to live in neighbouring villages were denied access to these services. As one Palestinian council member in Nazareth complained, 'The government supplies every new Jewish colony with roads, electricity, and water before anyone moves in. Why would electricity poles and water pipes pass Arab villages but leave them dark and dry?'[3] The unequal allocation of energy resources inside Israel have continued until today. Official

governmental Judaisation policies in the Negev and Galilee, where Palestinian citizens of Israel are concentrated, have translated into Kafkaesque housing policies that at the very least circumscribe new construction in or expansion of Palestinian communities. These policies have been reinforced by deliberate denial of access to vital infrastructures – including electricity or water – in both settled and Bedouin Palestinian communities.

Being connected to the Israeli electricity grid, however, has its own disadvantages. Only a few days after the occupation of East Jerusalem, West Bank and Gaza in 1967, Israeli Defence Minister Moshe Dayan remarked, 'If Hebron's electricity grid comes from our [Israeli] central grid and we are able to pull the plug and thus cut them off, this is clearly better than a thousand curfews and riot-dispersals.' In November 1967, Israeli Military Order 159 placed all electricity infrastructure in the occupied territories under the control of Israeli military administration. Today, Palestinians in West Bank produce only 14 per cent of their own electricity and are dependent on Israel for the rest. Before 1967, Israel regularly denied Palestinians within its borders access to electricity; after 1967, the occupied territories were made deliberately reliant on Israeli infrastructures that could be switched off at a flick of a switch. One by one, independent power plants in West Bank and Gaza have been shut down and Palestinian communities have been forcibly attached to the Israeli power grid.

Golda Meir was neither the first nor the last Israeli prime minister to secretly fly to Iran. Before the Iranian monarchy was overthrown in 1979, every Israeli prime minister bar one visited Tehran. David Ben-Gurion inaugurated such visits in 1961 as part of his 'periphery plans' to build alliances with non-Arab states – Iran, Ethiopia, Turkey – that encircled the Arab world. After Ben-Gurion, Levi Eshkol, Golda Meir, Yigal Allon, Yitzhak Rabin and Menachem Begin, and almost every Israeli foreign and defence minister flew secretly to Iran. The only prime minister not to pay his respects to the Shah was Moshe Sharett and he was in post for less than a year

in the mid-1950s. The vast majority of these visits were related to Israel's desperate need to secure energy resources and energy supply routes.

In the half-century-long Israeli search for hydrocarbons, the Sinai was the byword.

The southward-pointing Sinai wedge separates – or joins – the African and Asian continents. Sharm el-Sheikh sits at the southern tip of the Sinai Peninsula, where the gulfs of Suez and Aqaba meet to form the Red Sea. In the early twentieth century, imperial British geologists produced intricate survey maps of the Mediterranean and Middle Eastern shorelines they controlled, searching for reservoirs of water and eventually petroleum. Writing for the *Geological Magazine* in 1940, two geologists described the geography of the region as an arc of exploration for petroleum that ran from Syria, Palestine and Sinai to Iraq, Iran and Arabia, all the way to Oman.

Explorations in Palestine, and later Israel, however, proved largely futile. The absence of petroleum inside the 1949 armistice line must have been galling to Israeli leaders, given the relative proximity of Saudi Arabia, or Iraq, or even the Sinai, where British companies had discovered reserves of oil in the late 1940s. Titular Arab rulers in the Gulf balked at selling oil to the fledgling Israel. In its early years, the Israeli economy was dependent on agriculture, and oil-fuelled Israeli desalination plants used to irrigate water-intensive farm products produced for export. Anglo-Iranian Oil Company subsidiaries in Kuwait and Qatar sent secret tankerfuls of oil to their refinery in Haifa, which they finally sold to Israel in 1958.

Israel's energy needs and dependence on secret and unreliable sources was considered a national security concern – for Ben-Gurion, a 'matter of life and death' – the publicising of which could expose a significant Israeli vulnerability. Sinai tantalised not only with its strategic command over the Suez Canal, the Gulf of Aqaba, and the Strait of Tiran, but also with its petroleum potential.

In 1956, after Gamal Abdel Nasser nationalised the Suez Canal Company, high-ranking officials from Israel, Britain and France

secretly met in Sèvres, France, to plot the invasion of Egypt. France and Britain both wanted to regain control of the canal. Ben-Gurion saw in the imperial anxiety over the Suez Canal an opportunity to expand Israeli territory beyond the 1949 armistice line. His ambition was not only the overthrow of Nasser, but a wholesale transformation of the geopolitical map of the region, including the division of Transjordan between monarchical Iraq and Israel, resettling of Palestinian refugees outside the borders of Palestine, the expansion of Israel north into the Lebanese territory to the Litani River, and control over Sinai. None of this would be possible without a powerful European sponsor. Ben-Gurion recorded a side meeting at Sèvres with French Prime Minister Guy Mollet in his diary:

> I told him about the discovery of a great deal of oil in south-western Sinai, and that it is worthwhile to detach this peninsula from Egypt for it does not belong to her, but the English had stolen it from the Turks when they thought that they had Egypt in their pocket. I proposed laying down an oil pipeline from Sinai to the refineries in Haifa, and Mollet expressed interest in this suggestion.

During the four months between October 1956 and March 1957 that Israel occupied Sinai, the Geological Survey of Israel mapped the peninsula as they searched for oil with an eye to future control of the area. Once it was clear that the Eisenhower Administration would insist on Israeli withdrawal from Sinai, the Israeli military looted pipes, pumps and other equipment they found there to hobble Egyptian oil production, some of which found its way into the earlier, narrower version of the oil pipeline from Eilat.

The Israeli military reoccupied the Sinai, alongside West Bank, Gaza, East Jerusalem, and the Golan Heights in June 1967. In Sinai, Israel took over 117 offshore and onshore oil wells near Abu Rudeis on the Gulf of Suez.[4] The wells had been operated since 1954 by a joint consortium of the Italian ENI and the Egyptian General

Petroleum Corporation. As it reorientated its search for a powerful patron from the declining European empires to the United States, Israel left the oil fields of the American Oil Company undisturbed. If the country wanted to continue its territorial expansion and ensure a stable energy supply, it needed to do so under the US aegis.

A 1972 CIA report on oil developments in Israel, declassified in 2011, confirmed that the stolen oil from Sinai

> has enabled Israel to hold its imports of oil from foreign countries below the pre-war level. The foreign exchange savings to Israel has been on the order of $25 million a year. In 1969, imports of crude oil from Sinai were about 2 million tons and those from Iran a little over 3 million tons.

Golda Meir visited Iran again in 1972. The Shah's confidant and Minister of Royal Court, Asadollah Alam, recorded the occasion in his secret diaries:

> Thursday, 18 May – Audience. Golda Meir flew in at 7 this morning and I reported that she was taking a short rest. 'That old woman has such stamina,' HIM [His Imperial Majesty] said. He then asked after the time of their meeting which was scheduled for 3 p.m. She was received for around two and a half hours, before returning to the airport for her flight back to Israel.

The 1972 visit was arranged two years after the death of Nasser of Egypt, who was loathed by the Shah and Israeli leaders, both for the military threat he presented and his popularity across the Third World. With Nasser gone, the Shah had developed a personal friendship with his successor, the Egyptian president Anwar Sadat. During the meeting with Meir, the Shah conveyed a message from Sadat, requesting Israel withdraw from Sinai, which it had occupied since 1967.

Since making those territorial gains, Israel had become dependent on the Egyptian oil it was illegally extracting in Sinai and Meir chose to rebuff Sadat's overtures. A few months later she hinted at the reason in a joke she told at a reception for the West German Chancellor Willy Brandt: 'Moses took us forty years through the desert in order to bring us to the one spot in the Middle East that has no oil.' Rapprochement between Egypt and Israel would have required Israel to return Sinai to Egypt; permitted the reopening of the Suez Canal; and downgraded the Eilat–Ashkelon pipeline as an energy route and source of dollars. For months after her visit to Iran, Meir ignored a series of secret warnings from King Hussein of Jordan and the Shah of Iran about possible Egyptian retaliation.

In a move that took Israel and Meir in particular by surprise, the Egyptian military crossed the Suez Canal and overran the supposedly invincible Bar-Lev Line in October 1973. The repercussions of the initial roust of Israeli forces were wide-ranging. Golda Meir was forced to resign a few months later. She was succeeded by Yitzhak Rabin, who signed a separation-of-forces agreement with Egypt in May 1974. As evacuation from Sinai and the loss of its oil fields loomed, Rabin abruptly reversed Israel's opposition to apartheid South Africa and began negotiations over deliveries of coal from KwaZulu-Natal for new coal-powered electricity plants.

Meanwhile, the dependence on Iranian oil, as a source both of energy and foreign currency, intensified. So much so that Israeli officials considered a rival Egyptian plan to link the Gulf of Suez and the Mediterranean a direct threat to their domination of the overland route and the flow of petrodollars for the oil traded through the Eilat–Ashkelon pipeline. The *Financial Times* reported laconically that Tel Aviv must have felt 'extra piquancy' at claiming that it had bombed a 'military installation' in September 1969, when it targeted a hotel full of civil engineers working on the Suez–Alexandria pipeline.

Israel also signed a secret memorandum with the United States, which committed Washington to respond 'on an on-going and long-term basis to Israel's military equipment and other defence

requirements, to its energy requirements and to its economic needs.'
A 1978 diplomatic cable from the US Embassy in Tel Aviv explicitly
stated the reason: 'This country runs on oil and has no real short-
term alternative. That is the reason it insisted in Sinai II (Agreement)
on the US supply commitment.' The extravagant annual transfers of
US aid and armament to Israel were institutionalised.

In the decades that followed the Camp David Accords, Israel
continued to receive secret shipments of oil from a now functioning
spot market, while expanding its coal-fired electric plants. It licensed
oil companies to search – unsuccessfully as it turned out – for oil in
the Negev, as well as occupied West Bank and Golan Heights. Even
after the Oslo Accords of 1993, which led to the establishment of the
Palestinian Authority and its control – albeit nominal and uneven –
over Gaza and West Bank, Israel continued to search for energy in
the occupied territories.

In 1999, British Gas found vast reserves of natural gas off the
coast from the Gazan shore, a field now known as Gaza Marine.
This was within twenty-nautical-miles of Gaza, a region the Oslo
Accords specified as the Palestinian maritime economic zone. With
the discovery of the gas reserves, there has been successive Israeli
efforts to shrink Palestinian access to the sea, first to twelve nautical
miles in 2002, then six nautical miles after Hamas's election in
Gaza in 2006, and finally to three nautical miles after Operation
Cast Lead in 2008–9. While officially Palestinian fishermen are
permitted to work within this three-mile zone, the Israeli Navy has
reduced this zone of access to one nautical mile, by firing at will and
arbitrarily at Gazan fishermen. Almost every month in 2023 before
October, the Israeli Navy shot rubber or live bullets at Palestinian
fishermen, rammed their boats, or drove them back to shore using
high-velocity jets of water. In the latest Israeli onslaught on Gaza,
one of the earliest targets of the Israeli Navy's bombing was the
fleet of Palestinian fishing boats in Gaza City. The complete
Israeli control over Palestinian seas, and its refusal to allow the

Palestinian Authority or Hamas to make a deal with British Gas on *their* terms, led the company to abandon its plans to develop Gaza Marine.

In 2009, a decade after Gaza Marine was discovered, Israel found reserves of gas in the Tamar and Leviathan fields further out to sea and up the coast. The Israeli national oil company Delek partnered with Noble Energy of Oklahoma to exploit the two fields (Noble was later bought out by Chevron). In 2017, Jordan agreed to buy natural gas from Israel for its industrial facilities on the Dead Sea, thus indirectly financing the development of Tamar and Leviathan. The convergence on natural gas as the transitional fuel and the sabotage of Russia's Nord Stream pipelines to Germany have made the gas reservoirs in Europe's peripheries – Israel, Egypt, Algeria, Greece, Cyprus and Norway – all the more important. Tamar today provides 70 per cent of Israeli energy needs (with the rest still covered by coal, now imported from Russia and Colombia). Leviathan's gas is almost entirely exported – after it is shipped to Egypt for liquefaction, and, eventually, hydrogen production. While Israel's Arab neighbours make a show of disapproval about its depredations against Palestinians, they quite happily make back-room energy deals, away from their citizens' condemnatory scrutiny.

In June 2023, Netanyahu's government announced that it had agreed with the Palestinian Authority to grant licences for the development of Gaza Marine. It was clear that the policy was intended to shore up Mahmoud Abbas's regime in Ramallah, as the formal economic deal excluded Hamas. A proportion of the financial bounties of the deal was intended to trickle down to Gaza, thus effectively bribing Hamas into docility in Gaza. Then on 7 October 2023, Hamas militants broke through the Iron Wall, or as Palestinian analyst Mouin Rabbani has called it, a 'billion-dollar physical, electronic and digital barrier' surrounding Gaza, murdered around 1,200 Israelis and foreigners – about a third of whom were military forces – and took hundreds hostage.[5] The Israeli response was merciless.

Even in the heat of the hostilities, in November 2023, Israel granted twelve new licences to BP and ENI to develop other fields near Leviathan, though not Gaza Marine. European hydrocarbon companies, which have seen some of their most profitable years in their entire history, are actively looking for new sources of gas close to Europe. The concessions, given while Israel slaughtered at least 29,000 Palestinians, were Israel's means of reminding Europe that winter was coming. Europe, desperate to diversify its energy supply, would feel pressure to include Israeli natural gas among its sources. It remains to be seen whether Israel will also expropriate Gaza Marine.

In 1989, the National Iranian Oil Company sued Israel in an arbitration court in Switzerland to force it to pay for cargoes of oil delivered just before the victory of the revolution between September and December 1978. In 2016, twenty-seven years after the case was brought, the Iranians won more than $1 billion from Israel. Israel has refused to acknowledge the validity of the judgement or pay Iran. In January 2023, the Israeli Knesset renewed its confidentiality order on the Eilat–Ashkelon pipeline, which has been a 'secret' since the 1960s. After Netanyahu signed the Abraham Accords between Israel and the United Arab Emirates, Emirati oil has flown through the pipeline, built with Iranian money on Israeli soil. The UAE is also a major investor in Israeli gas fields in the Mediterranean.

Israeli trade through Bab el-Mandeb was blockaded by Egypt in successive twentieth-century wars. In the third decade of the twenty-first century, the Houthis in Yemen have effectively enforced a blockade on ships going to Israel through the strait. The Houthis belong to the Zaydi community of Yemen, whose imam in the 1960s was aided surreptitiously by Saudi Arabia and Israel to fight against Nasser of Egypt. Egypt, once the foremost enemy of Israel, is led by General El-Sisi's government, which provides intelligence to and coordinates with Israel on security in Sinai and Gaza. Iran, once the most intimate ally of Israel in the region, is now

its sworn enemy. South Africa – once the closest friend of Israel on the African continent, its primary source of coal and uranium, and its collaborator in developing and testing nuclear weapons – has dismantled apartheid and sued Israel at the International Court of Justice to hold it account for genocidal violence in Gaza.

In his analysis of settler colonialism, written in 1965, Palestinian scholar Fayez Sayegh describes the fate of Palestinians, who are subjected to

> foreign domination, exploitation, and dispossession. The territory of Palestine is under alien rule. Its resources are exploited by others. Its people are exiles from their homeland. The remnants of its Arab inhabitants languish under a regime of racist discrimination and oppression as harsh as any race-supremacist regime in Asia or Africa. All this has been accomplished by connivance with Imperialism, and by terror and violence.[6]

In the six decades since these words were written, more Palestinian territories have fallen under Israeli control. Deliberate policies of de-development have hardened Israel's grip on Palestinian natural resources and economy. Where Palestinian communities, businesses and life-sustaining infrastructures are not razed to the ground, they are remade to depend for their survival on Israel. Israel has insulated itself from international condemnation by becoming, in former US Secretary of State Alexander Haig's words, 'the largest unsinkable American aircraft carrier in the world'. If this was once true, it may no longer be the case. European, especially unconditional German, support for Israeli domination of Palestinians, as well as the more mundane trade in hydrocarbons acquired from and through Israel, have closely interwoven Israel into European energy networks. Today, Israel's future seems poised uncertainly between self-implosion and continued coddling by the

Western powers. Given the carte blanche Israel has been accorded, it is not implausible that it will remain the US's gendarme in the region, consolidating and expanding its natural-gas brokerage to Europe and its supine Arab allies. ∎

ENDNOTES

1. Uri Bialer, 2007, 'Fuel Bridge across the Middle East—Israel, Iran, and the Eilat–Ashkelon Oil Pipeline', *Israel Studies* 12(3): 29–67
2. Fredrik Meiton, *Electrical Palestine: Capital and Technology from Empire to Nation* (University of California Press, 2019)
3. Shira Robinson, *Citizen Strangers: Palestinians and the Birth of Israel's Liberal Settler State* (Stanford University Press, 2013), 181
4. Elias Shoufani, 1972, 'The Sinai Wedge', *Journal of Palestine Studies* 1(3): 85–94
5. Mouin Rabbani, 'Gaza Apocalypse', *SecurityInContext.com* (6 January 2024)
6. Fayez Sayegh, *Zionist Colonialism in Palestine* (PLO Research Centre, 1965), 50

Map illustrated by Manuel Bortoletti

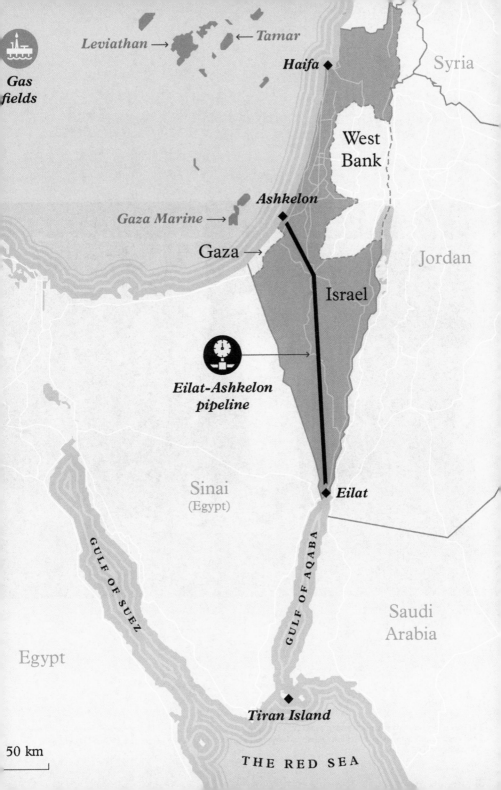

Gas fields

Leviathan → ← Tamar

Haifa ◆

Syria

West Bank

Ashkelon ◆

Gaza Marine →

Gaza →

Jordan

Israel

Eilat-Ashkelon pipeline

Sinai (Egypt)

◆ *Eilat*

GULF OF SUEZ

GULF OF AQABA

Saudi Arabia

Egypt

◆ *Tiran Island*

50 km

THE RED SEA

US engineer and ethnologist Richard Oglesby Marsh with a group of the Kuna people that he had brought to Washington DC in 1924

THE DARIÉN GAP

Carlos Fonseca

TRANSLATED FROM THE SPANISH BY JESSICA SEQUEIRA

Midway through the nineteenth century, as the rivers filled with evangelists and explorers in anticipation of the rubber fever soon to come, the voices of dozens of false millennialist prophets began to be heard through the Amazon rainforest. Visions of the end, speeches of redemption and repentance that would not have been out of place in the mouth of a European swindler, but that in this case were spoken in Indigenous languages. Of those that Juan Gómez has heard, the story of Awacaipu is the most memorable. A former assistant to the naturalist Robert Schomburgk, whose intrepid British team forged its way over those tumultuous rivers just a few years before, Awacaipu had managed by the 1840s to congregate hundreds of Amerindians. The name he gave to his settlement, located in a clearing between two rivers, was Beckeranta: 'land of the whites'. As a talisman of his divine power, he distributed pages from the *Times of London* to loyal members of the flock, pages that his former boss had used to wrap exotic flowers, but that now illustrated a millenarian promise: his devotees would someday have white skin, marry European women, and carry pistols rather than bows. In exchange, the false prophet asked for only one thing: those who wanted all of this first had to die. On the night of the full moon, they would drink and dance beyond the limits of their reason, after which they would

have to end their lives by their own hands. The next day they would be reborn on Mount Roraima, transformed into white souls, their skin as pale as the moon.

E ven though he is a historian, Gómez sometimes feels that history bores him. He gets tired of events threaded one after another like the beads of an old rosary, proposing causes and effects where initially there existed only the furor of the present. Maybe for that reason, leaving his coffee to one side to again confront the image staring at him from the pages of the newspaper, which shows hundreds of migrants crossing the Darién Gap, he thinks of Awacaipu's Beckeranta and tells himself that it is prophecy, delirium and senselessness that interest him, not history itself. The echoes that history produces against its will. He looks at the newspaper and thinks of the migrants making their way through the tangled jungle of the Darién, and he remembers how his father, during the nights of a now distant childhood, told him stories of those lands, and the way they seemed to inhabit another world. His old man spent his entire life working for the ships that crossed the Panama Canal. The canal is only a few hours away from the Darién, but when he spoke of the territory, it was as if it were a magical world that would take months to reach.

This is how Gómez grew up, hearing tales of a supposedly impenetrable jungle so dense that not even the ants could cross it. More than once, at the end of a story, he asked his father to take him one day, only to hear him laugh as he explained that it was impossible, since the highways did not stretch that far. Later, at school, his geography teachers backed up this claim: the Darién Gap is the only point where the Pan-American Highway that runs across South America all the way to North America is interrupted. 'That is the reason we are Panamanians and not Colombians,' they would add with a hint of mischief, gesturing toward the map to emphasize the proximity of Panama to the United States, a sarcastic movement that seemed to suggest that they were closer to the gods.

Looking at the images of the migrants, who seemed to be crossing

that gap so easily now, Gómez thought of his father. He had reached an age when he could look with tenderness at the older man's errors. Not as flaws, but as relics of an earlier age. His old man was no longer there to look with him at the thousands of people launching themselves across that territory every month, rucksack in hand and child on their back, no longer there to call it a recreation of the feat that for his father bore a single name: Richard Oglesby Marsh.

Maybe that is the reason that Gómez has been dedicating his afternoons to rewriting, in secret and in the form of a novel, the story of Marsh, a story he first heard in the hoarse voice of his father. In his father's telling, Marsh's crossing seemed otherworldly, blameless and mythical, more of a dream than a reality. It was a fairy tale that as a young boy had made him think of the books of Julio Verne.

The truth is that Marsh never imagined he would end up a revolutionary in the Darién. How could he have imagined it? He didn't know there were people there. He thought the jungle was virgin territory. Later, he would be called a traitor for siding with us, the Kuna, instead of the Panamanian state. But that was later. In the beginning, Marsh arrived with a simple mission, one that had nothing to do with politics and everything to do with money: he came looking for fertile land where rubber could be planted, financed by none other than Henry Ford and Harvey Firestone. Their factories needed rubber, simple as that. Marsh had previous experience visiting plantations in Ceylon and Malaya, so Ford asked him to explore new lands. The Darién at that time did not even appear on maps, though we had always been there, navigating its swollen rivers and jungle. Marsh had the luck, or perhaps it was a curse, to arrive and see the few of us among the tribe with fair skins. 'White Indians' he called us.

Marsh did not find what he was looking for. The jungle in the Darién is resistant to crops. Our land is incorruptible, our rivers furious. Marsh found no arable land, but he did find a myth – a fantasy, a chimera. White Indians. Sometimes one can move the world this way, chasing dreams. The rumor of our existence spread through the jungle and beyond, and sometimes we laughed at the fascination we exerted. But it was only

later, when I came to know Marsh better, that I understood how deep the enchantment truly went.

For me it was different. This was how I was born. Ever since they watched me enter this life, the tribe called me Chepu, which for us Kuna people means 'white'. They separated me from the others and forbade me from marrying. They put me in a shack with those who were like me. For me, whiteness was damnation. But for Marsh it meant purity and elegance.

There were evenings in Washington when he would become nostalgic and reminisce about his adventures in the Darién. I laughed when I heard him tell his gathered associates, always with passion, the story of how he came to discover our existence. He would light a Havana cigar and say that instead of rubber, he'd found something far more valuable: thousands of white Indians, never before described by science. A lost tribe of Europeans.

Now that he is no longer here, I sometimes sit down with the book he wrote about us: White Indians of the Darién. *He published it in 1934, more than a decade after the events it describes. I settle into the rocking chair and pursue his fascination like someone stalking a delirium not his own, watch him mounted in the canoe with his team of Black guides and explorers, heading up the Chucunaque until he reaches the village of Yaviza. For Marsh, it was all strange: he had been sure that the Darién was a virgin land, innocent of the sins of history, but wherever he looked there were ruins. Vestiges of an old Scottish colony, abandoned huts of a German radio station, works of the Sinclair Oil Company, debris produced by the United Fruit Company. He had traveled to the Darién trying to escape history, and all he found was its rubble.*

In Yaviza he saw a handful of dilapidated bamboo cabins. Muddy land crowded with flies and Black babies, dogs and trash. Marsh detested anyone who was not white, it must be said, for all it pains me to do so. Maybe it was for that reason he looked away, toward a clearing that extended into the jungle. This is when he witnessed the scene that would change his life. In the clearing, he glimpsed the silhouettes of three white Indigenous women, all of them adolescents. Long, blonde hair falling in perfect cascades over semi-naked bodies. Scandinavian bodies, as he describes them in the book. White bodies that disappeared into the jungle,

giving way to the obsession that Marsh would pursue for years to come. He
knew that we existed, that we were not just a myth. And if today I am here
in Washington, it is because Marsh knew that nobody would believe him if
he didn't put a white Indian like me in front of his compatriots, an Indian
as pale as those girls he saw vanish into the tropical forest, a sight that left
him with the sensation he was losing hold of the threads of a dream. It was
a twisted dream, that became clear to us rather quickly. His dream turned
us into souvenirs brought from afar, objects of science rather than men.

In the afternoons, while writing, Gómez often remembers with perplexity the way his father, who was even darker than himself, used to narrate the story from the perspective of Marsh. The triumph of crossing the Darién, the vindication of finding his 'white Indians', the stand he made in the end on behalf of the Kuna, fighting alongside them against the state. The irony of it all seemed lost to him. Did he not see that Marsh had been mistaken? That there had been no lost tribe of Europe? That might be why Gómez has decided to narrate the story from the perspective of Chepu, the Kuna boy that Marsh brought to Washington in the name of science when he was only ten.

Gómez had landed three hours late. The old man was already gone. Later that day, with the funeral preparations under way, he had distracted himself by inspecting the fifteen or so books on his father's shelves. Lost among fishing manuals he found an old copy of Richard O. Marsh's *White Indians of the Darién* and, within it, a magazine clipping with a photograph of Marsh in Washington, accompanied by a Kuna boy. The caption read: 'Marsh alongside "Chepu", a ten-year-old White Indian boy from San Blas.' Looking at the young, pale boy, his face expressing discomfort and confusion, Gómez smiled briefly, thinking how obvious it was that this was a simple case of albinism. In his father's telling of the story everything had been so mysterious. So much larger than life.

Now, pausing in his writing, he wonders from what position someone like him, a Panamanian mixed-race man who has never been to the Darién, should narrate this history of dreams and wars. From

what position should a Panamanian mixed-race man who has spent thirty years lost in the Anglo-Saxon academy narrate this history of borders and migrants? From what position should someone like him, a mixed-race man that Marsh himself would surely have looked upon with contempt, narrate this story of racial chimeras? The thing is, for all he knows it is not his place, sometimes he also sees himself as a kind of 'white Indian', a paradox forged by the strength of others' dreams and by his own repression. He thinks of himself as a man who has learned to be white by living among white people, though all it takes is a look in the mirror to realize his error. Perhaps that is why he finds his way into the story alongside Chepu, now a man, taken from one place he didn't belong, to another.

As soon as Marsh saw those pale adolescents disappear into the jungle, he set himself the task of finding them. It mattered little to him that neither Ford nor Firestone cared about our existence. Marsh pursued us with the force and ambition with which others seek riches. We were his delirium. He went back to the United States and looked for funding. It came easily. The Smithsonian, the Natural History Museum of New York, and the University of Rochester all took his side. The world of science wanted us to exist, they wanted a mirror that would show themselves reflected everywhere. A short time later Marsh was back, navigating the Chucunaque with a twelve-person team despite everyone in his path advising him against it, saying that the Kuna were fierce, and that no white man had survived the crossing. He didn't listen. Accompanied by the crew of scientists and soldiers the Smithsonian had provided, he crossed the Darién heading south.

We all know the way fantasies work. To pursue them in reality is enough to see them disappear behind the veil from which they emerge. So it happened to Marsh. He did not find white Indians anywhere. All he found were the suspicious gazes of a crew that, tired of exploring, spent their hours measuring out the dangers that surrounded them. They were right to do so. I am sure the jungle would have devoured them had it not been that Marsh, always perceptive, knew how to strike up friendships with the peoples he did

find. Marsh had long since perfected the knack of the gift: he carried a trunk with him everywhere, from which he took out small offerings brought from the Western world. Nobody dares say it, but I will: Marsh was the only one who could win over the Darién, uniting tribes in peace that until then had been fighting. He was blind to his true motives, to the force of his malady, larger than any conflict and any rivalry. But history is often made by people who blindly follow a vague intuition. It was this intuition that finally brought him to what he was looking for. The intuition that if what he was looking for were white Indians, he himself had to turn Indian, and that is what he did, in a manner of speaking. He deepened his friendships with our leaders, he began to understand our problems, he made our battle his own. The government wanted to us to speak their language, dress like them, go to their schools. But for Marsh, all this was pointless. We were pure and white already. Any association with Panama could only stain us. The chiefs heard him and understood they had found the man they needed to declare war on the state. Only then did they grant him the mirror he was looking for. That was when we were made to appear.

I will always remember my first impression of Marsh. He seemed to me an exhausted madman. In his eyes I read the fatigue of all he had seen and lost. But his exhaustion jolted into energy when we started to arrive by the dozens. In exchange for promising us the independence of the Kuna peoples, our leaders granted him the vision that had escaped him for so long. White Indians. I was only ten years old, but I remember looking at him from top to bottom, dressed with absurd formality in the mud. White like us, but infinitely distant.

Gómez likes to think he has preserved some of his father's ways of narrating the story: the snapshot-like, episodic quality of narrative, the atmosphere of reverie that pervaded his storytelling. But his old man's story was straightforward and epic, the tale of a white man saving a forgotten people, while his own is opaque. He has grown rather fond of Chepu, of his contradictions and his ambiguities. Often he thinks of the face he saw in the magazine clipping, the bewildered countenance that looked at him from the page. Chepu, a

boy who must have felt foreign everywhere. Maybe for that reason, as the image of the Darién migrants silently interrogates him from the newspaper, he remembers his first months in the United States, and the sensation of foreignness that invaded him then. He never said anything to his parents. He never complained. He had fought hard to win the scholarship, and a return to Panama would have been a failure. But he felt nausea and anxiety, and his consciousness was focused on a foreign language that always eluded him. Even so, the pride of being there, in halls filled with portraits of distinguished academics, had helped keep his insomnia at bay. He had adapted, little by little, learning the forms and references, slowly forgetting his difference, learning to be one among many. A 'white Indian', he thinks, laughing to himself.

If his peers at the university found out about his novel, what would happen? Telling the story from Chepu's position. Adopting the Indigenous voice. It was appropriation. He can't see how they would understand that all of history intuitively leads him back to that same place, to that figure of the young boy turned middle-aged man, remembering his guardian with that contradictory mix of affection and reproach.

Perhaps my name is what allowed him to project his dream upon me. Chepu. They gave it to me as soon as they saw I was white as milk. I think it is the reason why, at the end of the trip, Marsh decided that out of all of us who had traveled to Washington, I would be the one to stay with him. Maybe he felt my name captured the essence of it all. We were twelve: nine with brown skin, there to represent the political interests of the Kuna tribes, and three of us who were white, brought as subjects of scientific investigation. Mimi, as beautiful as the moon, must have been fifteen or sixteen. Olonipiguina, with whom I had spent my childhood, was fourteen. I was the baby. A ten-year-old forced to stand in front of the eyes of science, as if he were a strange flower brought from afar. Marsh brought me to Washington, proudly presented me, and then left me behind. He kept his promise. It was his responsibility to return to the jungle, to lead the uprising.

I didn't ask questions. I looked around, confirmed how different this new world was from the one I had left, and sat down to wait. Marsh gave me his home, but deprived me of mine. I remember thinking how huge the house felt, how empty and vast. Then it began to fill with the rumors and stories that arrived from the isthmus. It was said that Marsh had helped our leaders draw up a declaration of independence. It was whispered that he had helped supply our peoples with arms for the approaching battle. I heard all this and imagined Marsh amid the stormy, treacherous rivers of the Darién, fighting in our name. As winter arrived in Washington, we found out more. The Kuna, led by a Marsh who had begun wearing Indigenous attire, took Panamanian forts in Narganá and Sidra. We heard how after a tough battle they occupied the island of Parvenir. When Marsh returned, we learned that it was there, in Parvenir, that the meeting had been held. A meeting convened by the United States ambassador to which Marsh showed up late. The two representatives were already there and seated, the North American on one side, the Kuna on the other. I will never forget how Marsh sat on our side during that meeting.

Marsh returned to Washington a few months later, carrying the newspapers that announced his expulsion from Panama at the hands of President Chiari, the same dignitary who was promising to evangelize and civilize the Darién. Marsh held the pages as if they were jewels, proud of the news that they did not carry: the triumph of the Kuna peoples, the agreement the government had reached with our leaders. Marsh was transformed. It was as if something in him had broken while he fought in the Darién, or perhaps it had been lost in that clearing where he saw us for the first time, and where for the first time I saw him. More than once, in the years that followed, I saw him sitting in front of the trunk he brought back with him from Panama, that trunk he'd filled with the gifts that had gained him the friendship of our peoples. He sat there and reread those newspaper pages, and the letters he'd received from our leaders, poring over the strange story that he had lived. And I wondered, watching from a distance, if he had ever really seen us, or if we had never been more than a reflection of his self, and of his racial malady.

Sitting in the professors' lounge, sensing that the hour has nearly come for his lecture, Juan Gómez confronts the photograph in the newspaper one last time. The Darién of his boyhood had turned into a migratory route. If only he could tell his father about it, say that the migrants were managing to do what the engineers who had conceived the Pan-American Highway could not. He wonders how his father would have received this new story, how he would have narrated it back to him. What voice would he have adopted, what perspective. Where would he position himself in this new epic? He tries to imagine the migrants on their arduous journey, heading toward their own delirious fantasy of an America that no longer exists, but at each step the silhouette of Richard Oglesby Marsh intrudes. With the bitter taste of coffee still in his mouth, he lays aside the newspaper and stands up, conscious for a moment of the dozens of portraits of white men looking down at him from the lounge's walls. ∎

British Journal of Photography, founded in 1854, showcases photography pioneers and explores diverse narratives in art, culture, politics and society through top-tier photographers, plus it hosts prestigious international photography awards.

Become a *British Journal of Photography* Full Access Member to receive exclusive benefits, including home delivery of our quarterly magazine, plus free access to our internationally renowned awards, including Portrait of Humanity Vol 6, which is now open for entries.

thebjpshop.com

British Journal of Photography

DAN CURTIS
The Lasting Song, 2023

ON BOREDOM

Nuar Alsadir

Years ago, when my two daughters and I would come upon an obstacle such as a lamppost while walking down the street, we would play a game that involved calling out opposites as we briefly let go of one another's hands: 'Hot and cold!' 'Day and night!' One time my older daughter cried, 'Love and hate!' Love and hate aren't opposites, I explained, because they are both passionate. The opposite of love would be indifference. She understood immediately. When we encountered the next obstacle, she cried, 'Love and indifference!'

Along the same lines, the opposite of boredom is not excitement, but calm. Boredom is a restless state of mind, generally marked by dissatisfaction. Just think of how often you feel uninterested in something without being bored. The monotonous car ride from Chicago through Midwest cornfields to the New England college I attended was never boring to me, but a fertile ground for daydreams. When your imagination is free to roam, you can lose yourself in reverie. But when you're bored, you're unable to fantasize. You can't even think.

'I never quite hear what people say who bore me,' observes the writer Édouard Levé. What he gets at here is the psychological goal of boredom – tuning things out, although the person boredom tunes out most successfully is oneself. Boredom is a symptom of an

unconscious process – an internal muting, which leaves the conscious mind with both a lack and an itch to re-find what is missing.

From a psychoanalytical perspective, boredom is less a response to something in the external world than a defense against something in the internal world, an impulse or desire that is taboo – often sexual or aggressive in nature – which evokes guilt, anxiety, or fear of punishment. Boredom evades those negative emotions by blocking off thought that might lead to the prohibited impulses or desires that trigger them. 'The inhibition of fantasy,' writes psychoanalyst Martin Wangh, 'often occurs because of an unconscious fear that fantasy might lead to action of libidinal or aggressive nature – an impulse to masturbate or strike out – which in turn would bring about danger or pain.'

As children, we learn to use words, then to watch what we say. We move on to control what we think and feel. Thoughts and feelings travel together. One way to get rid of an overwhelming feeling (like anxiety, or guilt) is to repress the thought it is attached to (the desire or impulse that makes us anxious or guilty). That way there is no longer anything to feel bad about. But even after the desire or impulse has disappeared, and the bad feeling with it, the drive toward gratification remains. A bored person is therefore left with a hankering feeling that they want or are bothered by something, but, because their aim has been suppressed, they don't know what it is.

I remember a feeling of immense dread one dark Sunday afternoon in childhood. I turned for help to my mother, who was reading on the couch.

'I feel like there's something wrong,' I told her, 'but I don't know what it is.'

'You should read,' she said, lowering her book but not closing it. 'Get out of your head.'

To my mother, my uneasiness was a symptom of boredom, something that could be dealt with by an activity. But what she ended up teaching me was to reinforce the sort of repression that boredom usually indicates. To respond to my disquiet with distraction.

Childhood is the peak time for boredom because there are so many feelings a child is told not to have. 'Life, friends, is boring,' John Berryman writes in his famous poem on the topic, 'Dream Song 14', but, 'We must not say so'. The speaker recollects his mother telling him '(repeatingly) "Ever to confess you're bored / means you have no / Inner Resources"'. Parents often respond to their children's laments along the same lines: 'You're not bored – you're boring.' The parent that can't help their child develop Inner Resources will likely defend against the frustration and powerlessness called up in them with boredom of their own (*you're boring*). Perhaps part of what is so irritating to parents about their children's boredom is the amorphous need it expresses – they want help finding something, but they don't know what it is.

Boredom expresses the state of tension between a fear, desire or impulse that has been repressed and the leftover yearning that remains free-floating in consciousness, looking to attach to something. It is always easier to project that search into the external world than to look internally. But the external search can only fail. 'The person who is bored,' the psychoanalyst Otto Fenichel writes, 'can be therefore compared to one who has forgotten a name and inquires about it from others.'

We often think of forgetting as a bad thing, but for Søren Kierkegaard, 'A person's resiliency can actually be measured by his power to forget'. The same might be said about a person's ability to repress. Repression is a defense mechanism that disappears thoughts that would be too overwhelming if they were allowed into consciousness. It frees us up to function, to do what is expected, to give others what they want from us. We align with the social order, even if that means having to emotionally shut down.

'The defensive nature of boredom,' writes psychoanalyst Charles Brenner, is observed when 'a bored patient is *unconsciously* attempting to convince himself that he does not want to gratify the instinctual wishes that frighten him, that, on the contrary, he has no wish to

do anything.' But this defense, like others, only works for so long. 'When we speak of writing something in the book of oblivion,' Kierkegaard continues, 'we are indeed suggesting that it is forgotten and yet at the same time is preserved.' The psychological nature of boredom needs to be understood and worked through in order for it to be relieved.

Boredom that isn't resolved internally frequently causes the bored person to compulsively search outside of themselves for relief. This often leads to overactivity that psychoanalysts term 'manic defenses' – scrolling, swiping, substance abuse, constant socializing, actions that clutter out negative emotions that might otherwise have had the space to consciously register.

It's important to note that the psychoanalysts I've quoted here were all writing before the invention of the iPhone, which has become the ultimate tool for managing boredom. I can't tell you how many sessions I've spent listening to someone describe the misery they felt after scrolling on social media for hours – a misery, it always turns out, that was pursued because it was preferrable to some other more miserable thought that was then displaced. An upsetting thought that comes from the external world that is familiar and easy to interpret can defend against a more unmanageable thought by bumping it out of consciousness. But replacing one agitated state with another doesn't bring anyone closer to relief.

At the core of boredom is an urge that is impossible to satisfy because the bored person is always looking in the wrong place. Substitutes in the outside world – either too far removed from the actual desire or too close and thus provoking anxiety – will not only feel not quite right but are likely to call up feelings of dissatisfaction, frustration, even rage. Annoyance, anger, and bad odor are etymological roots of *ennui*, the French loanword. Boredom is a complicated stink of an emotion, one that is far more layered than we presume.

Every Wednesday afternoon, while training to become a psychoanalyst, I would meet with my supervisor in her office tucked into a corner of a prewar apartment-building lobby on Manhattan's Upper West Side. After a bit of conversation that served as a greeting, I'd take out my notebook to discuss the sessions I had conducted that week. Whenever I began to relate the material of one specific patient, I would start yawning. This didn't happen once or twice, but every few seconds. I wasn't sleepy or uninterested. If we talked about something else – even why I was yawning – it would stop.

One day, the patient who induced those yawns walked into my office, sat on the couch, and said, 'There's something I've been meaning to tell you.' My heart raced. I anticipated a hostile outburst. Instead, the patient relayed neutral information: she had plans to travel so would miss our next session. My physical response allowed me to understand what was happening. For months I had been picking up on strong negative feelings the patient wasn't expressing through words, but were nonetheless present. And some part of me knew it.

My response was an example of 'countertransference', an emotional reaction an analyst experiences when associations from the analyst's own past are transferred onto material presented by a patient, in the same way that a patient's associations and expectations from the past can be transferred onto the analyst in 'transference'. Sometimes countertransference is misplaced – an analyst (like a parent) is, after all, a human being. But at other times, it can serve as a useful tool for picking up on unconscious communication, which involves the body and the intellect. I knew what it felt like to have someone blow up at me. When, at the animal level, I received similar cues from my patient, I anticipated danger.

The patient's rage was being communicated unconsciously, but at that point in my career I didn't know how to work with unconscious communication. That moment of sudden anxiety allowed me to recognize that yawning in supervision had been my unconscious way of bringing the rage – as well as the anxiety it provoked – into our

discussion. As soon as we gained insight into what was happening and addressed the feelings beneath the surface – my own and my patient's – the yawning stopped.

Yawning is one of many psychological devices we use to modulate destabilizing feelings, and, like boredom, it's more complex than it seems. A friend of mine noticed her husband yawns before telling a lie. World Cup champion speed skater Apolo Ohno famously yawned before a race. Paratroopers often yawn before jumping; dogs sometimes yawn to avert a fight. Yawning exists on one end of a spectrum of defenses the mind uses against overwhelming emotions. Boredom stands somewhere in the middle, while fainting is at the extreme. At the physiological level, fainting can occur in response to an emotional trigger, such as anxiety, due to vasovagal syncope. Your heart rate slows and your blood vessels widen, making it difficult for enough blood to be delivered to the brain. Excess yawning is a less severe case and can arise from stimulation of the vagus nerve. Whereas yawning functions as an emotional balm, fainting offers an escape hatch to oblivion.

When I was fifteen, I had a job busing tables at a neighborhood restaurant whose owner was prone to hostile outbursts. The dominant emotion among the staff was fear. One evening after I'd been working there for a few weeks, the owner called me into his office, which was off the kitchen beside the walk-in fridge, and exploded at me. I don't remember what I'd done or the content of what he said, only that I was so overwhelmed that as soon as I exited his office and stepped back into the kitchen I fainted, knocking over and falling into a crate of strawberries.

The jam I created by fainting was not the most dramatic of the summer. A few weeks later, someone defecated in their underwear and flushed it down the men's room toilet, causing a clog and overflow. I can't hear the word 'shitstorm' without recalling that incident. If I were to make a film about my experience working at that restaurant, the overflowing toilet would symbolize all of the suppressed rage the

employees felt in response to the owner's treatment of them erupting into the concrete world.

In the animal kingdom, anal secretions are used for aggressive and defensive purposes, as with skunks. Even in language, we describe an emotional attack as 'shitting on' someone. Boredom is also evacuative, but the bored person evacuates inward. They push their impulses into repression – implode rather than explode.

After something has been repressed, Freud tells us, it doesn't just stay in the unconscious, 'as when some living thing has been killed and from that time onward is dead'; rather, 'the repressed exercises a continuous pressure in the direction of the conscious, so that this pressure must be balanced by an unceasing counter-pressure'. Think of holding a beach ball underwater: you can only keep it down for so long before it shoots out in a direction you can't anticipate.

Boredom can be a signal that powerful impulses beneath the surface might explode in an unexpected direction if given an opening. To the extreme, unrelieved boredom can lead to destructive behavior toward the self and others. There are numerous instances of people behaving in harmful ways – engaging in risky behavior, setting fires, committing murder – citing ennui as the cause. 'There is perhaps no more reliable indicator of a society's ripeness for a mass movement than the prevalence of unrelieved boredom,' cautions philosopher Eric Hoffer.

Boredom itself isn't dangerous, of course, but what lies beneath it may be. The bored have strong desires and impulses that need to be unpacked. You have to get at the root impulse or desire behind boredom – make the unconscious conscious – for genuine relief. Once what's beneath boredom is examined, you can then discover what's beneath that, which is usually hope. After all, you only feel disappointed when you care.

In a recent session, I found myself feeling sleepy. By then a much more seasoned psychoanalyst, I was able to recognize that my drowsiness was not an expression of my interest but a response to an unconscious communication from the patient. I was closing my eyes

to some thought or feeling he didn't want me to see. I explained to him what I suspected was happening. 'Instead of colluding with the pull I'm feeling to avoid whatever it is you don't want to talk about,' I said, 'I'm going to ask you to check in with yourself and see if you can identify what feels too huge to allow into consciousness.'

He said, 'I feel like I'm not living the life I want to live.'

A bored person similarly wants more out of the moment, and life, but often in ways that run counter to what is expected of them. Just as with envy, which is easier to work with if you focus on the desire behind it rather than its impulse to destroy – 'Tell me what you need to spoil,' the psychoanalyst Adam Phillips writes, 'and I will tell you what you want' – boredom marks the space where hope is buried. When you are bored, you can't dream, and without dreams, it's hard to care about the future. Taking interest in our boredom, we can uncover what we desire and what we want to change. ■

THE
BURLINGTON
MAGAZINE

A Francis Bacon discovery

Looking closely with Cezanne

30%
OFF

FOR NEW
SUBSCRIBERS

THE
BURLINGTON
MAGAZINE

Exhibitions

CONTRIBUTORS

Atossa Araxia Abrahamian is the author of *The Cosmopolites.* Her forthcoming book, *The Hidden Globe*, is about jurisdictions above, between and beneath nations.

Nuar Alsadir is a poet and psychoanalyst. She recently published the non-fiction book *Animal Joy: A Book of Laughter and Resuscitation.* She is also the author of the poetry books *Fourth Person Singular* and *More Shadow Than Bird.* She lives in New York.

William Atkins's latest book is *Exiles: Three Island Journeys.* He is working on a book about Sizewell and its nuclear power stations.

Tereza Červeňová works predominantly with analogue photography and film. She is currently artist in residence at the Warburg Institute for the duration of the Warburg Renaissance Project.

Bathsheba Demuth is a writer and environmental historian at Brown University, and author of *Floating Coast: An Environmental History of the Bering Strait.* A current Carnegie Fellow, she is writing a biography of the Yukon River watershed.

Carlos Fonseca is the author of the novels *Colonel Lágrimas, Natural History* and *Austral,* all translated into English by Megan McDowell. He teaches at Trinity College, Cambridge University.

Danny Franzreb is a photographer whose recent work examines the transformative impacts of mass tourism, urban development and crypto-mining, among other subjects.

Camilla Grudova is the author of *The Doll's Alphabet, Children of Paradise* and *The Coiled Serpent.* She was born in Canada and lives in Edinburgh.

Laleh Khalili is the author of, most recently, *The Corporeal Life of Seafaring*, published in 2024.

Benjamin Kunkel is the co-editor of, most recently, *Who Will Build the Ark? Debates on Climate Strategy from 'New Left Review'.*

Eka Kurniawan was born in Indonesia. His novels include *Beauty Is a Wound* and *Man Tiger.* He is currently working on his next novel, *Black Smudge.*

Rachel Kushner is the author of the novels *The Mars Room*, *The Flamethrowers*, *Telex from Cuba*, a book of essays on art, politics and culture, *The Hard Crowd*, and a story collection, *The Strange Case of Rachel K*. Her new novel, *Creation Lake*, will be published in September 2024.

Christian Lorentzen writes for the *London Review of Books*, *Harper's Magazine* and *Bookforum*.

James Pogue is the author of *Chosen Country: A Rebellion in the West*, and is a contributing editor at *Harper's Magazine*. He is writing a book about rural California. The Pulitzer Center helped to fund his reporting for 'Wagner in Africa'.

Thea Riofrancos is the author of *Resource Radicals: From Petro-Nationalism to Post-Extractivism in Ecuador* and co-author of *A Planet to Win: Why We Need a Green New Deal*. Her next book, *Extraction: The Frontiers of Green Capitalism*, will be published by W.W. Norton.

Jessica Sequeira is a writer, literary translator and the editor of *Firmament*. Her books include *Other Paradises*, *Golden Jackal / Chacal Dorado*, *A Furious Oyster* and *Rhombus and Oval*. Her translation of *The Eighth Wonder* by Vlady Kociancich is forthcoming.

Anjan Sundaram is an author, journalist, academic and artivist. His books include *Breakup: A Marriage in Wartime*, *Bad News: Last Journalists in a Dictatorship* and *Stringer: A Reporter's Journey in the Congo*. He has reported from Central Africa, Cambodia and Mexico for *Granta*, the *New York Times*, the *New York Review of Books*, the *Guardian* and the Associated Press, among others.

Annie Tucker is a translator from the Indonesian. Her translations of Eka Kurniawan's fiction include *Beauty Is a Wound*, *Vengeance Is Mine*, *All Others Pay Cash* and *Kitchen Curse*. Her translation of Laksmi Pamuntjak's story 'Anna and Her Daughter's Partner' was published in 2023.

Salvatore Vitale is a Swiss-based artist, editor and educator. He is a senior lecturer at the Lucerne University of Applied Sciences and Arts.